MASTERWORKS

OF AMERICAN

PHOTOGRAPHY

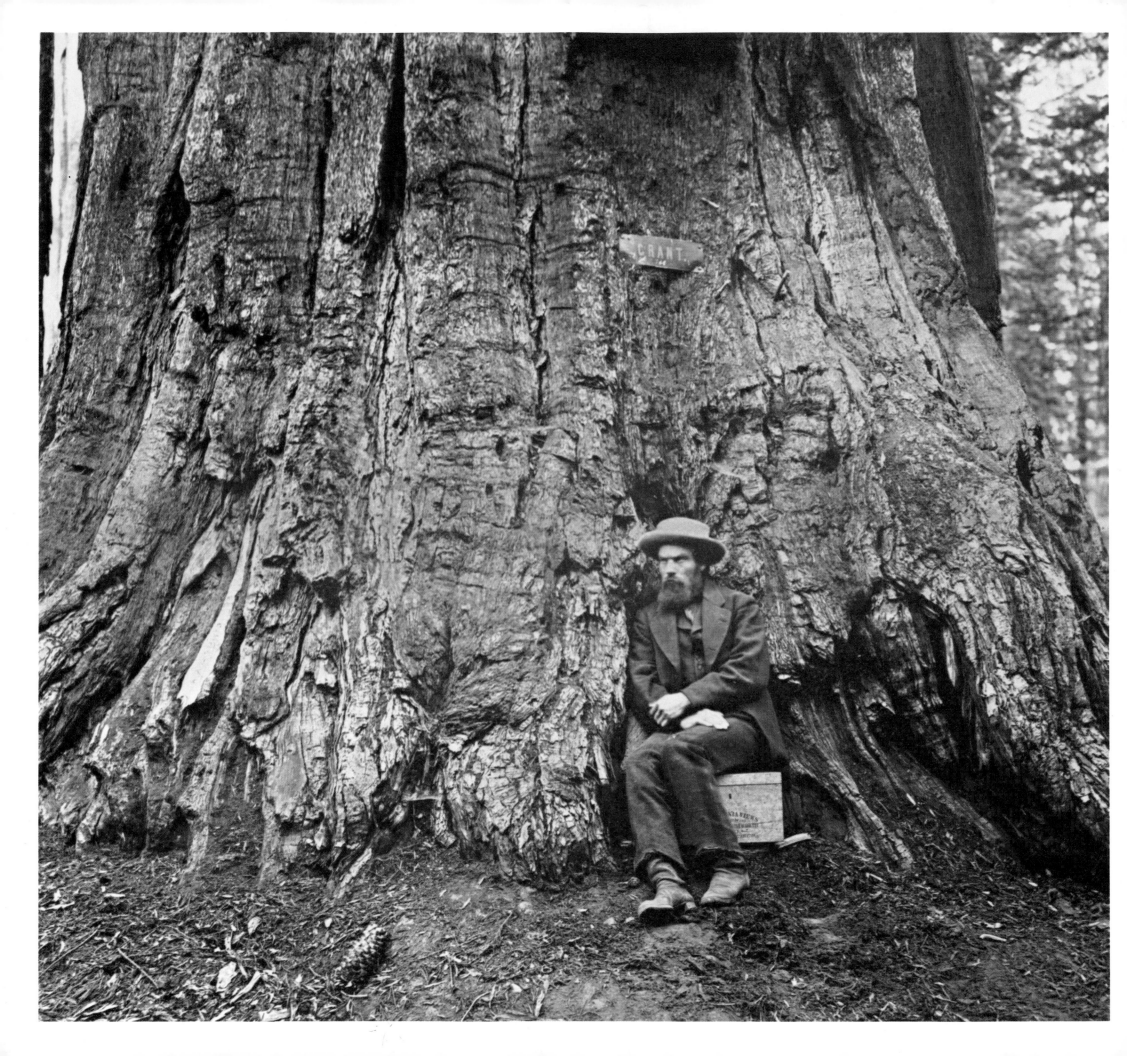

MASTERWORKS

OF AMERICAN PHOTOGRAPHY
The Amon Carter Museum
Collection

Martha A. Sandweiss

OXMOOR HOUSE, INC.
BIRMINGHAM

V.S.W.
Gift of Publisher
1-19-83

The Amon Carter Museum was established in 1961 under the will of the late Amon G. Carter for the study and documentation of westering North America. The program of the museum, expressed in permanent collections, exhibitions, publications, and special events, reflects many aspects of American culture, both historic and contemporary.

Library of Congress Catalog Number: 82–80594
ISBN: 0–8489–0540–8
Printed in the United States of America

FIRST PRINTING

Published by Oxmoor House, Inc.,
Book Division of Southern Progress Corporation
P.O. Box 2463, Birmingham, Alabama 35201

Editor-in-Chief *John Logue*
Editor *Karen Phillips Irons*
Production Manager *Jerry Higdon*
Associate Production Manager *Joan Denman*

Photograph by William Garnett, © 1951 William Garnett

Photographs by Barbara Morgan, © 1980 Barbara Morgan

"Church, Ranchos de Taos, New Mexico, 1930," © 1981 The Paul Strand Foundation

"Boy, Hidalgo, Mexico, 1933," © 1940, 1967 The Paul Strand Foundation, as published in Paul Strand: *The Mexican Portfolio*, produced by Aperture for the DeCapo Press, 1967

Photographs by Edward Weston, © 1981 Center for Creative Photography, Arizona Board of Regents

FRONTISPIECE: DETAIL PLATE 53
U.S. Grant, 80 Ft. Circ., Mariposa Grove [Portrait of Eadweard Muybridge] (1872) attributed to Charles Leander Weed

To

Amon G. Carter, Jr.

1919–1982

CONTENTS

Introduction ix

The Photographer as Historian 3

Early Photography in America 13

The Nineteenth-Century Landscape 21

Nineteenth-Century Portraits 49

The Pictorial Style 63

The Straight Photograph and the Documentary Style 87

The Twentieth-Century Landscape 125

Catalogue 136

Portraits of Photographers 149

Index of Photographers 155

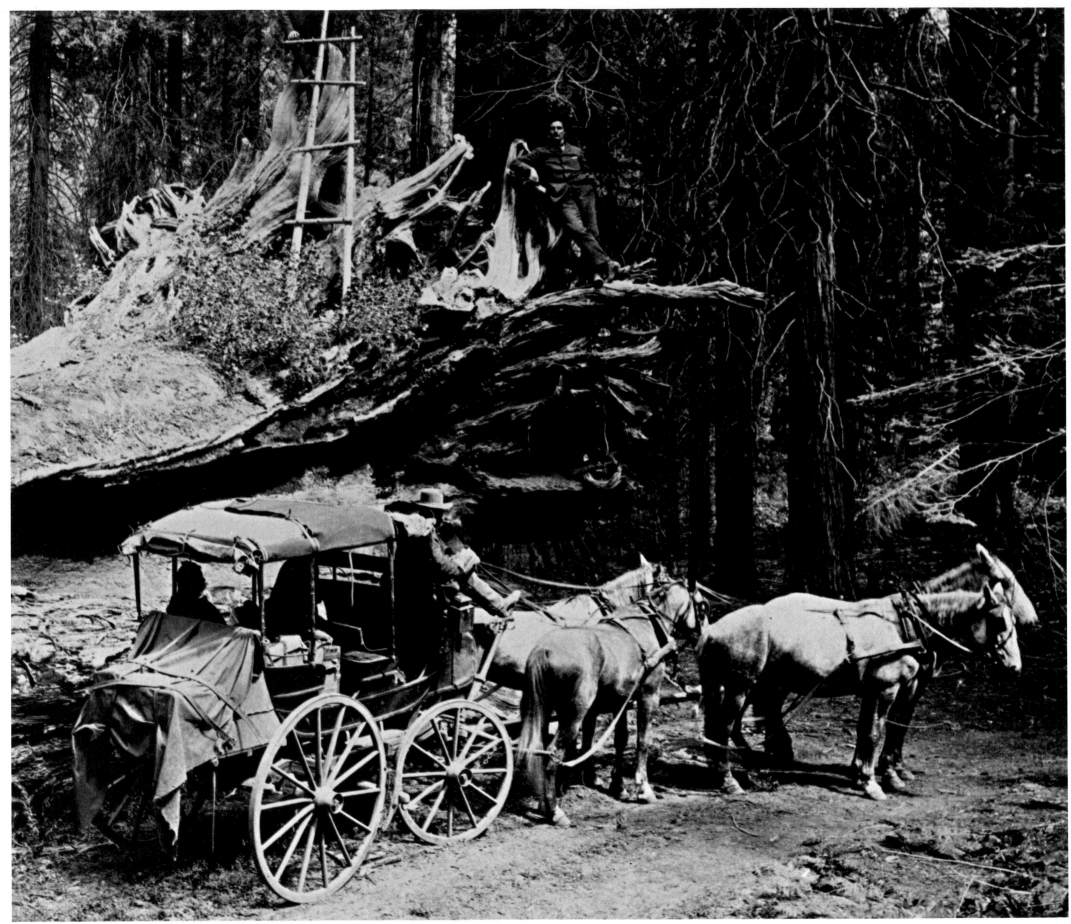

DETAIL PLATE 21 *Yosemite Stage by the Fallen Monarch. Mariposa Grove, 1894* (1894) I. W. Taber, Publisher

INTRODUCTION

I n 1961, photographer Dorothea Lange wrote to the newly opened Amon Carter Museum to describe a portrait she had made of cowboy artist Charles M. Russell. "My question is whether you have an interest in such a documentary photograph in connection with your museum . . . this is a revealing picture and should be seen and used."[1] Lange's candid portrait of Russell, taken on a late San Francisco afternoon in 1924 or 1926, became the first photograph in the Amon Carter Museum collection (p. 86). As a photograph by an important American photographer documenting the life of an artist whose work is amply represented in the museum, the portrait suggests the dual interest in American art and history that has guided the museum's programs and photographic acquisition policies for more than twenty years.

With more than 120,000 prints and negatives, the Amon Carter Museum now holds one of the country's major collections of American photography. The fine arts photography collection, from which most of the images in this book are drawn, includes approximately 2,500 photographs by the masters of American photography from the earliest times to the present, as well as the Laura Gilpin Estate. Bequeathed by the photographer to the museum in 1979, the Gilpin archive contains more than 27,000 negatives and 20,000 prints documenting Gilpin's sixty-five years of work in the Southwest.

1 Dorothea Lange to Amon Carter, 2 May 1961, Amon Carter Museum Archives, Fort Worth, Texas.

The historical photography collection includes several large groups of photographs, amassed by individuals and later acquired by the museum, that document specific areas of Western American history. The *Mazzulla Collection*, assembled by Denver residents Fred and Jo Mazzulla between 1940 and 1970, contains over 50,000 photographic prints and negatives pertaining chiefly to the history of nineteenth-century Colorado, focusing on Denver and on Colorado's early mining towns. The *Brininstool Collection*, assembled by Los Angeles newspaperman and amateur historian Earl Alonzo Brininstool, includes nearly 3,000 late nineteenth-century photographs of Plains Indians, done mainly by photographers working for the Bureau of American Ethnology. The *Everhard Collection* includes some 6,000 glass-plate negatives taken by a number of photographers that document the black community of eastern Kansas between 1875 and the first world war, military life in and around Fort Leavenworth, the Alaskan Gold Rush of 1898, and the route of the Great Northern Railway across the northern plains.

The architect of this large and diverse collection was Mitchell A. Wilder, the first director of the Amon Carter Museum. A photographer himself, Wilder had become interested in photography's place in the museum (and the museum's role in photography) in the 1930s when, as Curator of the Taylor Museum in Colorado Springs, he commissioned Laura Gilpin to photograph the religious architecture of the Spanish Southwest for a forthcoming book by George Kubler. Later, as Director of the Colorado Springs Fine Arts Center, he became increasingly involved in organizing photographic exhibitions, something few other American museums were then doing.

Museums, Wilder thought, should encourage outstanding creative photography and do more than merely hang the traveling "salon" exhibitions organized by amateur camera clubs that were the mainstay of most museum photographic exhibition programs. In a 1953 letter to Peter Pollack, head of the photography department at the Art Institute of Chicago, Wilder wrote, "We have grown so sick and tired of the 'salon' photographs which are available for museum use that I refuse to show them any more." He told Pollack of his plans for *The West*, a large thematic show of selected work by "fourteen outstanding photographers of America" and spoke of future programs:

> "Next year we hope to do a big show of young or at least less known photographers of distinction. The objective in all this is purely local or at least regional, and our hope being that we will encourage and point the way to the photographers of this area by aiding and abetting what we consider to be the creative use of the camera as opposed to the god damned pictorialists."[2]

2 Mitchell A. Wilder to Peter Pollack, 1 April 1953, Colorado Springs Fine Arts Center Archives, Colorado Springs, Colorado.

When Wilder assumed the directorship of the newly formed Amon Carter Museum of Western Art in 1961, he brought with him an awareness of the leading role museums could play in the photographic world. Although the museum's founding collection of work by the western painters Charles M. Russell and Frederic Remington included no photographs, Wilder quickly established a photographic collection as part of an active program that emphasized excellence and scholarship in both exhibits and publications.

His earliest acquisitions suggested his vision for the breadth of an Amon Carter Museum collection. After purchasing the Dorothea Lange portrait of Charles Russell, he collected large groups of work by William Henry Jackson, perhaps the most prolific of nineteenth-century western photographers, and by the Californian Edward Weston. All of these photographs, Wilder thought, fell under the museum's stated purview of interpreting "the westering of North America."

Bit by bit, as the museum has redefined the scope of its collection to embrace all of American art, it has acquired a comprehensive collection of American photography. And while the collection's particular strength remains the photography of the American West, recent acquisitions include important portraits by such masters as Albert Sands Southworth and Josiah Johnson Hawes, Thomas Eakins, and Alfred Stieglitz, views of the twentieth-century industrial landscape by Charles Sheeler, and the experimental light drawings of Carlotta Corpron.

The photographs in this volume provide a selective overview of the Amon Carter Museum holdings and of the history of photography in America. This book, however, is not a systematic and evenhanded survey of American photographic history, for it inevitably reflects the idiosyncrasies of the museum's collection. For example, while the Civil War photographs of Matthew Brady or Alexander Gardner are standard icons in photographic texts, only one Civil War image (by George Barnard) is illustrated in this book. But four daguerreotypes by an anonymous American who traveled to Mexico in 1847 to document the war with the United States are included. Selected from the museum's fifty-two Mexican War-related daguerreotypes, these unique and never-before-published views include the world's earliest photographs of war and are far rarer than the better-known Civil War pictures.

Again, the idiosyncrasies of the museum collection mean that a photographer's traditionally defined importance is not necessarily reflected in the number of works reproduced in the book. An anonymous turn-of-the-century portrait photographer who documented the black community of eastern Kansas is represented here by three photographs, as is Alfred Stieglitz, the acknowledged father of fine arts photography in this country. Not

REDUCTION PLATE 79
Charles M. Russell (c. 1924-1926) Dorothea Lange

surprisingly, Laura Gilpin, whose estate of 47,000 prints and negatives is housed in the Amon Carter Museum, is represented by the most images. Scattered through three sections of this book, these photographs only suggest the remarkable breadth and versatility of her long career.

The museum's collection is continually evolving as new photographs are acquired or interesting pieces long buried in the historical collections are rediscovered. This book presents some of the best of what the Amon Carter Museum has now; ten years hence it might well be a very different book. It is with great pleasure that we pause for a moment to survey the museum's collection of photographs and share it with the public.

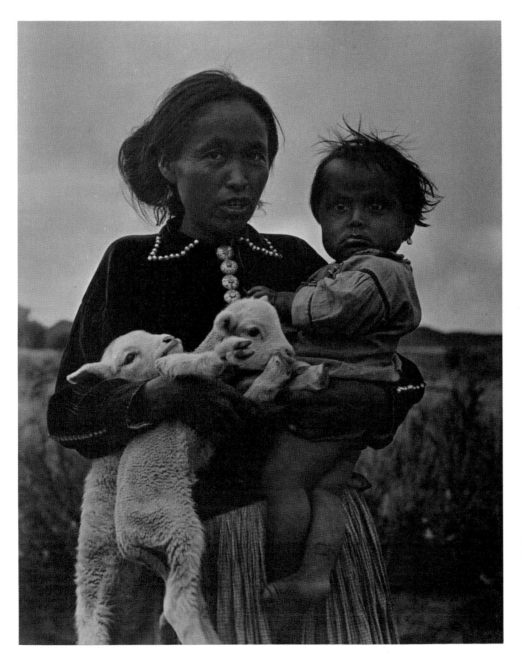

REDUCTION PLATE 84
Navaho Woman, Child and Lambs (1931) Laura Gilpin

MASTERWORKS

OF AMERICAN

PHOTOGRAPHY

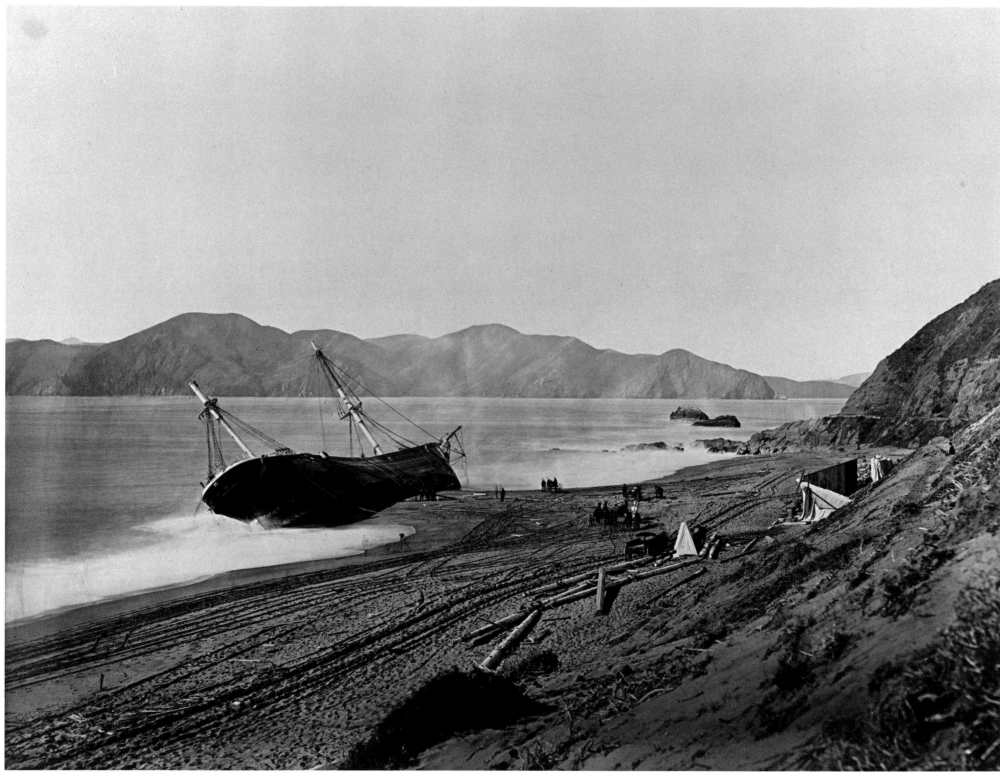

PLATE I *The Wreck of the Viscata* (1868) Carleton E. Watkins

The Photographer as Historian

To look on, to analyze, to explain matters to myself

One day late in the week of March 8, 1868, San Francisco photographer Carleton E. Watkins loaded a small stereo camera, a mammoth-plate camera, jars of chemicals, a portable darkroom tent, and an assistant into an open, horse-drawn cart and set out for the beach at Fort Point, just outside the Golden Gate. He wanted to photograph the *Viscata*, a grain-laden British barque that had run aground while tacking out of San Francisco Harbor on March 7th. Watkins had already visited the site with a stereo camera and made an informative but rather lackluster photograph of the fully rigged ship. Now, aware that all the publicity surrounding the shipwreck might boost the sales of his work, he returned with his large camera to make a great view of the hapless ship that was being steadily destroyed by the wind and the water.

When Watkins arrived at the site of the wreck, he found work crews unloading the vessel's cargo. The workers had constructed a large chute from the *Viscata's* deck to the beach and were sliding sacks of grain down the chute to waiting laborers who placed them in horse-drawn carts for transportation to city warehouses. Much of the ship's rigging lay dismantled on the beach, the masts and spars strewn like driftwood washed up in the tide.

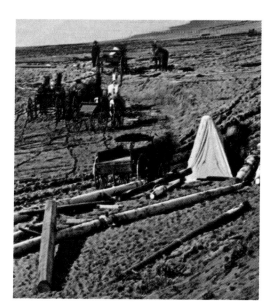

DETAIL PLATE I

Watkins set up his white-draped darkroom tent on the beach above the high-tide mark and unloaded his equipment. Having already decided that he *wanted* to photograph the ship, he now had to decide *how* to do it. He set his stereo camera on the water's edge and sent his assistant to photograph the wreck from there. Positioning his large camera for a grand view was more difficult, for the wet-plate negative process Watkins used was slow and laborious, and any ill-planned shot would be a waste of much effort and time. To make a negative, Watkins had to shut himself inside his small, sand-bottomed darkroom tent and coat an 18-×22-inch glass plate, first with a sticky transparent substance called collodion and then with light-sensitive chemicals. Then he had to load the plate into a negative holder, carry it to his camera, expose it, carry it back to the tent and process it chemically; all of this had to be done before the collodion coating on the plate dried and lost its sensitivity to light. This process took at least half an hour and had to be repeated for each shot. To be efficient, Watkins needed to visualize his ideal photograph from the start.

The events on the beach did not dictate what Watkins' great photograph might look like. He had to select his vantage point carefully. If he set his camera close to the ship, he might describe its naval architecture, capture a portrait of a worker with a grain sack, or document the mechanics of the rescue operation. Instead, Watkins put his bulky camera on a sandy rise some distance from the ship; this spot allowed him both to document the rescue efforts and to portray the *Viscata* as an element in a much larger landscape. From there, the vessel looked like a beached whale, stranded at the mercy of the forces of nature. It assumed a formal elegance, with the stubs of its two remaining masts linking the distant hills to the sandy shore in the foreground.

Having selected the spot to set up his tripod, Watkins then had to decide how to frame his photograph. Should the ship be dead center? Should the camera be tilted downward to exclude the empty sky? Watkins carefully made his decision—and timed his shot—to include the tiny train snaking around the shoreline cliff and the wonderful enigmatic man seated on the footpath at the right. This marvelous dark-suited figure, like Watkins an observer of the drama, is the sort of ironic onlooker a painter or novelist might have invented to lend interest to a story. He is so splendidly placed on the periphery of the scene that one wonders whether Watkins found him there or placed him there.

Indeed, Watkins was not afraid to leave traces of his own hand at the scene. His darkroom tent and supply wagon are in the middle of the photograph, and some of the footprints in the sand are undoubtedly his. His stereo camera and his assistant, whose movements were blurred by an exposure of several seconds, are visible at the water's edge. It is not improbable, then, that Watkins might leave further evidence of his presence by arranging for the mysterious man to pose on the sandy overlook.

The photograph that Carleton Watkins made on that sunny March afternoon is a masterwork of nineteenth-century American photography. The view is artfully arranged so that the diagonal lines of the wagon ruts and the littered spars quickly draw us into the photograph. Our eye stops to linger, though, on the massive dark shape of the doomed *Viscata*. The photograph contains an extraordinary amount of information—about a particular vessel, a specific rescue operation, the working methods and paraphernalia of a nineteenth-century photographer—all carefully selected, molded into a whole, and presented by the photographer. While the information contained in the photograph is specific, Watkins has framed a scene that suggests a more timeless and universal drama: man against the larger forces of nature. The handsome beached whale of a ship is doomed, and the tiny figures standing on the beach can do nothing to forestall her inevitable demise. The image is at once specific and general, confirming both the transitory and immutable nature of the world.

What Carleton Watkins did when he made this picture, and what every photographer does when he clicks the shutter, was to describe the world as he saw and understood it. The wreck of the *Viscata* is presented to us not simply as it was, but as Watkins saw it and photographed it on a particular day. The final print has an order and structure imposed by the photographer who has made deliberate choices about what to include.

If art is a form of creative expression that can reflect personal style, express and reveal beauty, convey information, and inspire emotion, then photography—despite the naysayers who see it only as a record of the physical world—is an art. Even in a "documentary" photograph like *The Wreck of the Viscata*, the maker's hand is apparent. But photography is different from painting. With its insistent reference to concrete things, it will always be more literal than the older medium.

The popular metaphor of the photographer as an artist, who works like a painter by making two-dimensional images within a given frame, is useful but not really adequate to describe what the photographer does. The photographer is also a historian. Like the historian, it is his business to describe the outside world. Moreover, the historian and the photographer practice their crafts in similar ways. They begin with an interest in a particular subject. They survey the myriad of facts or the bits of information that comprise or elucidate that subject, select what seems most interesting or relevant to their concerns, and arrange what they have found for presentation. Though both the historian and the photographer describe things that actually did exist, subjective choices are involved at every step of the process. "History is not alone facts, not alone ideas, but facts in their relation to ideas," the historian Hubert Howe Bancroft wrote.[1] Photography is much the same thing.

The choices a photographer faces when he makes a picture are very much like the choices that a historian might face in describing an event. After selecting his subject, the

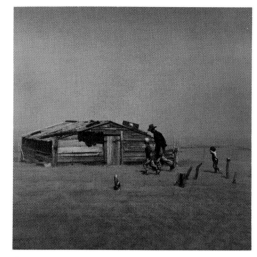

REDUCTION PLATE 110
Farmer and Sons Walking in the Face of a Dust Storm (1936) Arthur Rothstein

1 Hubert Howe Bancroft, "History Writing," in *The Works of Hubert Howe Bancroft*, v. 38, *Essays and Miscellany* (San Francisco: The History Co., 1890), p. 94.

historian must select the particular moment or time period he wants to describe and settle upon a vantage point from which to survey the scene. A historian writing about the *Viscata*'s untimely demise, for example, might focus on the biography of the man leading the rescue operation or stand back and view the wreck as one of the many caused by the tricky winds and currents of San Francisco Harbor. The historian must also decide how much to include in his story and how to frame the event. Finally, he must decide whether he shall try to adopt a neutral posture towards his subject or make his own presence apparent, as Watkins did by including his own footprints and the accoutrements of his trade. In making these sorts of choices, both the photographer and the historian seek to transform mere facts into art.

All artists manipulate their materials, and a reliance on actual objects or events does not ensure the truth of either a photograph or a historical account. Both historians and photographers can describe true things in false ways. As Lewis Hine, who fully understood the photograph's power to persuade, wrote, "While photographs may not lie, liars may photograph."[2]

Historians can ignore bits of evidence, examine facts out of context, recombine disparate bits of information, and choose between an intensive and extensive examination of events when they set out to describe a scene. Photographers have all the same strategies at their disposal. Arthur Rothstein gave stage directions to the figures in his famous Dust Bowl photograph (p. 114) to enhance the effect of the howling wind.[3] William Henry Jackson cut and pasted bits of different photographs and rephotographed the resulting collages as if they were real landscapes in order to present a more dramatic version of the West.[4] The distance between the photographer and his subject also influences the apparent significance of the subject: how different Allie May Burroughs would look if Walker Evans had photographed her from across the street (p. 92)!

By literally or visually describing something and isolating it from all that surrounds it, historians and photographers confer upon it a special importance. They invite our scrutiny of common things and reveal the unseen patterns of everyday life. Edward Weston wrote that the discriminating photographer "can reveal the essence of what lies before his lens with such clear insight that the beholder will find the recreated image more real and comprehensible than the actual object."[5] This is the same sort of clarity the perceptive historian strives for when he describes events familiar to his readers.

The idea of a connection between the writing of history and the making of photographs is not a new one. Photography and history—two crafts plagued by debates over their proper status as science or art—were often linked by nineteenth-century writers, though

2 Lewis Hine, "Social Photography: How the Camera May Help in the Social Uplift," *Proceedings of the National Conference of Charities and Corrections* (June 1909), reprinted in Alan Trachtenberg, ed., *Classic Essays on Photography* (New Haven: Leete's Island Books, 1980), p. 111.

3 Arthur Rothstein, "Direction in the Picture Story," *The Complete Photographer* 4, no. 21 (April 10, 1942): 1360.

4 A number of photographic paste-ups of Jackson's western landscapes are in the collection of the Amon Carter Museum.

5 Edward Weston, "Photographic Art," *Encyclopaedia Britannica* (1942), vol. 17, pp. 801–802, reprinted in Peninah R. Petruck, ed., *The Camera Viewed: Writings on Twentieth Century Photography*, vol. 1, (New York: E. P. Dutton, 1979), p. 100.

such links were overshadowed by the more prevalent discussions about photography's similarity to painting. At mid-century, as the Romantic spirit in American intellectual and cultural life waned, the new realism apparent in American painting made Americans receptive to the idea that the inherently realistic craft of photography might be an art. Similarly, the emergence of the so-called "scientific history," with its emphasis on objective observation and the accumulation of facts, made historians and photographers aware of the connections between their crafts.

Holgrave, the fictional daguerreotypist of Nathaniel Hawthorne's *The House of the Seven Gables* (1851), described the historian's quest as well as his own when he explained why he made photographs. "It is not my impulse . . . either to help or to hinder; but to look on, to analyze, to explain matters to myself, and to comprehend the drama which, for almost two hundred years, has been dragging its slow length over the ground where you and I now tread."[6] And indeed, from the start, photographers thought of themselves as historians—or at least antiquarians—who could analyze and document both the everyday world and the important event. They understood that their craft could not only preserve the past by recording the appearance of vanishing things, but could also function as an aid to memory and thus contribute to the increase of knowledge.

One of the world's first photographers to document a newsworthy event for posterity was the anonymous American who followed American troops to Mexico in 1847 to photograph the Mexican War (pp. 15, 16, 17). Since then, many photographers have been self-proclaimed historians systematically analyzing the world around them. One thinks of the nineteenth-century survey photographer carefully charting the natural wonders of the unexplored West, or of Edward S. Curtis methodically documenting the fading culture of the North American Indian (pp. 77,78, 85).

A photograph could, of course, have a historical value that its maker might not have anticipated. Thus, in 1859, Oliver Wendell Holmes called for a library of stereographs to preserve the forms of "any object, natural or artificial."[7] A fellow Bostonian's discourse "Photography as an Aid to Local History" in 1888 called on local camera clubs to photograph the growth of their communities, to document what the scientific historians of the late nineteenth century saw as the almost inevitable institutional evolution of farm to hamlet to village to town. We must make an attempt, wrote George Francis, "to bring together pictorial records with the same thoroughness that marks our storing of books and manuscripts."[8]

What made the photograph so valuable to historians was its seemingly inexhaustible wealth of detail. "In a picture you can find nothing which the artist has not seen before you,"

6 Nathaniel Hawthorne, *The House of the Seven Gables* (1851; reprint ed., New York: Lancer Books, 1968), p. 307.

7 Oliver Wendell Holmes, "The Stereoscope and the Stereograph," *Atlantic Monthly* 3 (June 1859), reprinted in Beaumont Newhall, ed., *Photography: Essays and Images* (New York: Museum of Modern Art, 1980), p. 60.

8 George Francis, "Photography as an Aid to Local History," *Proceedings of the American Antiquarian Society*, (April 1888): 282.

9 Oliver Wendell Holmes, "The Stereo-scope," p. 58.

10 Francis Parkman, *The California and Oregon Trail* (1849), cited in Richard Rudisill, *Mirror Image: The Influence of the Daguerreotype on American Society* (Albuquerque: University of New Mexico Press, 1971), p. 75.
11 Friedrich Nietzsche, *Beyond Good and Evil* (1886), cited in Carl L. Becker, *Detachment and the Writing of History: Essays and Letters of Carl L. Becker*, ed. Phil Snyder, (Ithaca: Cornell University Press, 1958, 1967 reprint), pp. 8–9.

12 Justin Winsor, "The Perils of Historical Narrative," *Atlantic Monthly* 66 (September 1890): 296.

13 Cited in Van Deren Coke, *The Painter and the Photography* (Albuquerque: University of New Mexico Press, 1972), p. 22.

14 Winsor, "Historical Narrative," p. 296.

Holmes wrote, "but in a photograph there will be as many beauties lurking, unobserved, as there are flowers that blush unseen in forests and meadows."[9] And to the scientific historians who valued extensiveness of description over selective analysis, what could be more useful?

For these historians, photographic scrutiny of the world came to symbolize the historian's task. Recalling a detailed description of an old camping site, the historian Francis Parkman noted "that camp is daguerreotyped on my memory."[10] Friedrich Nietzsche described his ideal observer of society as one who "waits until something comes, and then expands himself sensitively, so that even the light footsteps and gliding past of spiritual beings may not be lost on his surface and film."[11]

If Nietzsche invoked the camera as the symbol of passive as well as objective observation, other nineteenth-century writers equated the camera with a more aggressive, unrelenting scrutiny of the external world. "Writers of a timid sort hold that to be a detective is to lower the dignity of history," Justin Winsor wrote in 1890. "Their art eschews what the camera sees, and trusts to the polite eye. Nature hides her ungainliness to the slow eye. It is the business of an artist to second Nature; it is the work of the historian to expose Nature."[12] The historian with his relentless camera vision could expose everything, all the while maintaining a cool, objective distance from the facts he reported.

Historians invoked the idea of this camera vision because the camera seemed so well suited to preserving minute detail. It seemed as if life itself was preserved in the chemical emulsion of the photograph; as if the historian could study the actual appearance of things he had never seen. No longer was he limited to studying the lives of great men who had left written records of their careers. Through the democratic medium of photography, anyone could present himself for historical scrutiny. "'Tis certain," Ralph Waldo Emerson wrote, "that the daguerreotype is the true Republican style of painting. The artist stands aside and lets you paint yourself."[13] Some fifty years later, in a similar vein, a historian could boast of his craft's republican virtues: "The fact that the historian's search is symbolized by the camera disposes of that old-time notion of the dignity of history. The camera catches everything, however trivial, and shows its relation to the picture."[14]

The idea that the camera could "catch" anything and preserve its lifelike appearance for public scrutiny was so deeply ingrained in the nineteenth-century consciousness that it was reflected in the language used to talk about photography. The medical terminology sometimes invoked suggested that a subject was like a patient at the mercy of a doctor's scrutiny. It was not inappropriate for daguerreotypists to speak of their clients as "patients," for the iron stands that clamped the sitter firmly about the head and waist to hold him still

resembled the primitive tools in surgeons' offices. Early daguerrian studios were often referred to as "operating rooms" and traveling photographic wagons were sometimes known as "ambulances," a word traditionally used to describe mobile hospitals. Timothy O'Sullivan, in fact, used a converted Civil War ambulance as a darkroom when he went west with the King Survey in 1867, and William Henry Jackson adapted a similar ambulance for his 1870 trip with the Hayden Survey.

The hunting metaphors also used to discuss photography suggest that a photographic "ambulance" would have been welcomed by the subjects, soon to be transformed into big-game trophies that could be studied in the privacy of a Victorian parlor. Persuaded that photography gave one the power to preserve "form" without "matter," Oliver Wendell Holmes wrote, "Every conceivable object of Nature and Art will soon scale off its surface for us. Men will hunt all curious, beautiful, grand objects, as they hunt the cattle in South America for their *skins*, and leave the carcasses as of little worth."[15] Later he spoke of "flaying our friends and submitting to be flayed ourselves, every few years or months or days, by the aid of the trenchant sunbeam. . . ."[16]

Writing in less vivid terms, the noted German photographic chemist Hermann W. Vogel commented in 1867 that "landscape photography and hunting resemble each other . . . we have mainly holiday hunters amongst landscape photographers, who waste their ammunition on every sparrow, but never succeed in killing nobler game."[17] The term "snapshot," already in vogue by 1860 as a term to refer to a quickly made photograph, was adopted from the world's traditional meaning of a hurried shot taken without deliberate aim at a moving animal.[18] "Stalking," too, was a word used in the nineteenth century to describe the photographer's pursuit of his prey, foreshadowing the modern "photo-safari."[19]

Until about 1890, when hand-held cameras and faster films gave the photographer the ability to make a photographic likeness without his subject's knowledge, almost everyone who sat for his portrait was a willing victim of the life-stealing camera. Ironically, though, by allowing themselves to be "shot," they gained the chance to become immortal, to live forever in the chemical emulsion of their photograph. "How these shadows last, and how their originals fade away!" Holmes marveled.[20]

Around the turn of the century, the penchant for objective scrutiny and accumulated facts, shared by both photographers and historians, gave way to a point of view that emphasized personal vision. For the practitioners of both crafts, the external world became something to describe because it elucidated private concerns, not because it might reveal interesting new information. The so-called "New History" that became popular among American historians emphasized the primacy of the historian's own moral values in the writing of

15 Holmes, "The Stereoscope," p. 60.

16 Oliver Wendell Holmes, "Sun Painting and Sun Sculpture; With a Stereoscopic Trip Across the Atlantic," *Atlantic Monthly* 8 (July 1861): 13.

17 Hermann W. Vogel, "German Correspondent," *Philadelphia Photographer* 4, no. 47 (November 1867): 362.

18 *Oxford English Dictionary*, 1971, s.v. "snapshot," p. 2889.
19 *Oxford English Dictionary*, 1971, s.v. "stalk," p. 3008.

20 Holmes, "Sun Painting," p. 14.

history. The New Historians, who studied the past to find answers to present problems, viewed history less as a science than an art. Similarly, the photographic Pictorialists championed the cause of photography as a fine art and emphasized that the photographer's own feelings should dictate his choice and presentation of subject matter. While most late nineteenth-century historians and photographers seemed reticent about revealing their hand in their work, the New Historians and the Pictorialists relished their presence in the final product. The supposed objectivity of the nineteenth-century "camera vision" no longer seemed a possible or a desirable thing. Carl Becker, a proponent of the New History, wrote that it was absurd to think that intelligence can be "reduced to a kind of mechanical instrument, set carefully in a sealed case to protect it from deflecting influences of environment . . . capable of acting automatically when brought in contact with objective phenomena."[21] The very act of *wanting* to know about something implied a certain subjectivity.

While the New Historians and the Pictorial photographers used their crafts to elucidate personal interests, at other times, American historians and photographers have shared more didactic concerns. The landscapes of the late nineteenth-century survey photographers promoted the intense nationalism and interest in forging a specific national character that marked much contemporary historical writing. Similarly, the social documentary tradition of early twentieth-century American photography, as exemplified by Lewis Hine and the later Farm Security Administration photographers, had its counterpart in historical thinking and writing. Just as the Progressive Historians used historical writing as a tool of economic analysis that could promote progress and social change, so, too, these photographers used photography as a social tool that could stimulate change. In fact, both Hine and Roy Stryker, who supervised the Farm Security Administration photography project, studied at Columbia University where Charles Beard, the dean of Progressive Historians, was developing his economic critique of American society.

It can be misleading to carry these parallels between American historical thinking and American photography too far. Both historians and photographers share in the broader cultural assumptions of the day, and their general concerns about portraying the world are shared by other writers and visual artists. Moreover, historical facts are usually less concrete than the visual facts that photographers describe. They are already symbols: shadows or signs of people and places that are gone. The historian is thus one step further removed from the world he describes than the photographer, who is always there with his camera to record the emanations of light from the subject itself.

But history and photography do have a special relationship because at their core is a specific reference to the outside world. This sets the two crafts apart from other arts and makes their practitioners different from other sorts of visual or literary artists.

21 Carl L. Becker, *Detachment*, p. 9.

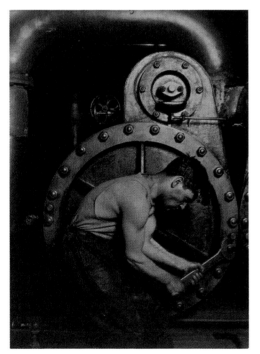

REDUCTION PLATE 113
[*Steamfitter*] (1921) Lewis Wickes Hine

It is impossible to run down the list of American photographers included in this book, designating one as a photographer-painter, another as a photographer-historian, on the basis of either their intent or the content of their work. George Barnard, who photographed the ruins of Atlanta in order to document the ravages of the Civil War, nonetheless created a photograph with a still, eerie beauty (p. 25). John K. Hillers, Timothy O'Sullivan, and William Bell photographed the West with strict instructions as to what geological formations to document; yet their photographs, intentionally or not, have a dramatic presence and beauty that transcends their function as geological documents (pp. 30, 37, 42, 47). Conversely, though Alice Boughton's subtle portrait of her daughter with its fragile, pencillike lines was made to be a deliberately *artistic* portrait, it nonetheless documents a specific presence and thus has a historical value (p. 72). Laura Gilpin's early Navaho portraits, dismissed by Roy Stryker of the Farm Security Administration as being too pictorial, still form an invaluable record of reservation life during the 1930s (pp. 94, 105, 121). It seems pointless to argue over whether she was more concerned with the traditional design problems of a painter or the historian's problems of explication; she was a photographer.

The metaphor of the photographer as a kind of painter, dependent on camera and chemicals rather than pigments, is inadequate to describe the photographer's work. To it must be added the metaphor of the photographer as historian, for the photographer shares the historian's task of describing the world by transforming literal facts into art. While the photographer who emphasizes the *form* of his image might appear to be like a painter, and the photographer who emphasizes the *content* might appear more like a historian, the two roles are inextricably linked. In the way that he presents the world, every photographer is both a historian and a visual artist. And every photograph can instruct us both through *what* it describes and *how* it describes it.

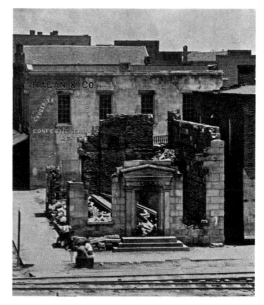

DETAIL PLATE 14
City of Atlanta, Georgia, No. 2 (1864) George Barnard

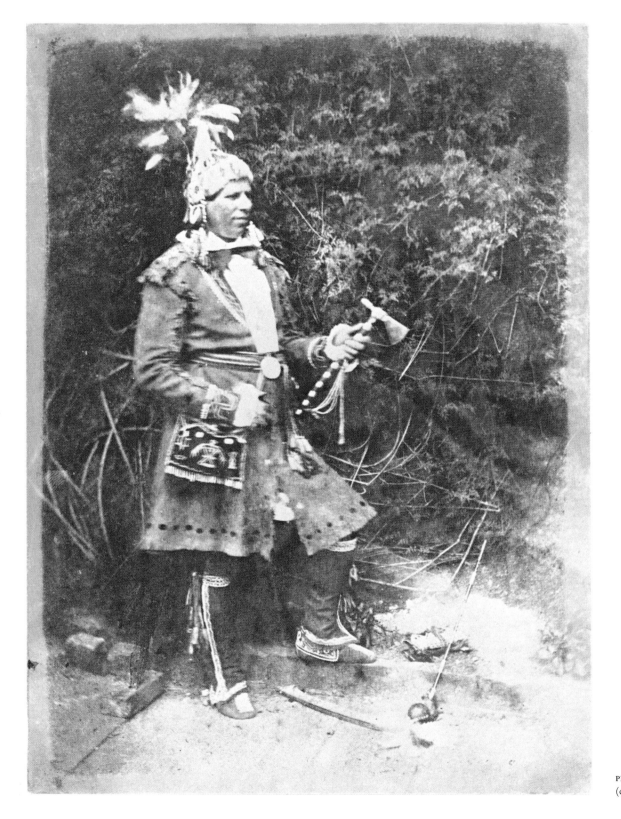

PLATE 2 *Reverend Peter Jones (Kahkewaquonaby)*
(c. 1844-1846) David Octavius Hill and Robert Adamson

Early Photography in America

The Most Extraordinary Triumph

When news of the Frenchman Jacques Louis Mandé Daguerre's marvelous discovery reached the United States in early 1839, Americans quickly embraced the new technology as if it were their own. The essence of Daguerre's discovery was simple. he had found a way to fix the images reflected through the lens of a camera obscura onto the surface of a silver-plated copper sheet coated with light-sensitive silver salts. Americans rushed to instrument builders to purchase specially built cameras and obtained the chemicals and equipment necessary to polish and ready the copper sheet to receive "the spirit of face." Daguerrian images seemed to possess an extraordinary detail. "They cannot be called copies of nature, but portions of nature herself," the painter and inventor Samuel F. B. Morse declared in 1840.[1]

At first, it was the men of science who took up the new invention as a hobby. But daguerreotypy soon proved to be a democratic art that could be practiced by anyone with a little patience and wherewithall. "It was but a step from the anvil or the sawmill to the camera," the daguerreotypist James Ryder later recalled. "It was no uncommon thing to find watch repairers, dentists and other styles of business folk to carry daguerreotypy 'on the side.'"[2] By 1850, an estimated 2,000 professional daguerreotypists were serving a population of about 23 million and in 1853, at the peak of the daguerreotype's popularity, an estimated 3 million daguerreotypes were produced in the United States.[3]

1 Cited in Richard Rudisill, *Mirror Image: The Influence of the Daguerreotype on American Society* (Albuquerque: University of New Mexico Press, 1971), p. 57.

2 James F. Ryder, *Voigtlander and I in Pursuit of Shadow Catching* (Cleveland: The Imperial Press, 1902), pp. 14, 20.

3 Rudisill, *Mirror Image*, pp. 197–198.

Over 95 percent of American daguerreotypes were portraits, a circumstance dictated by Americans' intense desire to have their likenesses made and the daguerreotypists' concomitant wish to operate their businesses in the most profitable fashion. Sitting for a daguerrian portrait, however, could be hard work. In 1839, exposure times of 10 to 20 minutes meant portraits could only be made of subjects posing with closed eyes. By 1850, improved lenses and chemical processes had reduced the time required for a studio portrait to 15 to 20 seconds. Nonetheless, an iron headstand was still required to hold the sitter motionless. This seems to have had no ill effect on a subject like Colonel John Francis Hamtramck (p. 17) with his ramrod military bearing. It was more difficult to capture a relaxed image of a mother and child (p. 19), and daguerreotypists and mothers alike developed a preference for sleeping babies.

Daguerreotypists resorted to a number of tricks to satisfy clients who wanted an accurate—but perhaps not too truthful—likeness. One recalled, "We always had sticking-wax by us to keep wingshaped ears from standing out from the head, and we often placed a wad of cotton in hollow cheeks to fill them out."[4] The daguerreotype might be, as Oliver Wendell Holmes suggested, a "mirror with a memory." But this did not prevent daguerreotypists from tampering with the subject before the mirror.

Only rarely did daguerreotypists venture out-of-doors. Usually, as in the case of the anonymous photographer who photographed the Exeter, New Hampshire, Volunteers setting off to the Mexican War (p. 16) or his contemporary who actually went to Mexico (pp. 15, 16, 17, 18), it was to record an event of importance. Landscape daguerreotypes are quite rare, and it has been suggested that their detailed realism was out of tune with the romanticism of contemporary American landscape painting. But as the haunting and evocative daguerreotype of Henry Clay, Jr.'s grave in Mexico proves, a daguerreotype could have all the imaginative power of a painted view (p. 15).

The daguerreotype's popularity began to decline in the mid-1850s with the introduction of the ambrotype, which lacked the surface polish and glare that made the daguerrian image so difficult to see. The ambrotype was based on the collodion negative process invented in England by Frederick Scott Archer in 1851. Archer coated a glass plate with collodion—a highly flammable mixture of gun cotton in ether and alcohol—then dipped the sticky plate into a light-sensitive silver nitrate solution and exposed it in the camera while it was still wet. Though this process produced the first really practical photographic negatives, it became popular in America mainly because it could be used to produce ambrotypes. The ambrotype was a negative image on a piece of glass, made to appear positive by a black backing placed behind the image. The tintype, patented in 1856, was just a variation of

4 Abraham Bogardus, quoted in Rudisill, *Mirror Image*, p. 205.

the ambrotype process, with the collodion emulsion floated onto a sheet of dark japanned metal rather than glass.

Daguerreotypes, ambrotypes, and tintypes had one serious drawback—they were all unique images. With no negatives from which to print multiple images, most early-American photographers found it unprofitable to make difficult and expensive trips into the countryside for the purpose of making landscape views. Moreover, these processes generally produced small images (up to 6½ × 8½ inches) that lacked the dramatic impact of larger printed or painted views. Ambrotypists, like daguerreotypists, dealt chiefly in portraits (p. 19), venturing out-of-doors only on rare occasions to make images of a popular site or a special event, such as a gold-mining operation (p. 18) that might find a buyer.

The calotype process, popular in England but never widely practiced in the United States because of patent laws, did use paper negatives. But the resulting positive prints on paper lacked the crisp detail that Americans had become accustomed to in daguerreotypes. It is ironic that two Scottish photographers' calotype portrait of Kahkewaquonaby, an Ojibway Indian and missionary who made frequent trips to Europe, should be the earliest surviving image of the most American of types (p. 12).

By the late 1850s however, American photographers, including the renowned daguerreotypists Albert Sands Southworth and Josiah Johnson Hawes, were beginning to use glass-plate negatives to make paper prints (p. 19). This technical innovation made possible the great era of American landscape photography.

PLATE 3 *Burial Place of Son of Henry Clay in Mexico* (1847) Unknown photographer

15

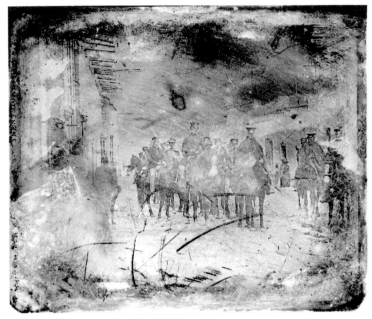

PLATE 4 *Exeter, New Hampshire, Volunteers* (c. 1846) Unknown photographer

PLATE 5 [*General Wool Leading His Troops down the Street in Saltillo, Mexico*] (c. 1847) Unknown photographer

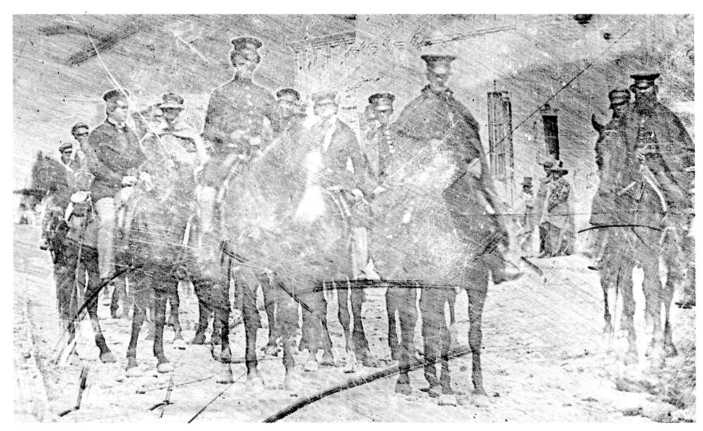

DETAIL PLATE 5

PLATE 6 *Colonel John Francis Hamtramck, Virginia Volunteers* (c. 1847) Unknown photographer

PLATE 7 [*James Knox Polk*] (c. 1849) Unknown photographer

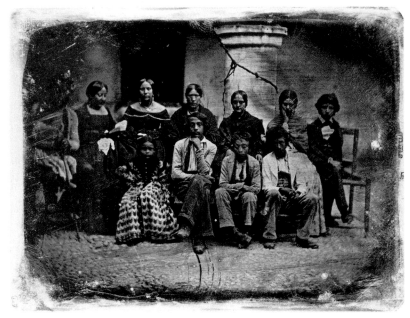

PLATE 8 *Mexican Family* (c. 1847) Unknown photographer

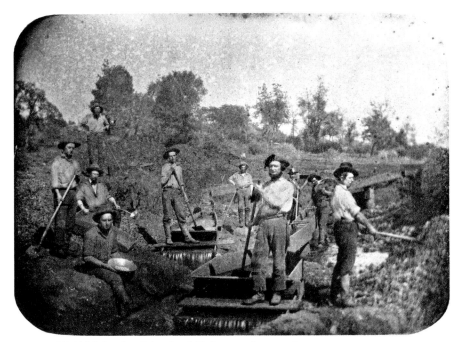

PLATE 9 [*Gold Mining Scene*] (c. 1850s) Unknown photographer

DETAIL PLATE 8

18

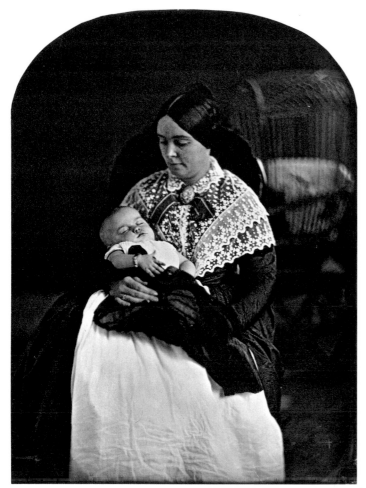

PLATE 10 [*Woman and Child*] (c. 1850s) Unknown photographer

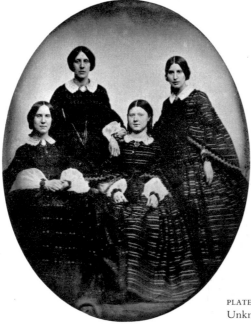

PLATE 12 [*Four Women*] (c. 1857)
Unknown photographer

PLATE 11 [*Portrait of a Young Girl*]
(c. 1853–1862) Albert Sands Southworth
and Josiah Johnson Hawes

19

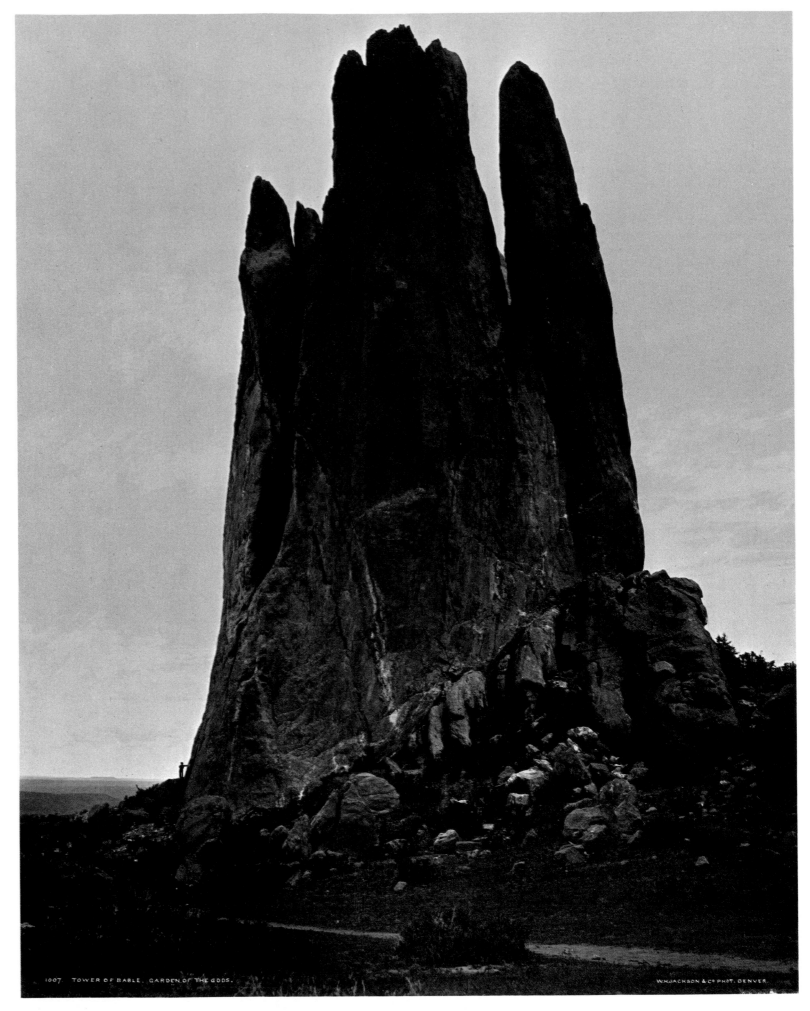

PLATE 13 *Tower of Babel, Garden of the Gods*
(c. 1880s) William Henry Jackson

The Nineteenth-Century Landscape

The Grandeur of This Nation's Masterpiece

The photographic exploration of the American landscape, which began slowly during the daguerrian era and accelerated with the introduction of the collodion negative process in the mid-1850s, was abruptly curtailed by the Civil War. With the outbreak of war in 1861, the interests of photographers, and the resources of the federal government and the army which had sponsored several western photographic expeditions during the 1850s, were directed elsewhere. Only in the relative isolation of California did landscape photography flourish. While future western photographers such as Timothy O'Sullivan, A. J. Russell, and Alexander Gardner were getting valuable photographic training on the bloody Civil War battlefields, and William Henry Jackson and John K. Hillers were serving in the military, San Francisco-based photographers C. L. Weed and Carleton Watkins were already exploring the spectacular wonders of Yosemite Valley.

But after the Civil War, Americans, eager to forget the painful memories of regional conflict, turned their attention to the West and dreams of a great new Union. The subsequent photographic exploration of the West, supported by railroad companies, government surveys, and the growth of a commercial market for photographic views, produced many of the greatest American landscape photographs ever made.

The railroad companies' impetus to employ photographers was economic. Photographs taken along the lines of their new western tracks would not only document and advertise the construction process, but could serve as enticements to the prospective settlers and businessmen whose interests were crucial to the railroads' success. Thus, Civil War veterans Alexander Gardner and A. J. Russell charted the Union Pacific's growth across Kansas into Wyoming from 1867 to 1869, while A. A. Hart documented the scenes along the western routes of the Central Pacific. Railroad work was attractive to photographers because it provided steady employment as well as an inexpensive way to see new scenery. William Henry Jackson took advantage of the mobility afforded by the new Union Pacific lines to make a speculative trip from Omaha to Salt Lake City in 1869—experience that proved valuable when he began working for the Denver and Rio Grande line in the 1880s (pp. 28, 34, 38). Carleton Watkins, a friend of railroad magnate Collis P. Huntington, loaded a mobile darkroom wagon on a flat train car and made frequent excursions along the Central Pacific Railroad lines (p. 34). And Pennsylvania photographer William Rau, as if to prove the West had no monopoly on either beautiful scenery or beneficent railroad companies, made a comparable survey along the lines of the Lehigh Valley Railroad (p. 44).

Government-supported survey expeditions afforded photographers access to even more remote and exotic regions of the West than did the railroads. In 1865 and 1866, Watkins had proved that photography could serve the interests of scientific exploration when he accompanied Josiah Whitney's California State Geological Survey to Yosemite (p. 36). In 1867, when Clarence King, an assistant on that Yosemite survey, led a federal team of scientists and explorers on an ambitious trek to map and study the land along the 40th parallel, he took along photographer Timothy O'Sullivan. O'Sullivan worked for King from 1867 to 1869, and he provided an example for future expeditions. The Darien Survey, commissioned to determine possible routes for a canal across the Isthmus of Panama, employed O'Sullivan in 1870 and replaced him with Philadelphia photographer John Moran in 1871 (pp. 26, 27). Ferdinand V. Hayden employed William Henry Jackson as the official photographer for his survey of the Yellowstone region and the Rocky Mountain West from 1870 to 1878. John K. Hillers worked for Maj. John Wesley Powell's 1871–72 Colorado River expedition (pp. 30, 47); William Bell and O'Sullivan both served on Lt. George Wheeler's 1871–79 survey of the land west of the 100th meridian (pp. 37, 42); and Watkins and King again paired up for a survey of the Mt. Shasta region in 1870 (pp. 33, 40).

In acknowledgement of the faith that nineteenth-century Americans placed in the camera as the quintessential recording instrument, the *New York Times* noted in a 1875 review of the survey projects that "While only a select few can appreciate the discoveries of the geologists or the exact measurements of the topographers, everyone can understand a

picture."[1] And, indeed, the survey photographs had a profound impact on the public's understanding of the West. Watkins' Yosemite views and Jackson's photographs of the Yellowstone were instrumental in persuading Congress to enact legislation setting these areas aside as parks, and the numerous western photographs reproduced in popular periodicals helped persuade a doubting public that the West was, in fact, spectacular.

The photographs made by the western survey photographers, like the maps drawn by the survey cartographers and the new transcontinental railroad lines, served to make the West accessible, in one form or another, to Americans hungry for knowledge about their growing nation. A burgeoning interest in the West, a growing faith in the artistic merit of photography, and the prevalent use of the wet-plate negative process which enabled a photographer to make numerous prints from a single negative, combined to create a new popular market for landscape photography. From his Yosemite Art Gallery in San Francisco, Watkins marketed his well-known views of the scenic valley, in competition with such rivals as Eadweard Muybridge (p. 36). After 1884, visitors to Yellowstone could purchase photographic prints from the park's official photographer Frank J. Haynes (p. 31). George Barker churned out scores of stormy, romantic views of Niagara Falls, the only site the East could offer to rival those of the West (p. 29).

The great nineteenth-century landscape photographers endured extraordinary hardships to make their spectacular views. The wet-plate process was cumbersome. Jackson carried two cameras, glass for 400 negatives, chemicals, and a portable darkroom—more than 300 pounds of equipment—with him on the Hayden survey in 1870.[2] Watkins required a twelve-mule train to transport a staggering 2,000 pounds of equipment and supplies to Yosemite in 1865.[3] His specially constructed 18-×22-inch camera used large glass-plate negatives weighing nearly four pounds apiece. Jackson noted that it ordinarily took him half an hour to make a single view; this after trekking for hours or days across an inhospitable landscape, unpacking his equipment, and waiting for the ideal sunny, windless conditions.[4]

Every photographer had at least one horror story to tell. Following a season of work with the Hayden survey in 1873, Jackson lost most of his work when "an evil mule named Gimlet slipped his pack and broke many of my exposed plates."[5] In 1867, Timothy O'Sullivan found the conditions in the Humboldt and Carson Sinks almost unbearable:

It was a pretty location to work in, and *viewing* there was as pleasant work as could be desired; the only drawback was an unlimited number of the most voracious and particularly poisonous mosquitoes that we met with during our entire trip. Add to this the entire impossibility to save one's precious body from frequent attacks of that most ennervating of all fevers, known as the 'mountain

1 *New York Times*, 27 April 1875, cited in Beaumont Newhall and Diana E. Edkins, *William Henry Jackson* (Dobbs Ferry, New York: Published in cooperation with the Amon Carter Museum by Morgan & Morgan, Inc., 1974), p. 13.

2 William Henry Jackson, *Time Exposure* (New York: G. P. Putnam's Sons, 1940), p. 189.
3 William Henry Brewer to Josiah Dwight Whitney, 14 August 1865, William Henry Brewer Papers: Correspondence with Josiah D. Whitney; 1860–84. The Bancroft Library, Berkeley, California. Citation courtesy Peter Palmquist, Arcata, California.
4 Robert Taft, *Photography and the American Scene* (1938; reprint ed., New York: Dover Publications, 1964), p. 369.
5 Jackson, *Time Exposure*, p. 215.

6 "Photographs from the High Rockies," *Harper's New Monthly Magazine* 39 (September 1869), reprinted in Beaumont Newhall, ed., *Photography: Essays and Images* (New York: Museum of Modern Art, 1980), p. 124.
7 *The Philadelphia Photographer* 3, no. 36 (December 1866): 371.

ail,' and you will see why we did not work up more of that country. We were, in fact, driven out by the mosquitoe and fever. Which of the two should be considered as the most unbearable it is impossible to state."[6]

Few, fortunately, met with the same ill-luck as the Philadelphia photographer Ridgeway Glover who was killed by Sioux Indians in 1866 while photographing near Fort Kearny.[7]

Despite the physical and technical difficulties of field photography and despite the constrictions placed upon them by expedition leaders or railroad executives, these photographers persevered to make an extraordinary body of images. The West depicted in their photographs is a place of both awesome and romantic splendor. The human figure, often included by the photographers to give a sense of scale to the scene, is dwarfed by the magnificence of the western landscape. Man might be the measure of all things, but he was inadequate to describe the grand scale and minute detail of the American landscape. For that, he needed a camera.

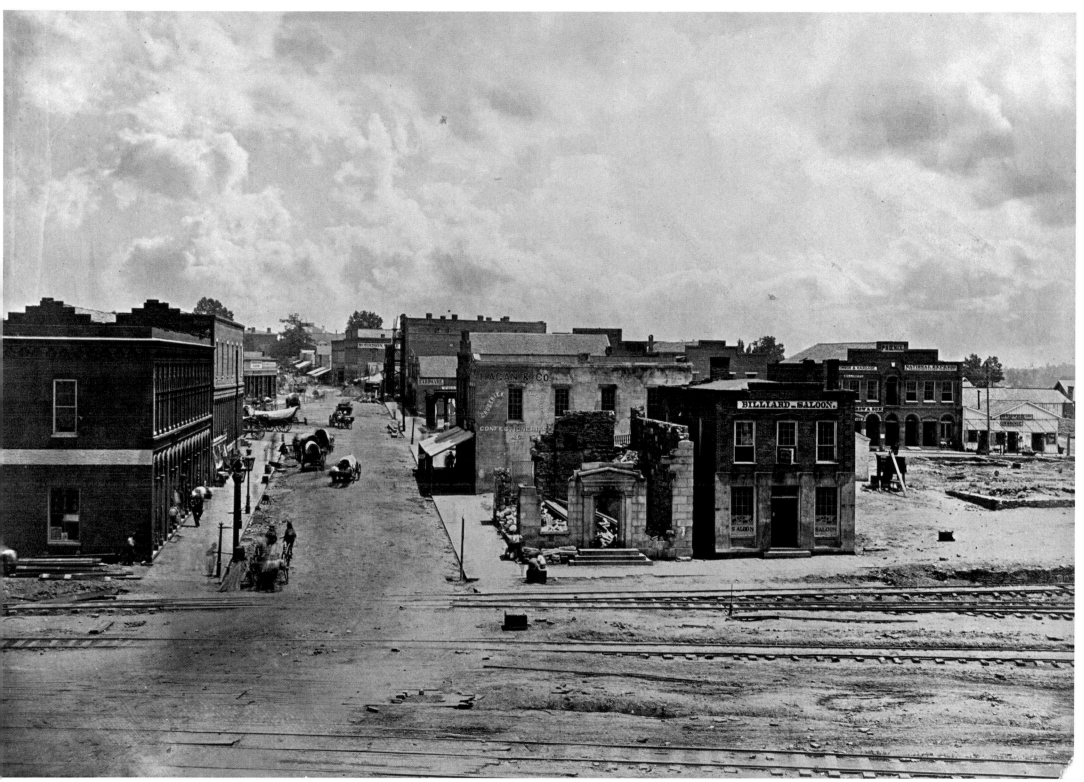

PLATE 14 *City of Atlanta, Georgia, No. 2* (1864) George Barnard

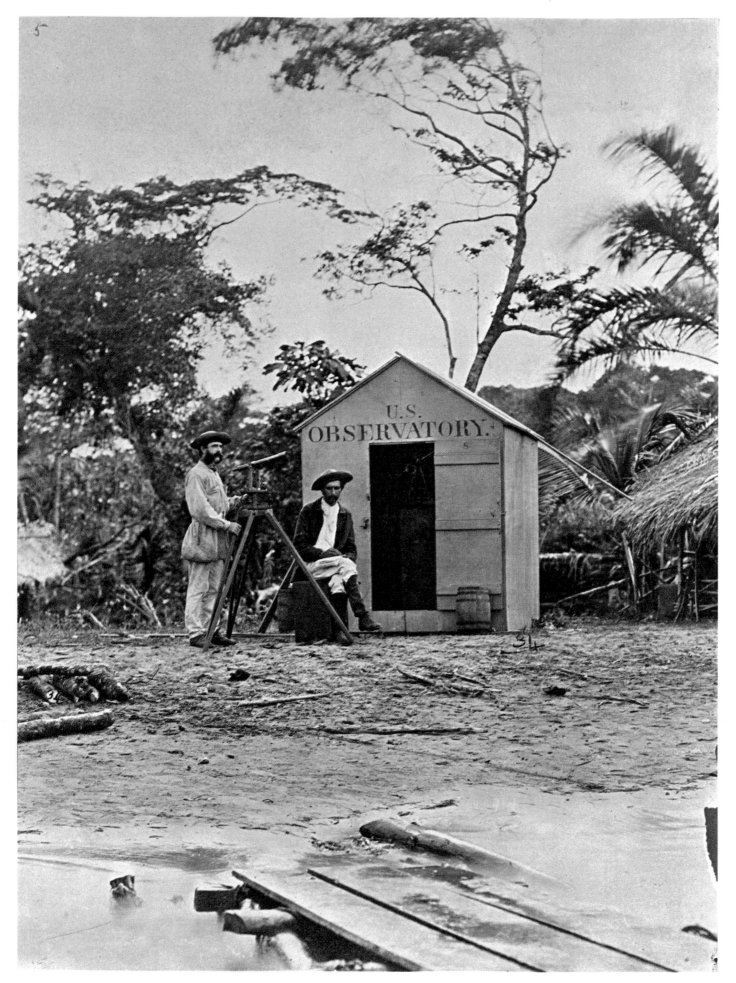

PLATE 15 [*U.S. Observatory*] (c. 1870–1871)
John Moran or Timothy H. O'Sullivan

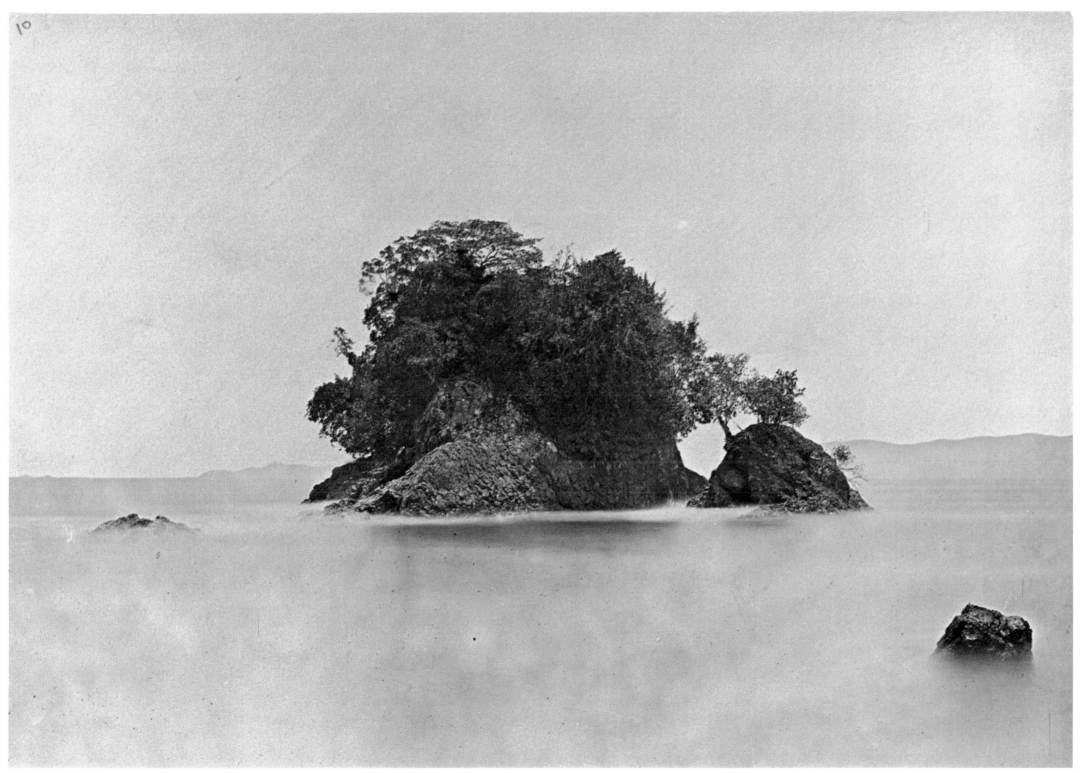

PLATE 16 *Island, Limon Bay* (1871) John Moran

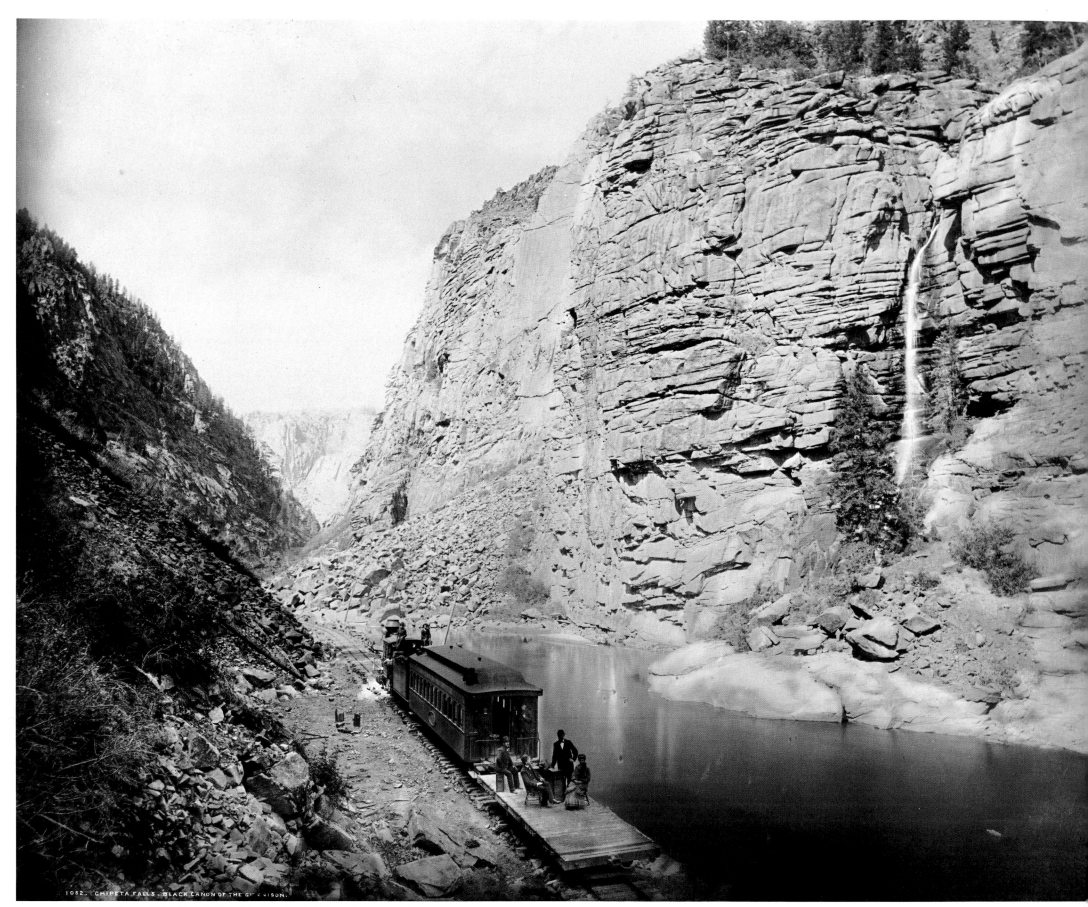

1052. CHIPETA FALLS - BLACK CAÑON OF THE GUNNISON.

PLATE 17 *Chipeta Falls, Black Cañon of the Gunnison* (1883) William Henry Jackson

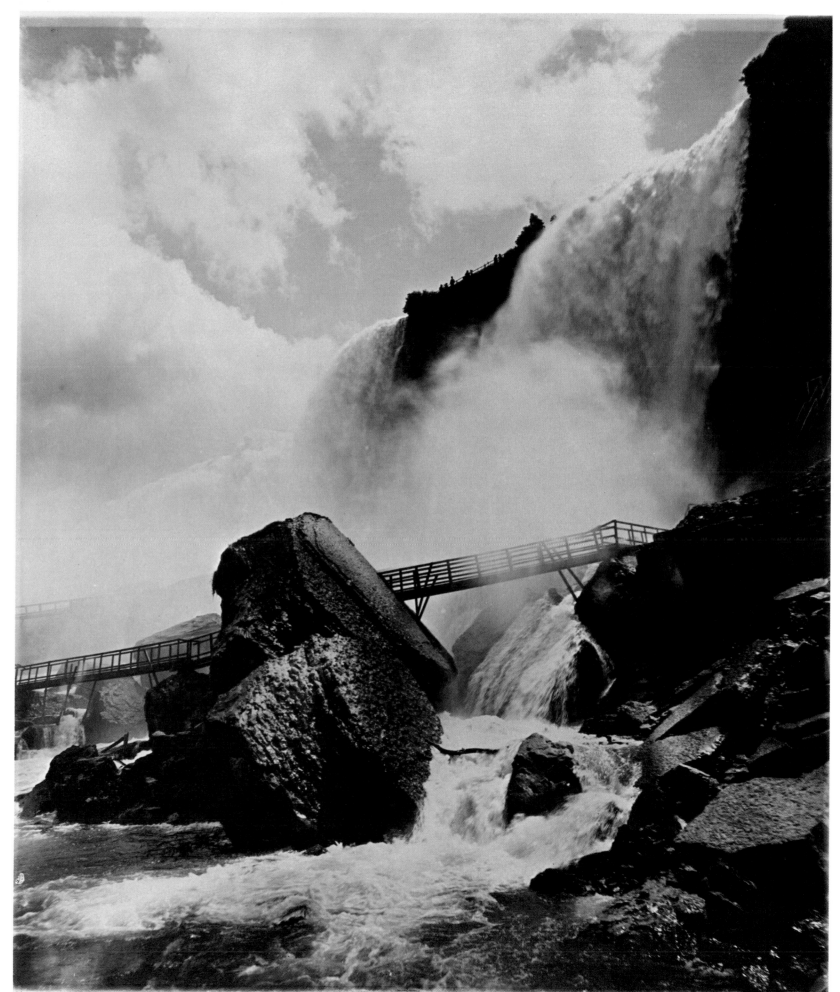

PLATE 18 [*Niagara Falls*] (1888)
George Barker

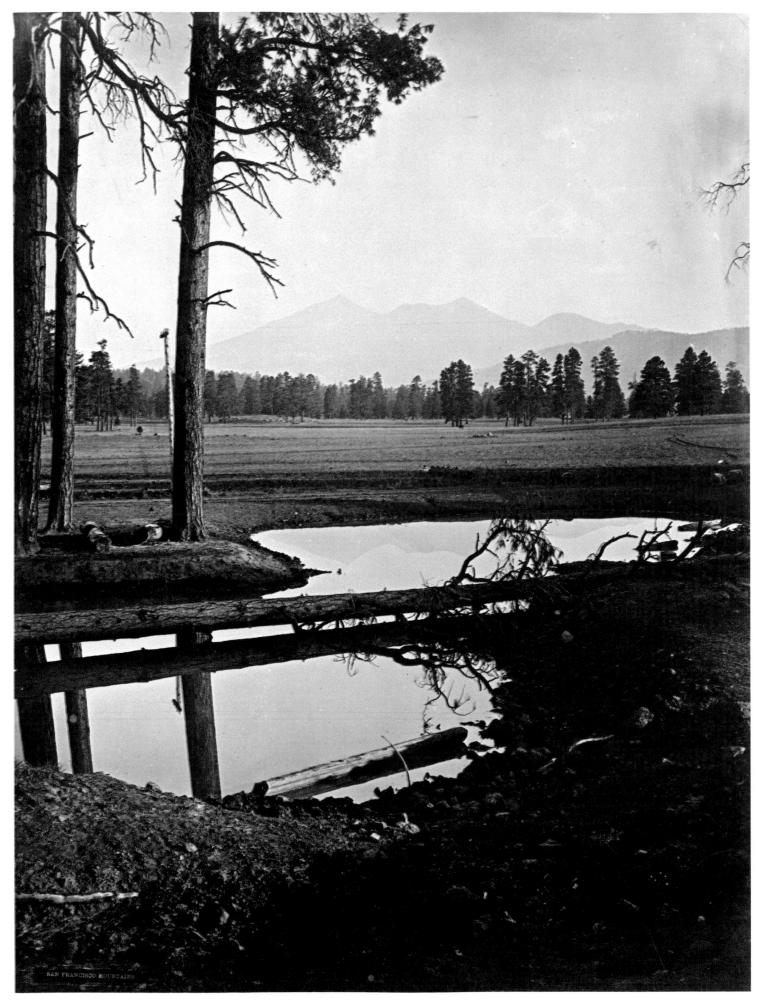

PLATE 19 *San Francisco Mountains* (c. 1870s)
John K. Hillers

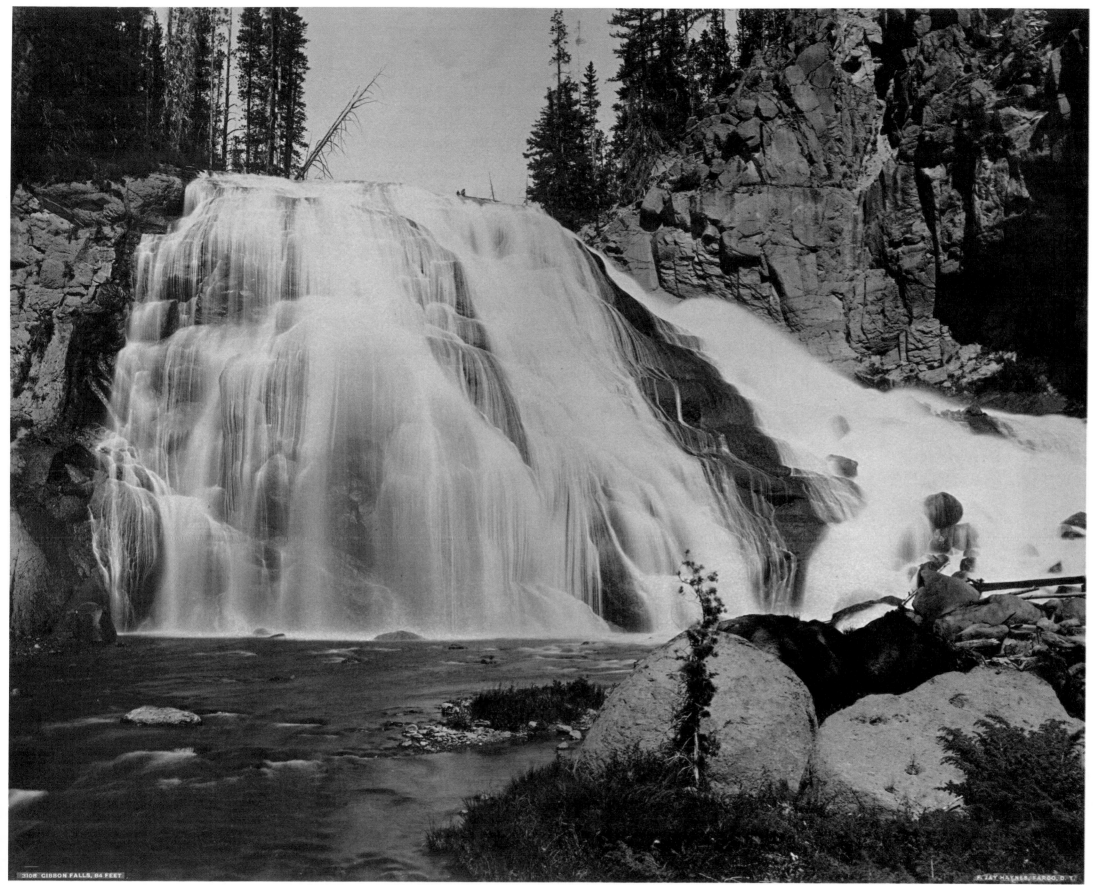

PLATE 20 *Gibbon Falls, 84 Feet, Yellowstone National Park* (c. 1884) Frank Jay Haynes

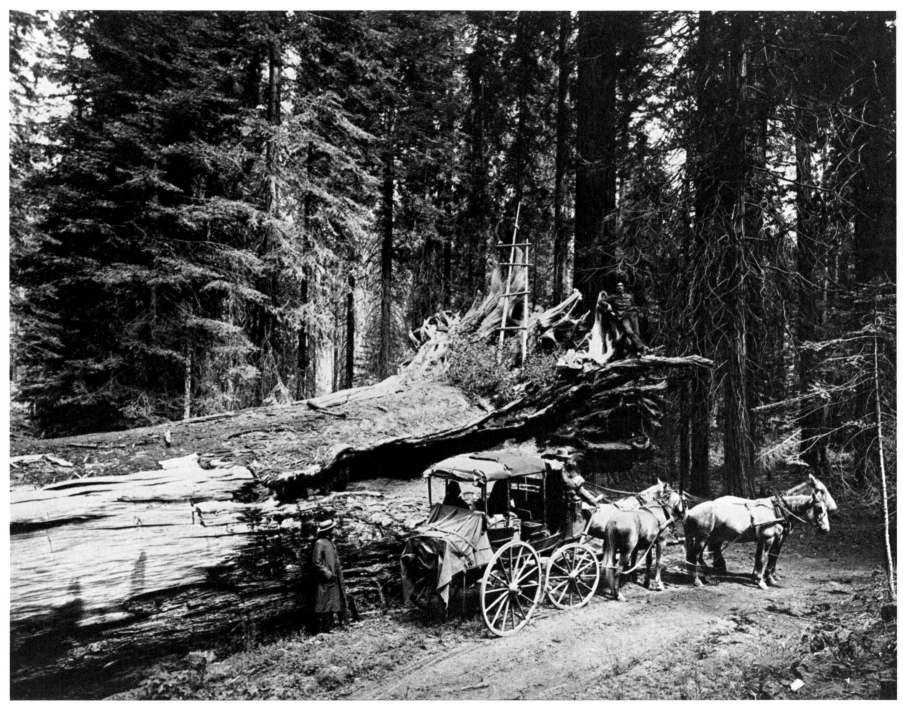

PLATE 21 *Yosemite Stage by the Fallen Monarch. Mariposa Grove, 1894* (1894) I. W. Taber, Publisher

PLATE 22 *Mount Shasta from Sheep Rocks* (1870) Carleton E. Watkins

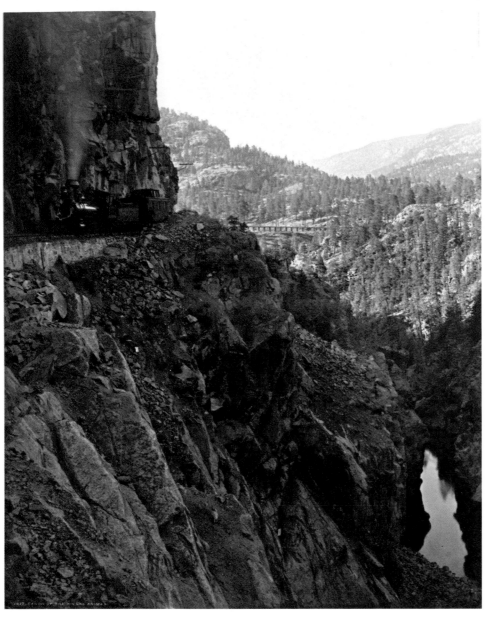

PLATE 23 *Cañon of The Rio Las Animas* (c. 1884)
William Henry Jackson

PLATE 24 [*Watkins' Photographic Wagon along the C.P.R.R. Tracks, Utah*] (c. 1874) Carleton E. Watkins

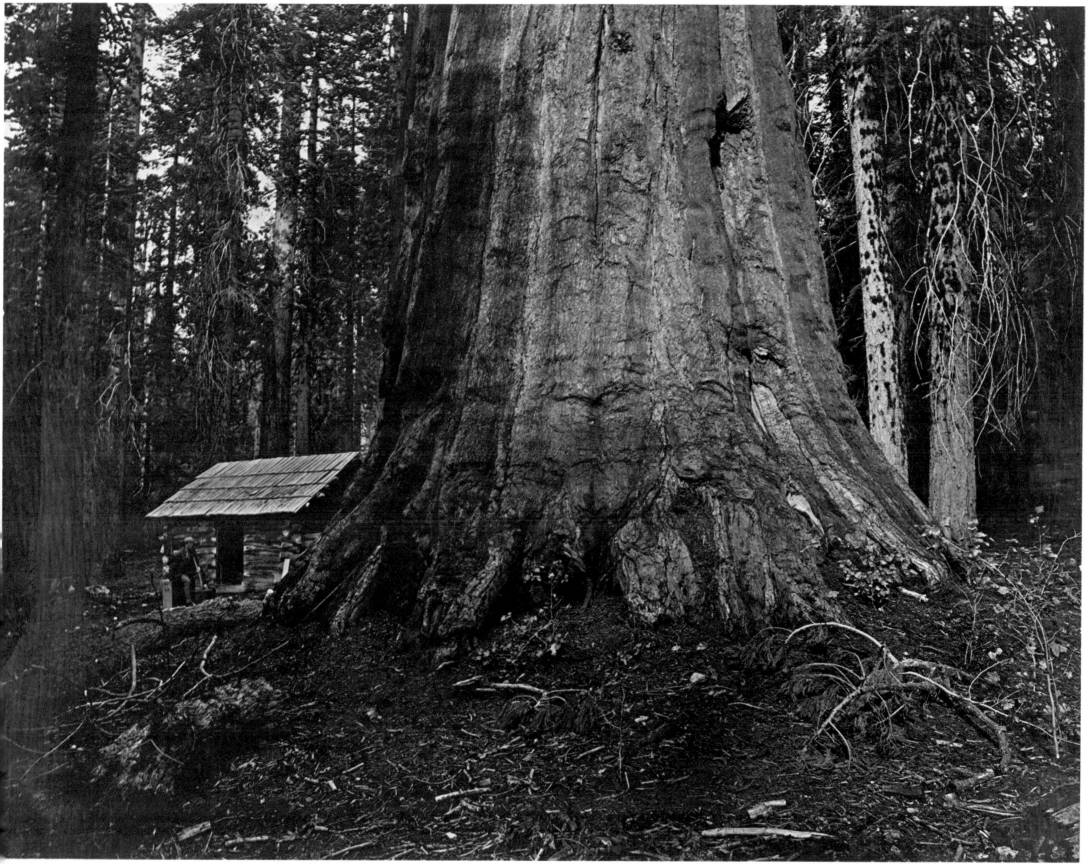

PLATE 25 *Mariposa Grove of Mammoth Trees, William H. Seward,*
85 Feet in Circumference, 268 Feet High (1872) Eadweard Muybridge

35

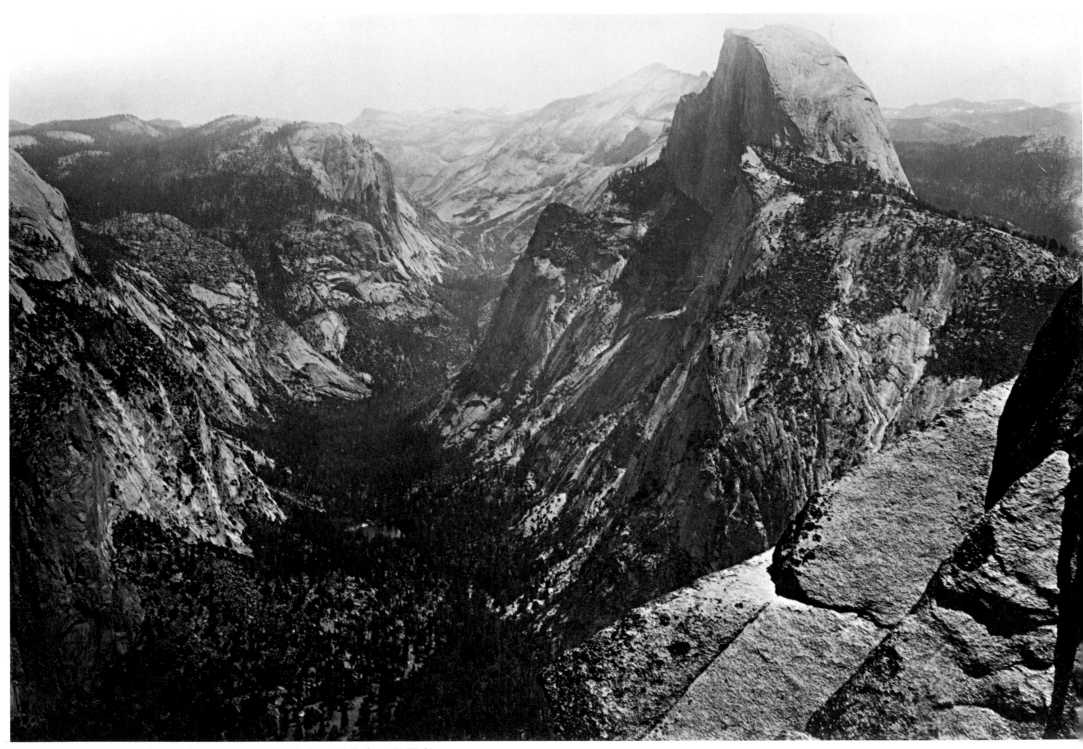

PLATE 26 *The Half-Dome from Glacier Point, Yosemite* (c. 1866) Carleton E. Watkins

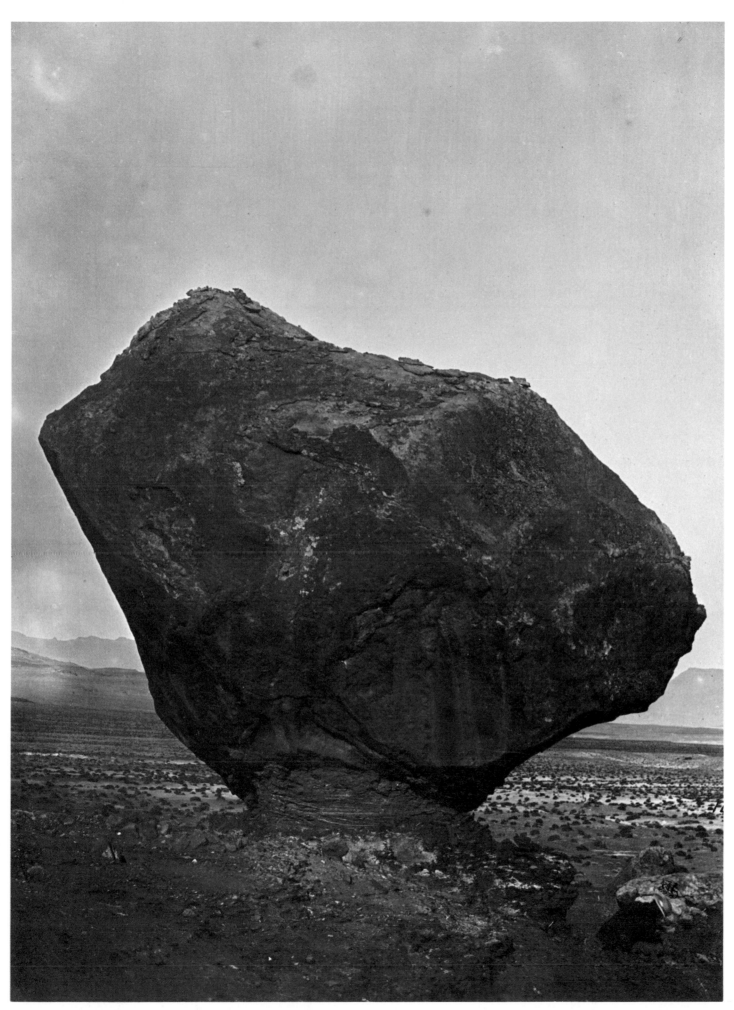

PLATE 27 *Perched Rock, Rocker Creek, Arizona* (1872)
William Bell

37

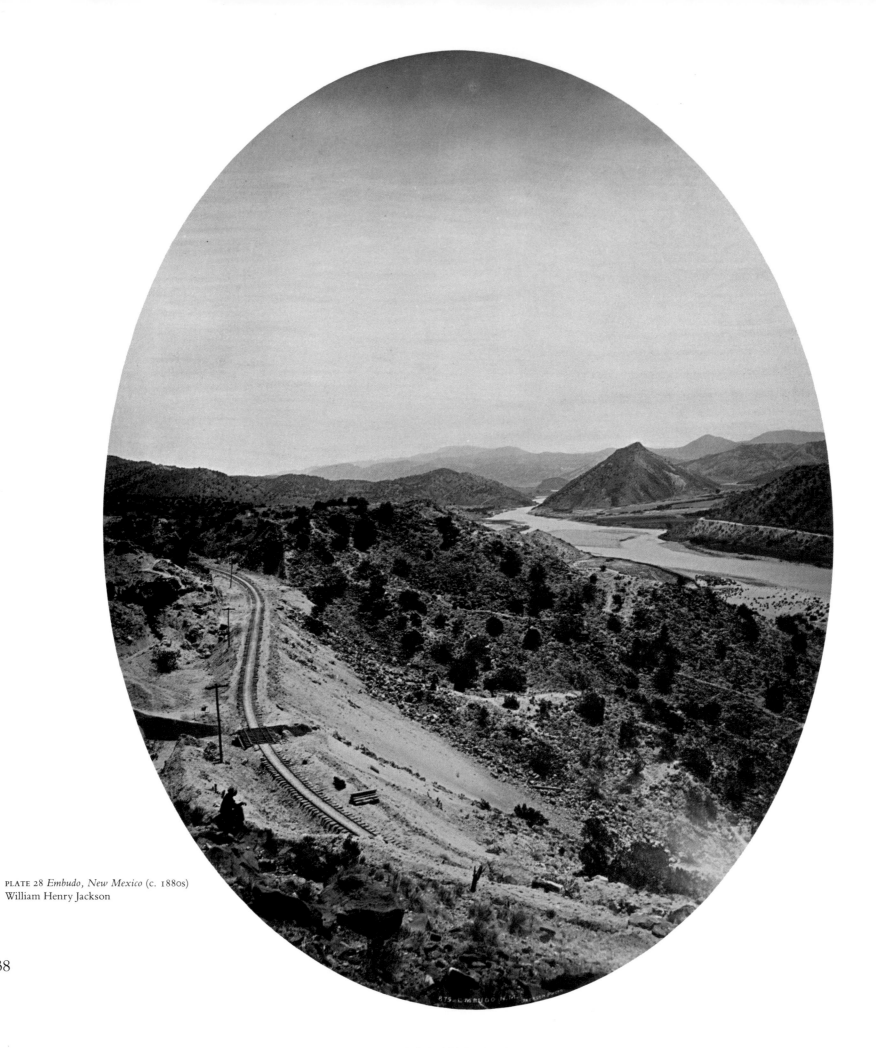

PLATE 28 *Embudo, New Mexico* (c. 1880s)
William Henry Jackson

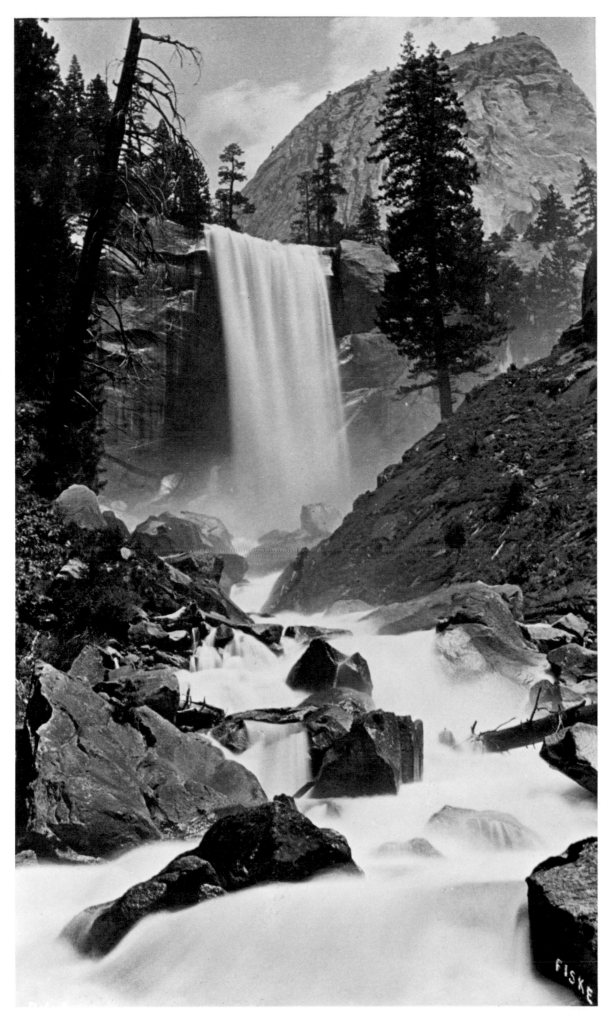

PLATE 29 *Vernal Fall. 350 Feet* (c. 1879-1881) George Fiske

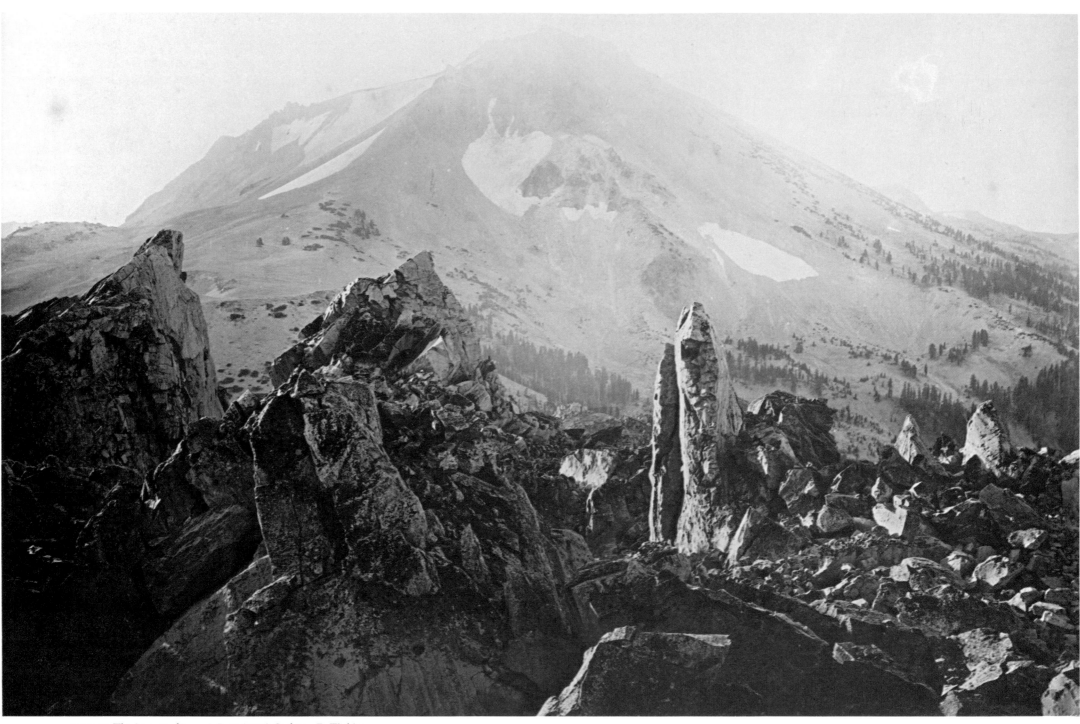

PLATE 30 *The Summit of Lassen's Butte* (1870) Carleton E. Watkins

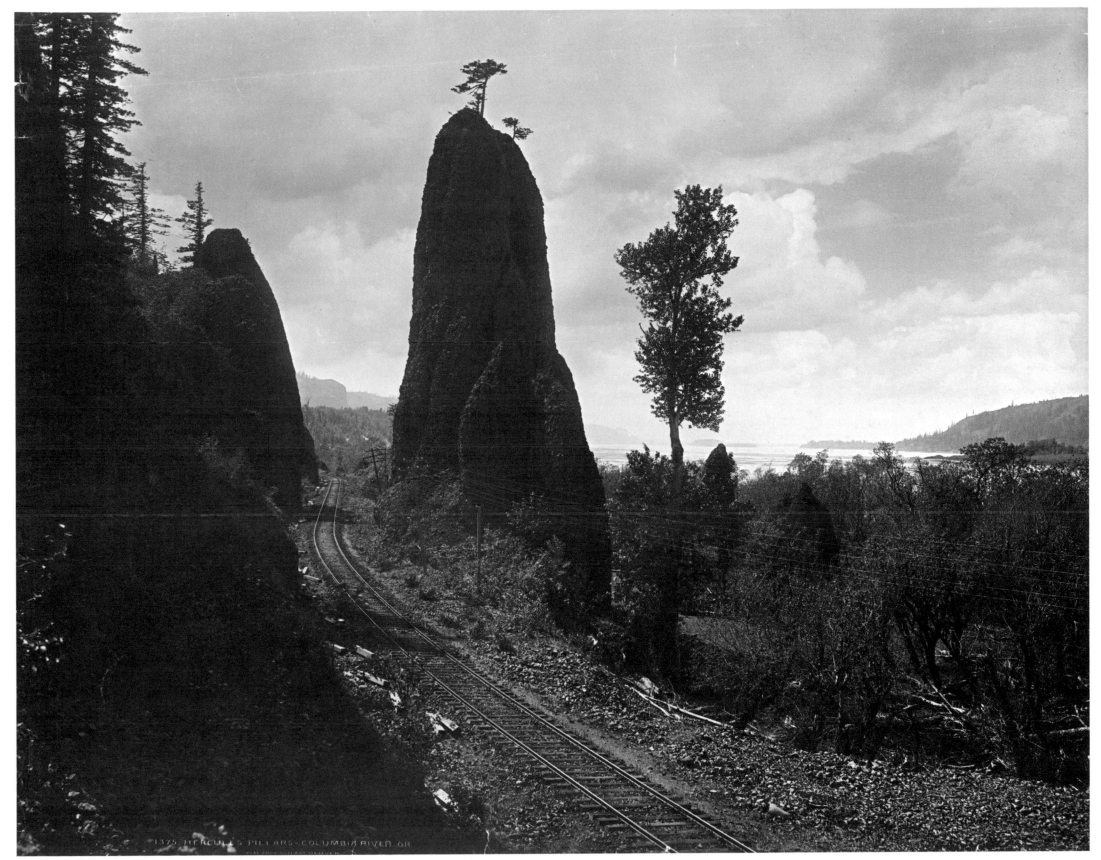

PLATE 31 *Hercules' Pillars—Columbia River, Oregon* (no date) William Henry Jackson

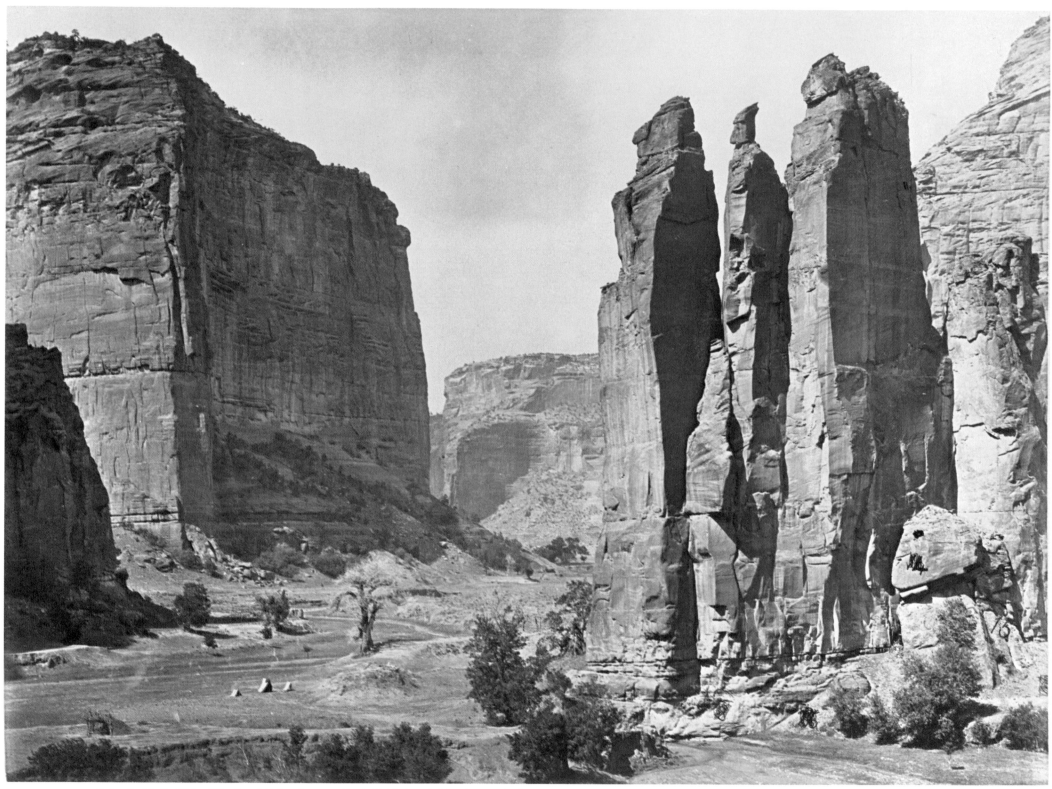

PLATE 32 *Cañon De Chelle. Walls of The Grand Cañon about 1200 Feet in Height* (1873) Timothy H. O'Sullivan

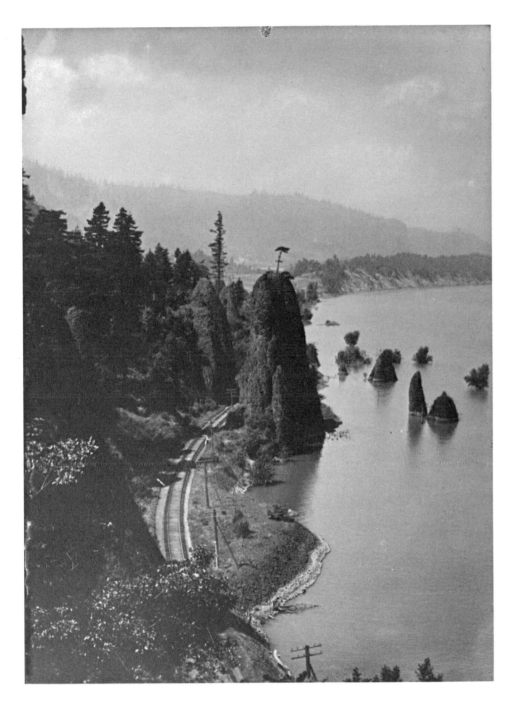

PLATE 33 *Flooded Meadow* (c. 1902) Willard Worden

PLATE 34 *East Rush, L.V.R.R.* (c. 1900) William Herman Rau

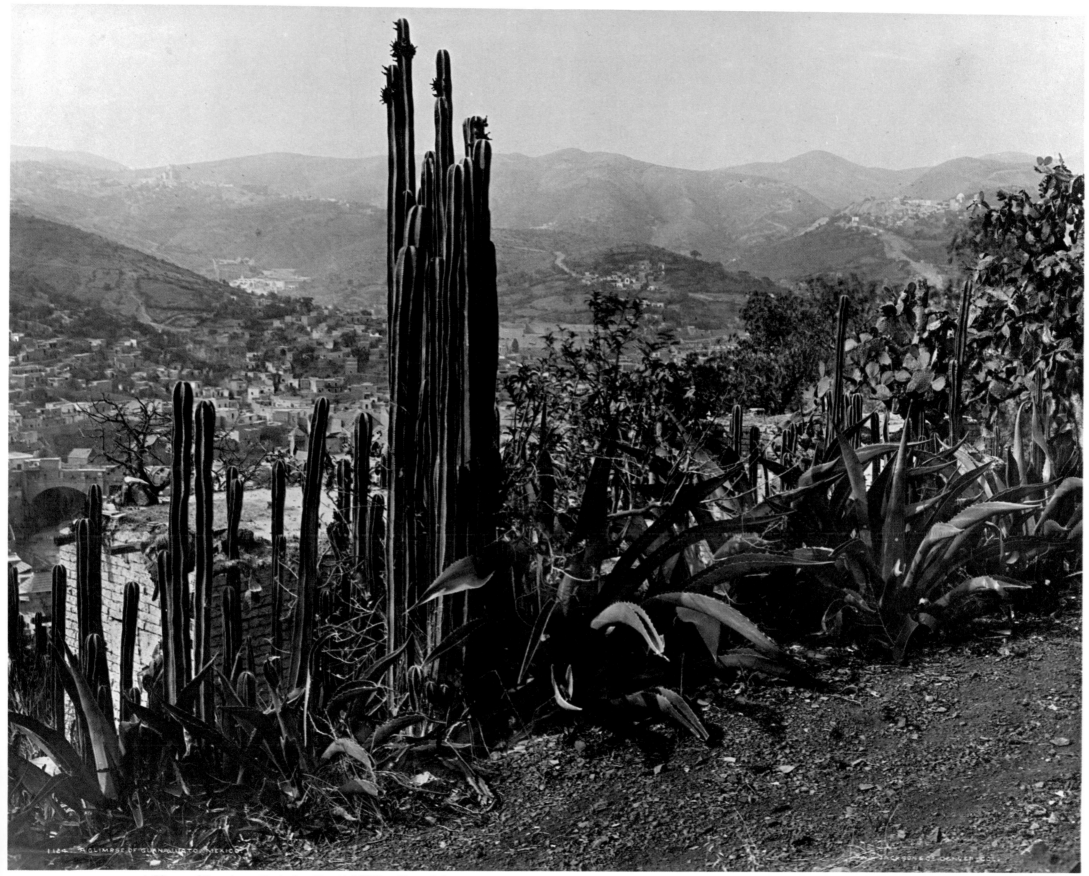

PLATE 35 *A Glimpse of Guanajuato, Mexico* (c. 1883-1884) William Henry Jackson

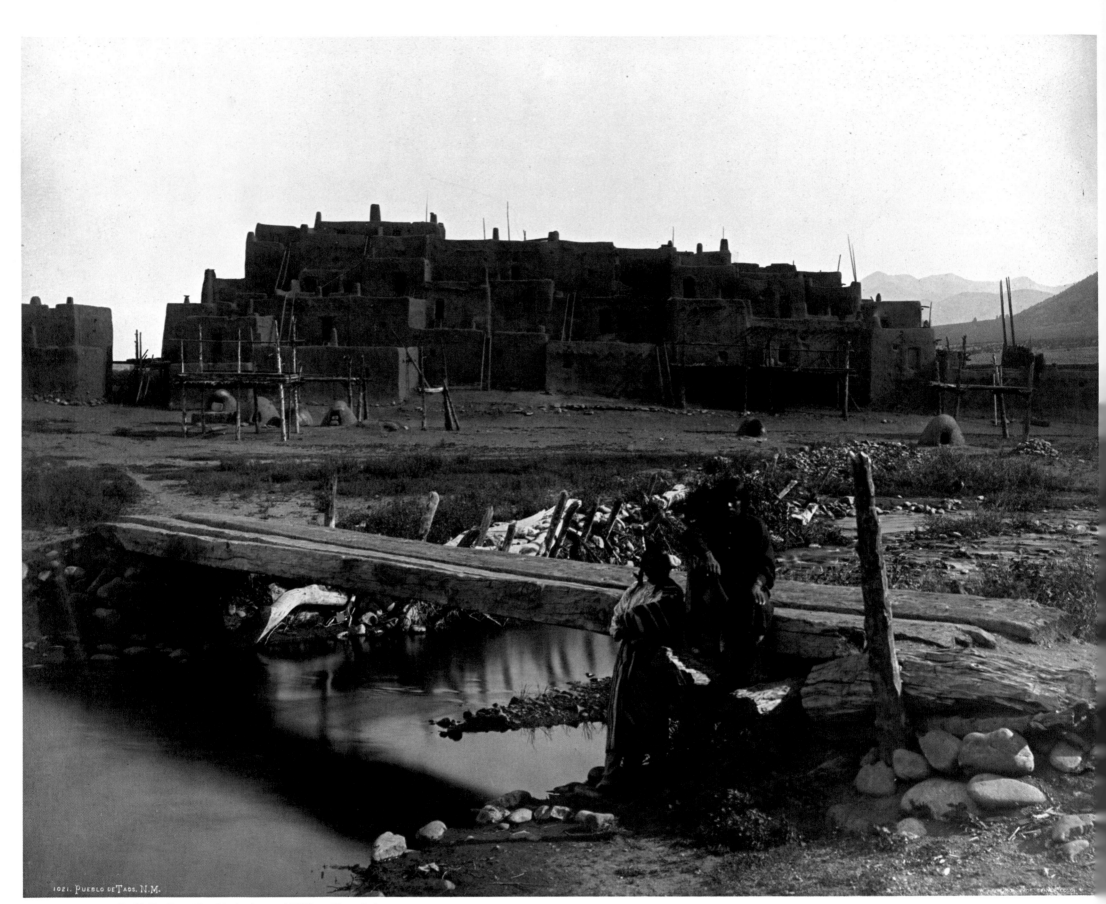

PLATE 36 *Pueblo De Taos, New Mexico* (c. 1883) William Henry Jackson

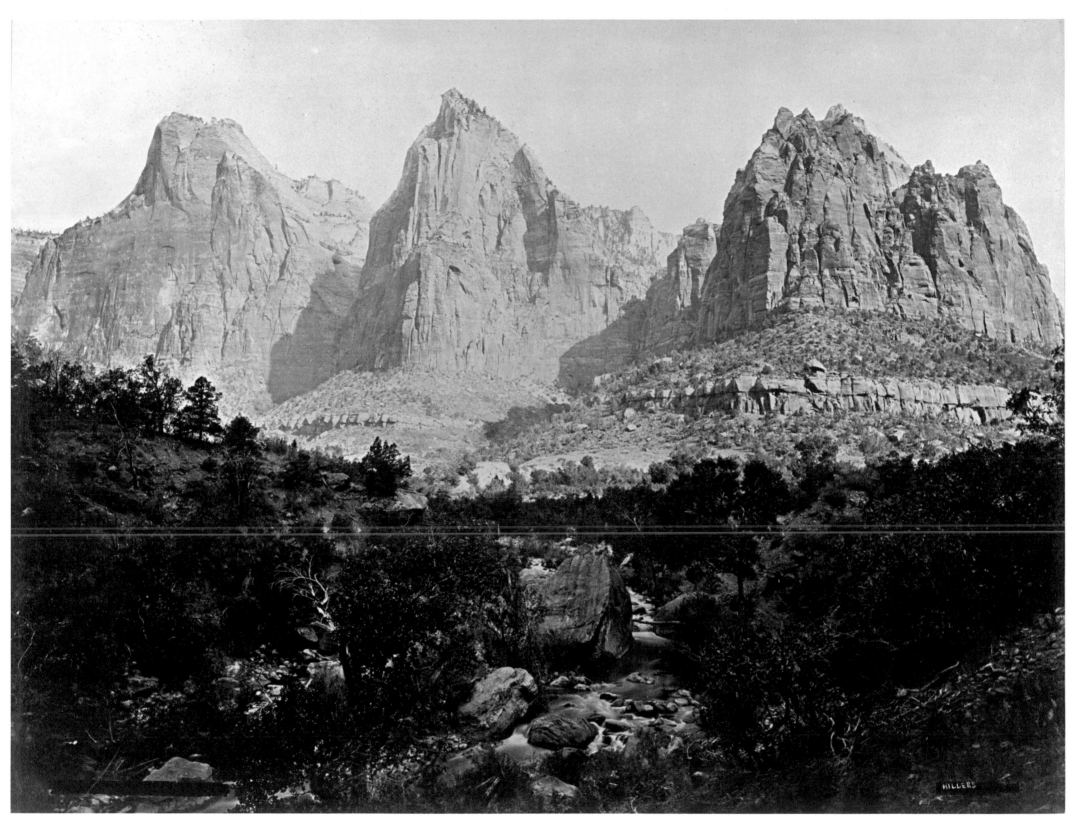

PLATE 37 *Three Patriarchs, Zion Canyon, Rio Virgen, Utah* (1872) John K. Hillers

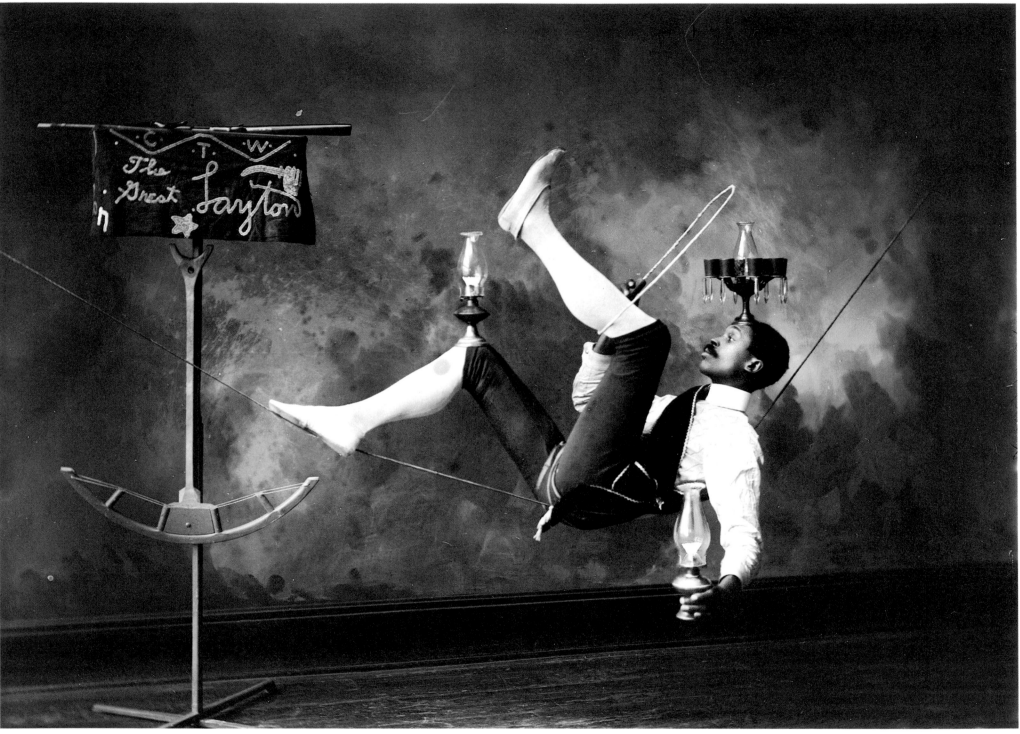

PLATE 38 *The Great Layton, Circus Performer* (1885) Harrison Putney

Nineteenth-Century Portraits

The True Republican Style of Painting

Nothing illustrated photography's status as a democratic art so well as the extraordinary range of nineteenth-century American portraits. The photo album, crammed with prints of family members and celebrities, was a ubiquitous feature of the late nineteenth-century American home. Anyone, it seemed, could have his likeness made: cowboys and Indians, desperadoes and lawmen, small-town settlers and urban immigrants. "The results of this art are not confined to *wealth* for encouragement and success," a photographer wrote in 1872. "But in consideration of its superior *fidelity* to nature, *cheapness* and *rapidity* of production, it now justly receives the support of the masses, of the *people*."[1]

Until hand-held cameras and fast roll-film made it possible for photographers to make quick snapshots of their subjects, all portraits were *staged* rather than *found* images. That is, they were posed not candid photographs. Technical manuals, directed at both sitters and photographers, boasted chapter titles like "Expression—How to Look Beautiful and Create Beauty."[2] But sitters often aimed for something besides a carefully calculated air of ethereal beauty. Charles D. Kirkland's *Wyoming Cowboy* projects an air of jaunty self-confidence (p. 52). Annie Oakley skillfully projects her stage persona (p. 61). The four sisters posing for a studio portrait betray the solemnity and importance of the event (p. 52), while Jesse James playfully poses as an outlaw and reveals the comic possibilities of photography (p. 57). If the camera could immortalize the famous, it could surely do the same for the notorious.

1 H. J. Rogers, *Twenty-Three Years Under a Sky-Light* (Hartford, Conn.: H. J. Rogers Publisher, 1872), p. 15.

2 Ibid, chapter 5.

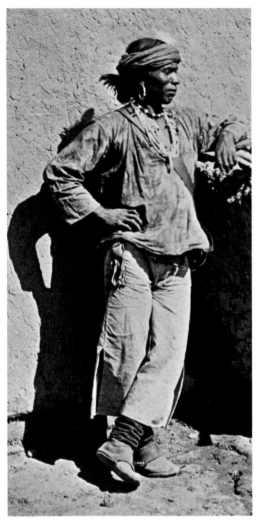

DETAIL PLATE 43
A Zuni Eagle Cage (1879) John K. Hillers

Portraiture was attractive to photographers because most portraits were commissioned and paid for by the sitter and thus involved little financial risk. Portraits of well-known celebrities or popular types, like the cowboy, had even greater commercial possibilities. In the 1880s and 1890s, C.D. Kirkland made a series of 80 views showing every aspect of the cowboy's work and sold them to tourists and probably a few would-be cowboys eager to look and act like the real thing. Laton Huffman made his images of the trail drive to document a life that he knew was fast disappearing. He marketed his views from the 1880s and 1890s until his death in 1913, selling them to an audience nostalgic for the romance of the Old West (p. 57).

Indians, too, were popular subjects for Americans infatuated with the exotic allure of the West. Some of the photographers who carefully documented the appearance of the western Indian tribes, even as the federal government was fighting them or consigning them to reservations, were actually employed by the federal government. John K. Hillers, for example, worked for the Smithsonian Institution's Bureau of American Ethnology which systematically assembled the most comprehensive collection of Indian portraiture anywhere (p. 53). But while many nineteenth-century Indian portraits were made for ethnographic purposes, as often as not their scientific accuracy is dubious. The buying public liked to view their Indians from a safe distance as the Indians lay mortally wounded on a battlefield (p. 58) or docilely posed in an elaborate Victorian photographic studio, perhaps wearing a costume from the photographer's own collection (p. 56).

Like other sorts of photographs, portraits could serve the interests of either science or art. Eadweard Muybridge made his *Woman Pirouetting (.277 Second)* as part of his scientific investigation of the dynamics of motion (pp. 54–55), and painter Thomas Eakins made his haunting and evocative portrait of his father-in-law as part of a personal investigation into the possibilities of artistic photography.

But whatever the intent behind the making of the photograph, the sheer number and popularity of nineteenth-century American portraits revealed something about the character of American life. During a period of extraordinary change in American life, these photographs provided a kind of continuity. They gave one the ability to possess likenesses of friends and relatives who had moved west, or to show them how one's own family fared after a long move; they could provide evidence of one's new status as an American, or offer confirmation of one's home-town roots; they could allow one to feel a special closeness to stage celebrities or elaborately costumed Indians living in remote regions of the country. They could, in short, allow one to relish and feel part of the vast, rich complexity of American life.

PLATE 39 *H. Lissik, Circus Performer, Twirling Baton* (1886)
Harrison Putney

PLATE 40 *Wyoming Cowboy* (c. 1895) Charles D. Kirkland

PLATE 41 [*Four Children*] (c. 1890s) Unknown photographer

52

PLATE 42 *Harry Wiekler* (1901) Unknown photographer

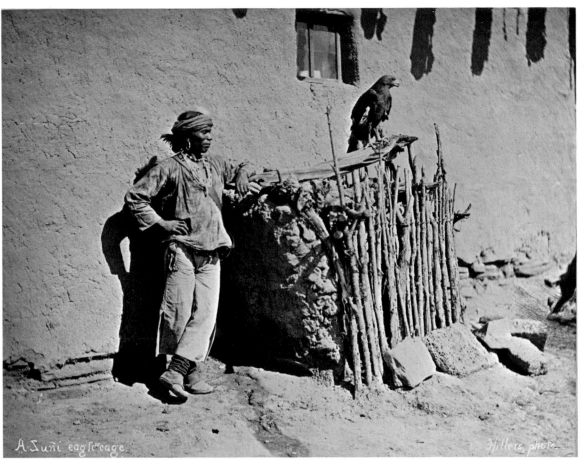

PLATE 43 *A Zuni Eagle Cage* (1879) John K. Hillers

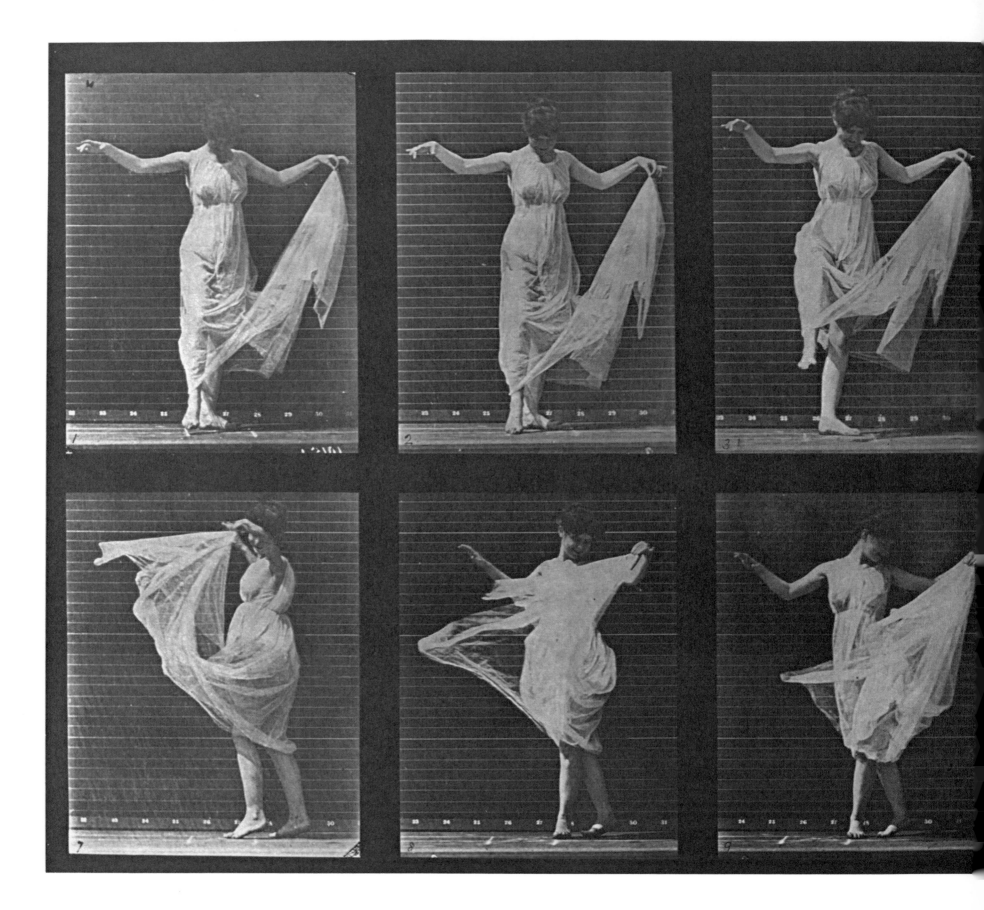

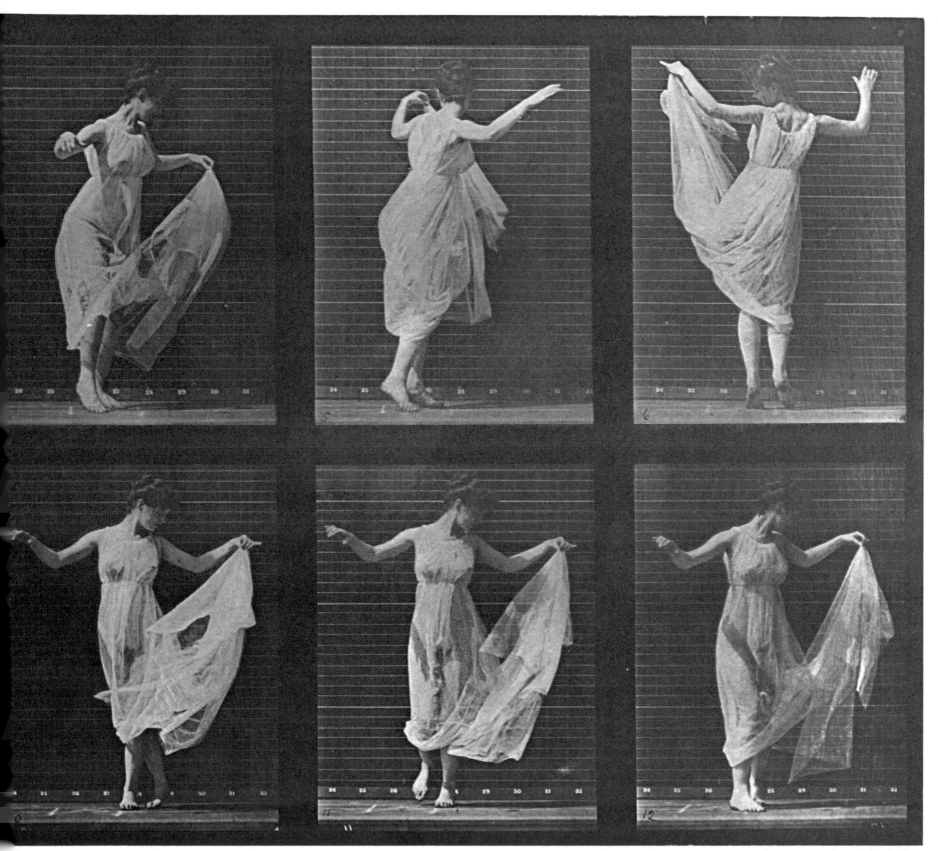

PLATE 44 *Woman Pirouetting (.277 Second)* (1887) Eadweard Muybridge

PLATE 45 *Little Big Man, Ogalalla Dakota* (1877) Charles M. Bell

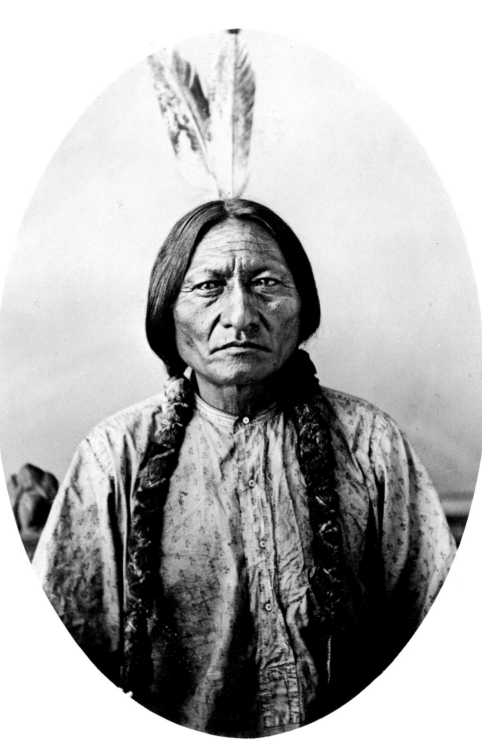

PLATE 46 *Sitting Bull* (c. 1884) David F. Barry

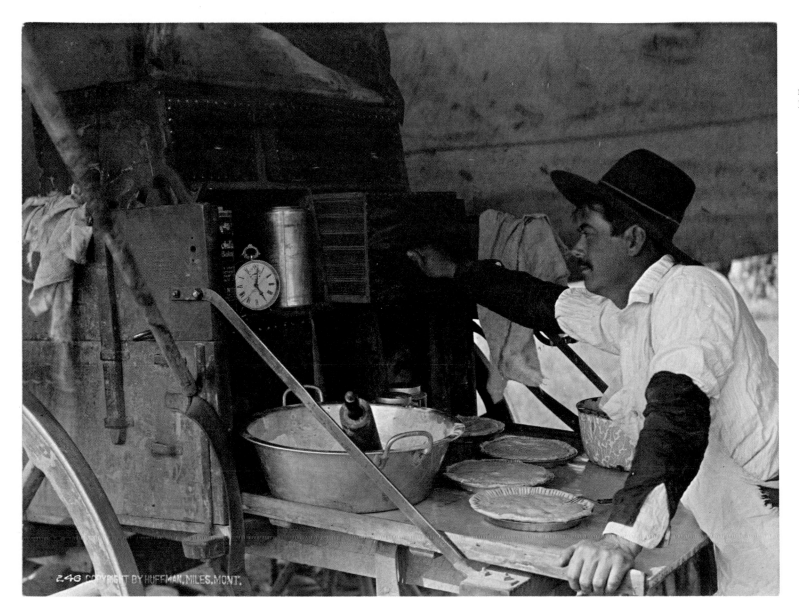

PLATE 47 *The Mess Wagon* (c. 1890s)
Laton Alton Huffman

DETAIL PLATE 48

PLATE 48 [*Jesse James on Horseback*] (c. 1870) Unknown photographer

PLATE 49 *A Chinese Bagnio, San Francisco*
(c. 1880s) I. W. Taber, Publisher

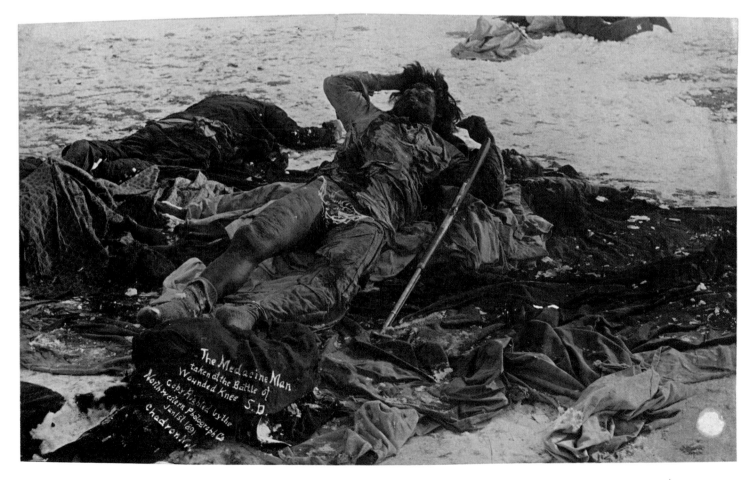

PLATE 50 *The Medicine Man—Taken at the Battle*
of Wounded Knee, South Dakota (1891)
George Trager

PLATE 51 *Mexican Boy Captured by Comanches*
(c. 1871) Unknown photographer

PLATE 53 *U.S. Grant, 80 Ft. Circ., Mariposa Grove* [Portrait of Eadweard Muybridge] (1872) attributed to Charles Leander Weed

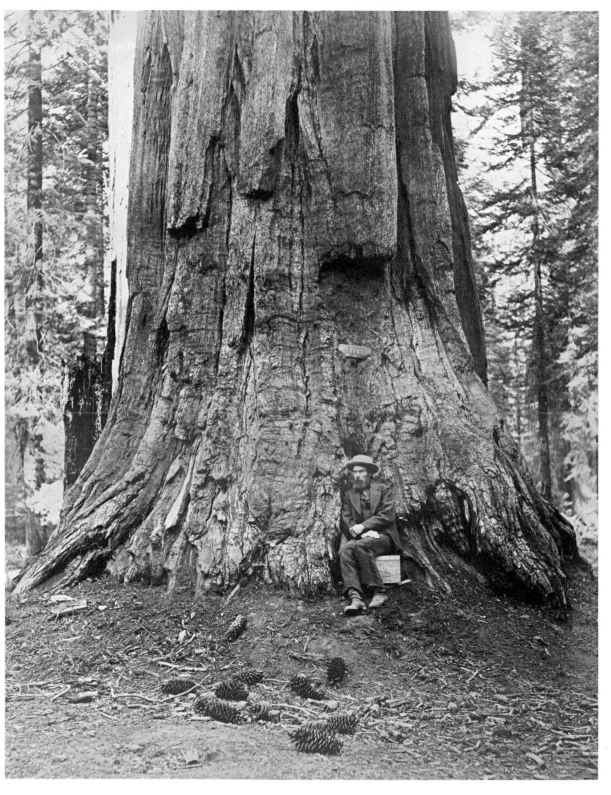

PLATE 52 *William H. Macdowell* (c. 1884)
Thomas Eakins

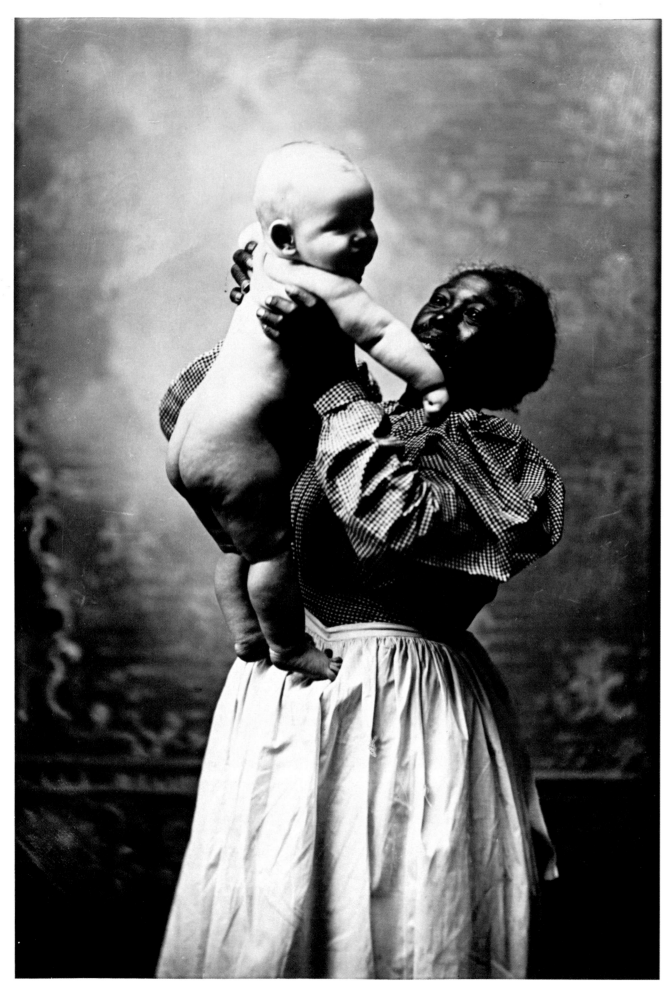

PLATE 54 *Mrs. Wilson's Nurse* (c. 1890s) Unknown photographer

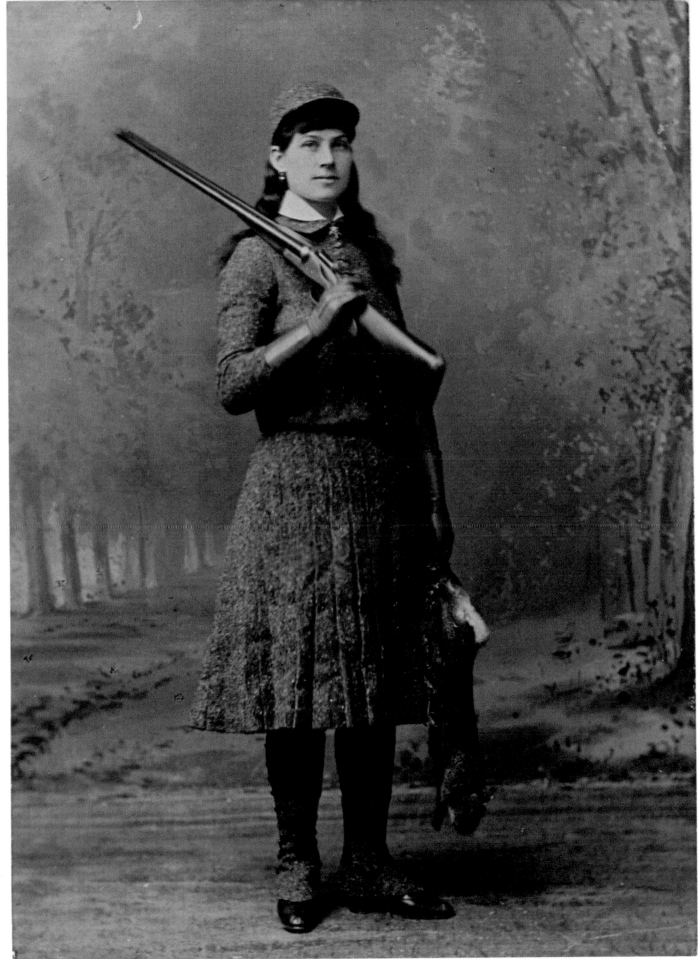

PLATE 55 *Miss Annie Oakley (Little Sure Shot)* (c. 1880s)
John Wood

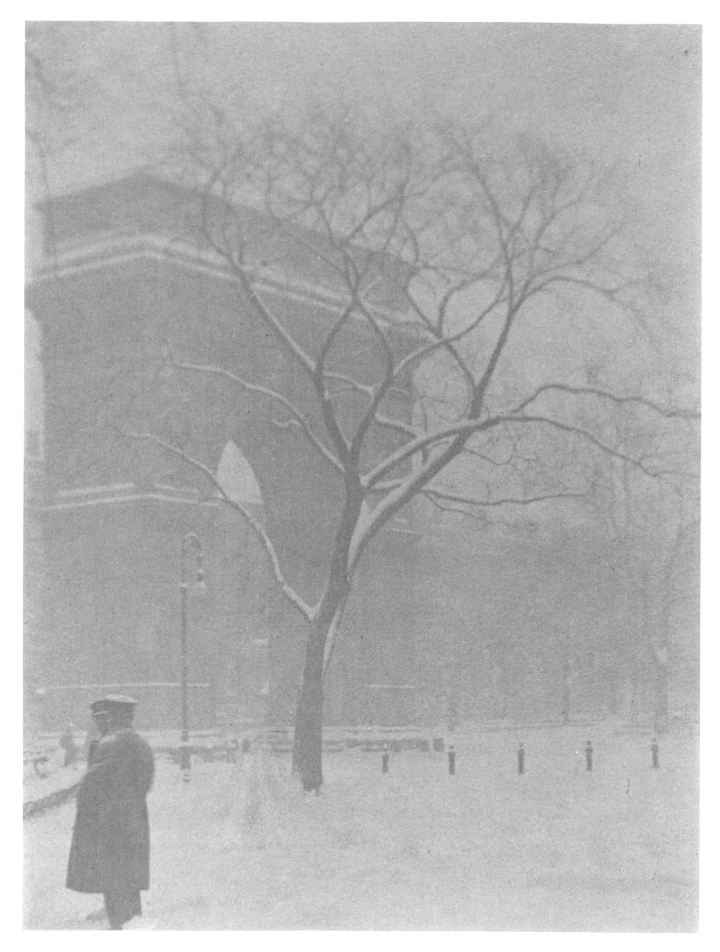

PLATE 56 *Washington Square, New York* (1916) Laura Gilpin

The Pictorial Style

The Feeling and Inspiration of the Artist

For most of the nineteenth century, American photographers remained fascinated by the camera's miraculous ability to aid memory and enhance knowledge by accurately documenting the appearance of things. But in the 1890s, many photographers began experimenting with a new style that emphasized the importance of personal expression and an idealized concept of beauty at the expense of strictly accurate reporting. This new movement came to be known as "pictorial photography," for its practitioners carefully distinguished between artistic "pictures" and the mere "photographs" mindlessly churned out by amateurs with Kodak cameras.

The pictorialists stressed that serious photographers must bring "feeling and inspiration" to their work and guard against making pictures that were just slavish imitations of reality. Alfred Stieglitz, the guiding light of American pictorialism, proclaimed that truly artistic photographers would use their cameras and chemicals "simply as tools for the elaboration of their ideas, and not as tyrants to enslave and dwarf them."[1] Through his periodical *Camera Work*, begun in 1902, Stieglitz promoted the principles of fine arts photography with articles and stunning photogravure reproductions of fine images (pp. 67, 70).

In an effort to establish photography as a fine art and to prove that they could exercise creative control over the process, the pictorialists often manipulated either the print or the negative. To add to the overall effect of stylized beauty in his portrait of Yvonne Verlaine, for example, Edward Weston scratched two teardrop shapes into the dark background of his

1 Alfred Stieglitz, "Pictorial Photography," *Scribners Magazine* 26 (November 1899), reprinted in Beaumont Newhall, ed., *Photography: Essays and Images* (New York: Museum of Modern Art, 1980), p. 164.

2 Henry Clay Price, *How to Make Pictures: Easy Lessons for the Amateur Photographer* 11 (New York, Scovill Manufacturing Co., 1882), p. 68.

negative; they appear in the final print as elegant and mysterious sources of light (p. 75). The pictorialists also favored exotic and easily manipulatable printing processes, often hand-coating papers with platinum or gum-bichromate solutions rather than using commercially prepared silver papers (pp. 66, 71, 72, 77). As a part of this emphasis on craft, they also favored unusual textured papers and sometimes prepared elaborate colored paper mounts for their pictures.

Though pictorialists generally strove to present an idealized notion of beauty, aesthetic pleasure was not the sole end of their work. Nor were idealized landscapes, romantic studio portraits, or carefully arranged still lifes the only appropriate subject matter for their photography. A specific event might be documented in a pictorial style, as Arnold Genthe demonstrated when he borrowed a camera to document the great San Francisco earthquake of 1906 (pp. 68–69, 80). His images of the disaster have the same pervasive moodiness and suggestive silhouetted figures that characterize many pictorial photographs, but they still convey information about a particular happening. With a similar concern for documentary intent and pictorial style, Edward S. Curtis and anthropologist Frederick Monsen made a visual record of Native American culture (pp. 76, 77, 78, 85). Stieglitz, Karl Struss, and Laura Gilpin proved that even the industrial American city could furnish subject matter for pictorial photography (pp. 62, 81, 84).

The emergence of the pictorialist movement and the concurrent growth of amateur photography in America coincided with two technological developments that served to draw large numbers of women into photography for the first time. The dry-plate negative, which came into common use in the mid-1880s, could be purchased commercially. It freed the photographer from the tedious process of coating glass sheets with a light-sensitive collodion mixture before each exposure. A popular 1882 instruction manual for amateurs proclaimed that women, at last, could be freed from the sheer physical drudgery of photography: "The 'tyrant man' will not be needed to carry about a pocket outfit, consisting of a 4 × 5 camera, accompanying dry plate holder, and an extension tripod weighing complete but three and three quarters pounds."[2] The Kodak, first marketed in 1888, provided even more freedom from the messy darkroom; "You push the button and we'll do the rest," its promoters promised. Women, as can be seen by the illustrations in this book, were active and important members of the pictorial photography movement. In fact, more women have probably been recognized for their achievements in photography than in any other area of twentieth-century American art. This is due, perhaps, to the lack of a formal academy tradition that excluded women, and to the ease with which photography could be practiced at home, without elaborate or expensive equipment.

Many of the photographers who began by working in the pictorial style—for example, Alfred Stieglitz, Paul Strand, Edward Weston, and Laura Gilpin—later adopted a hard-edged approach that eschewed any manipulation of the print or negative as well as the romantic, hazy tone of much of their previous work. This so-called "straight" photographic style, which has come to dominate twentieth-century American photography, is often portrayed as being in direct opposition to pictorialism. But the two schools of photography share a crucial tenet. At their core is the basic idea that photography is a form of creative expression and that it can be used to reveal more than might meet the unaided eye. Followers of both styles aspired to what Paul Strand called the "highly-evolved crystalization of the photographic principle, the unqualified subjugation of a machine to the single purpose of expression."[3]

3 Paul Strand, "Photography and the New God," *Broom* 3:4, 1922, reprinted in Peter C. Bunnell, ed., *A Photographic Vision: Pictorial Photography, 1889–1923* (Salt Lake City: Peregrine Smith, Inc., 1980), p. 204.

PLATE 57 *The Prelude* (1917) Laura Gilpin

66

PLATE 58 *Peppers* (c. 1923) Paul Outerbridge

PLATE 59 *Still Life* (1908) Baron Adolf De Meyer

67

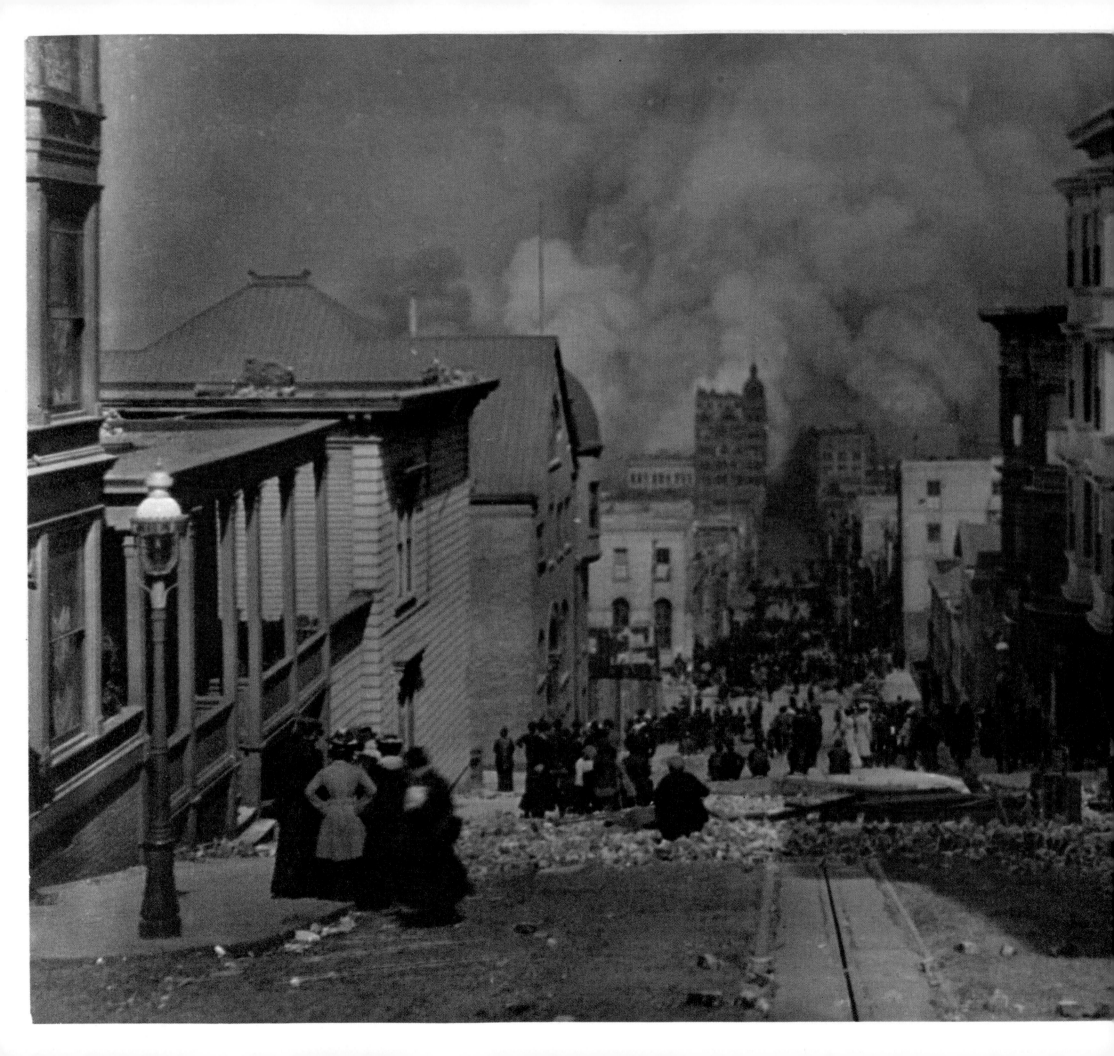

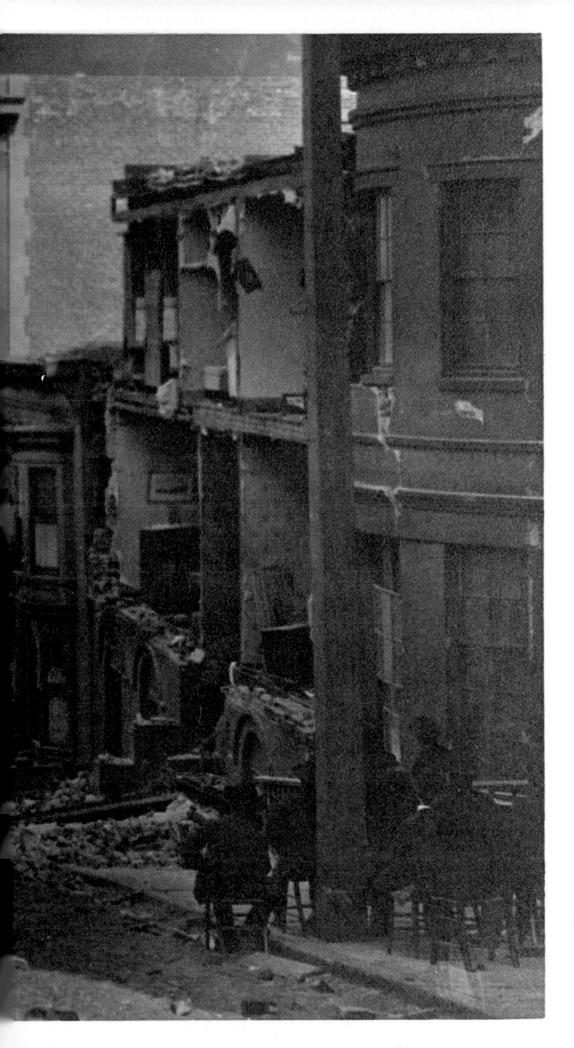

PLATE 60 *San Francisco, April 18th, 1906* (1906) Arnold Genthe

69

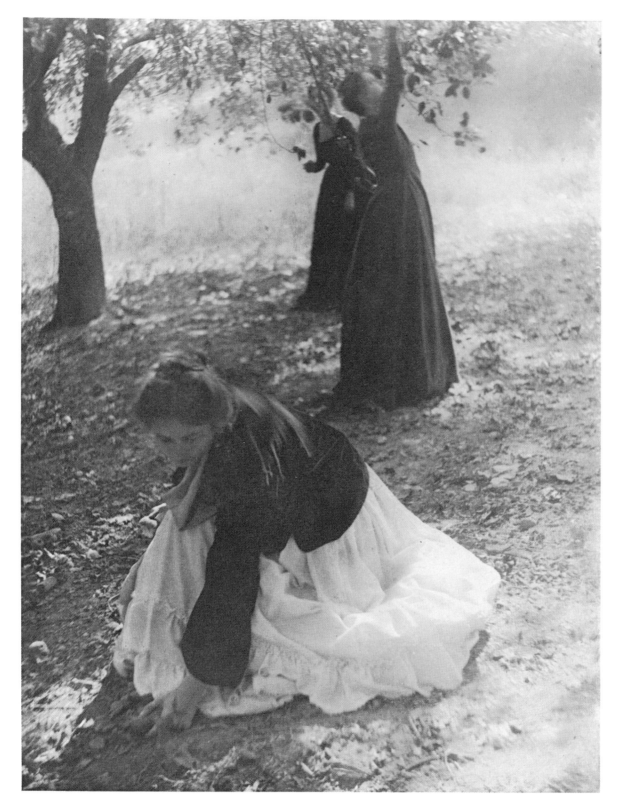

PLATE 61 *The Orchard* (1902) Clarence H. White

PLATE 62 *Narcissus* (1928) Laura Gilpin

71

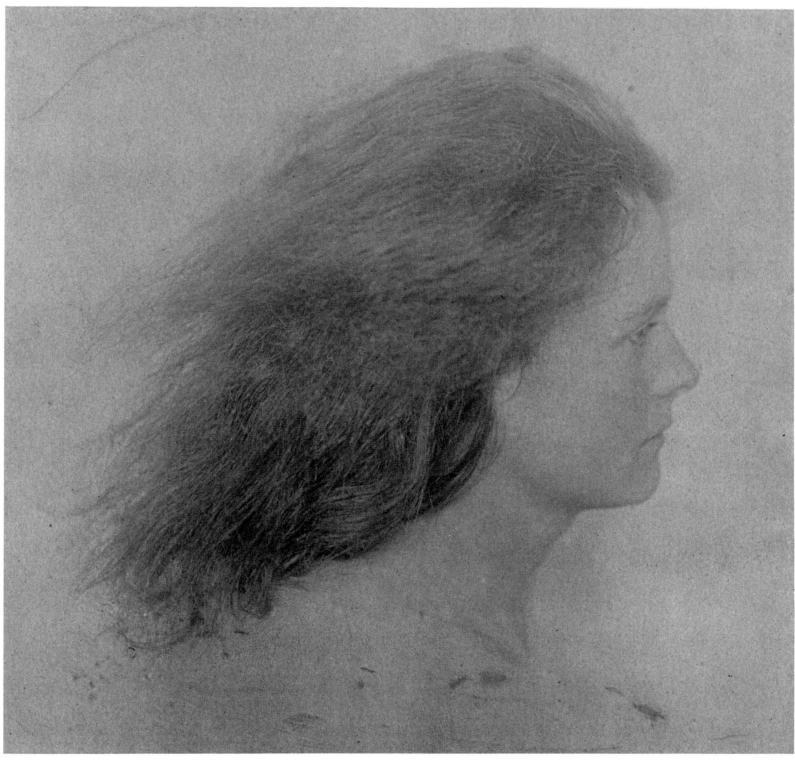

PLATE 63 [*Portrait of Daughter*] (c. 1909) Alice Boughton

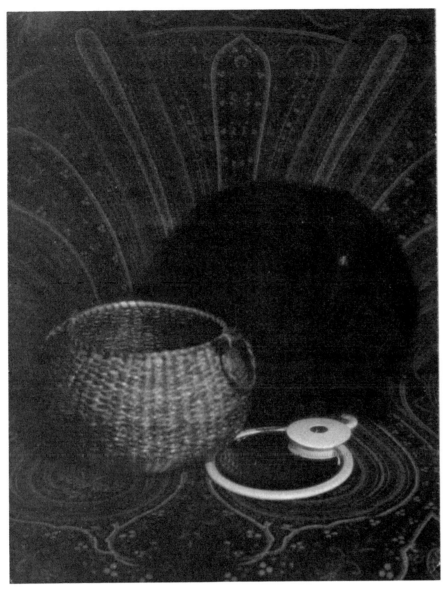

PLATE 65 *Yellowstone National Park* (c. 1912) Louise Deshong Woodbridge

PLATE 64 *Still Life* (c. 1921) Ira Martin

73

PLATE 66 *Lorado Taft: The Man and His Work* (1917) Jane Reece

74

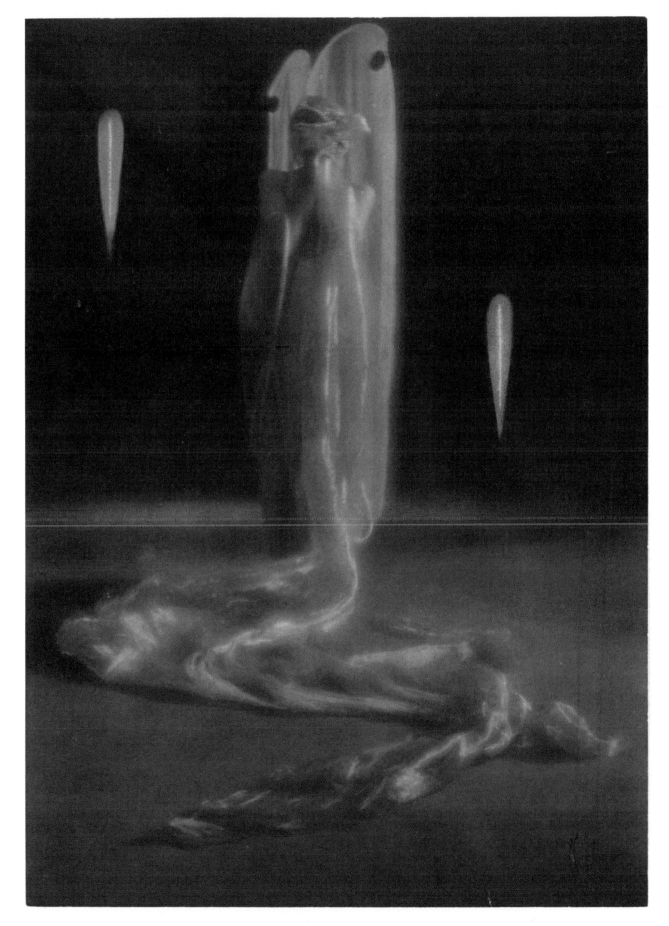

PLATE 67 *The Goldfish [Yvonne Verlaine]* (1917)
Edward Weston

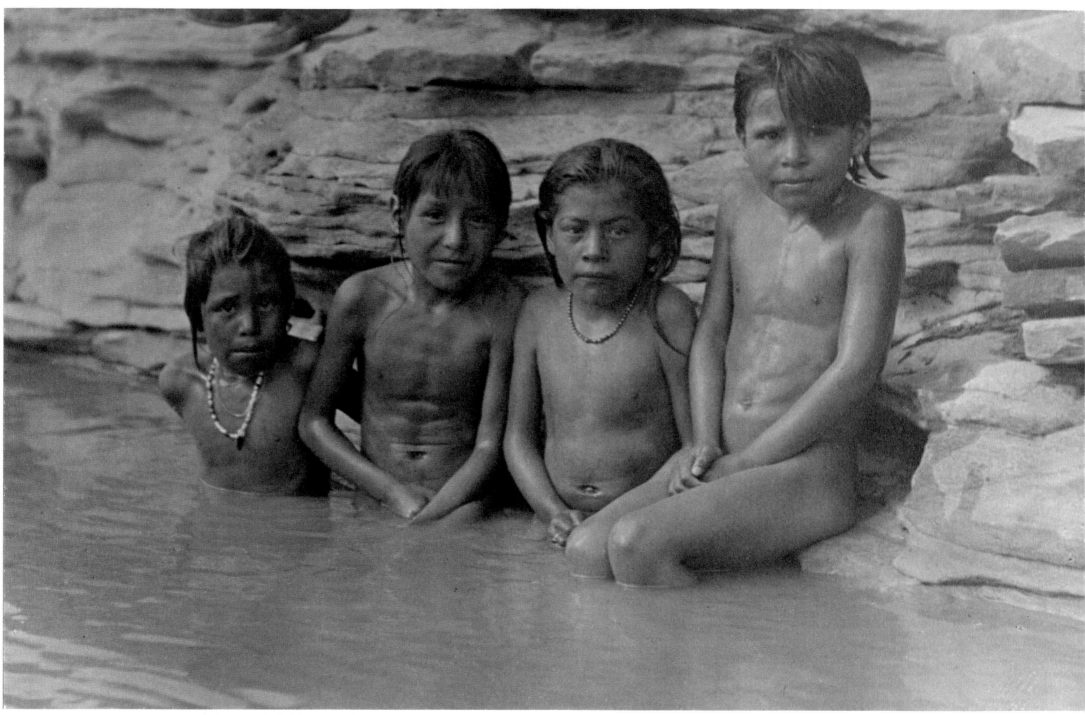

PLATE 68 *Mohave Indian Children* (c. 1890s) Frederick Imman Monsen

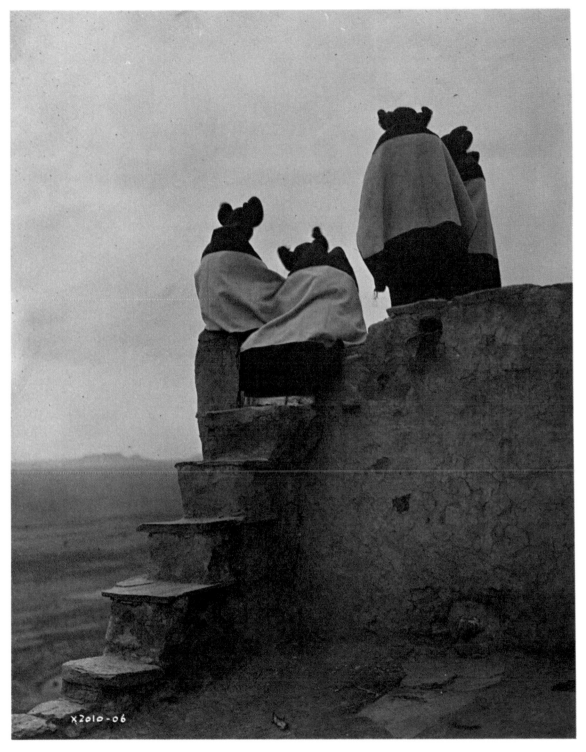

PLATE 69 *Watching the Dancers* (1906) Edward S. Curtis

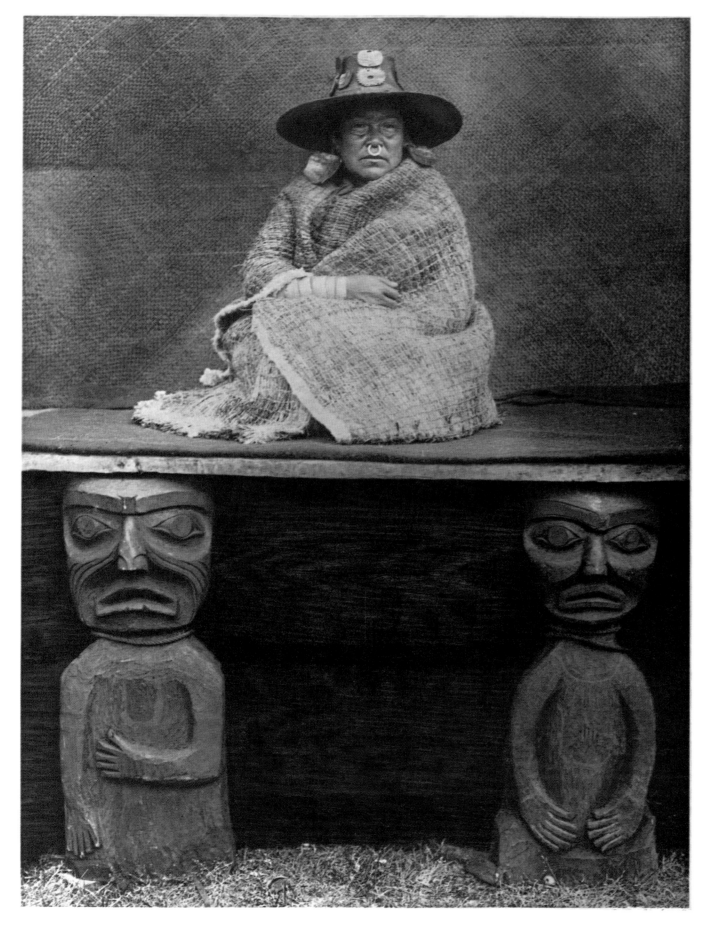

PLATE 70 *A Nakoaktok Chief's Daughter* (1914) Edward S. Curtis

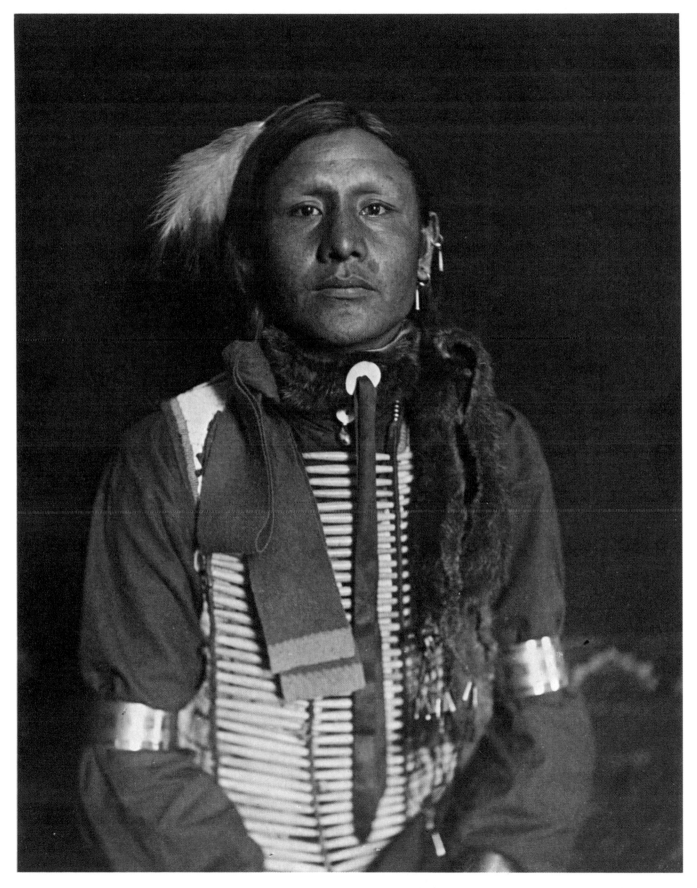

PLATE 71 *Has-No-Horses* (1898) Gertrude Käsebier

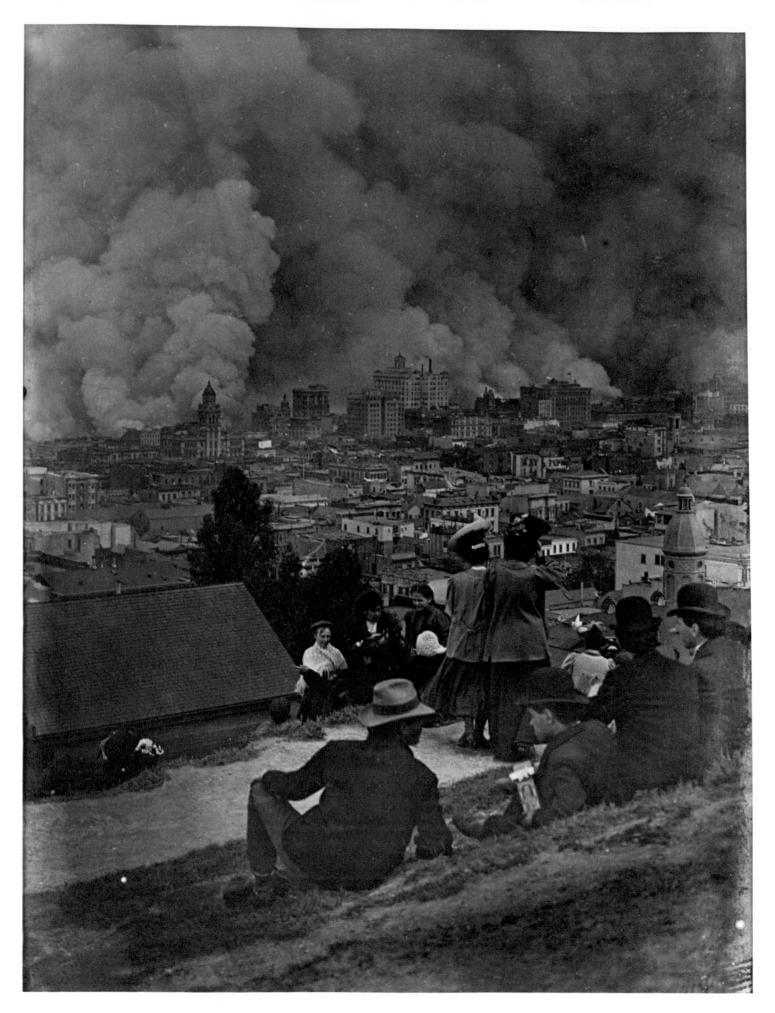

PLATE 72 *Watching the Approach of the Fire* (1906)
Arnold Genthe

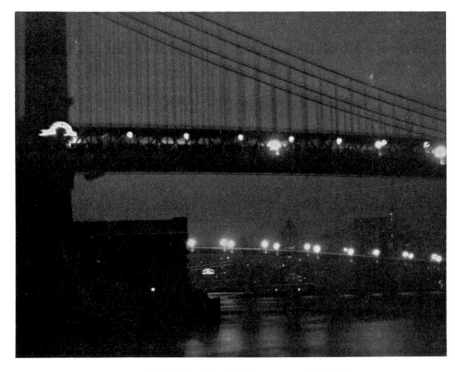

PLATE 73 *Bay Bridge, New York* (c. 1912–1913) Karl Struss

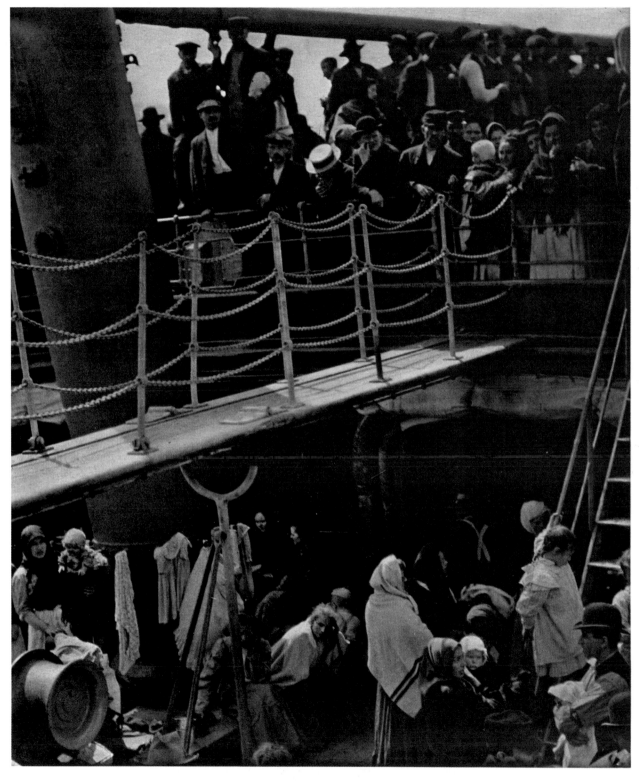

PLATE 74 *The Steerage* (1907) Alfred Stieglitz

81

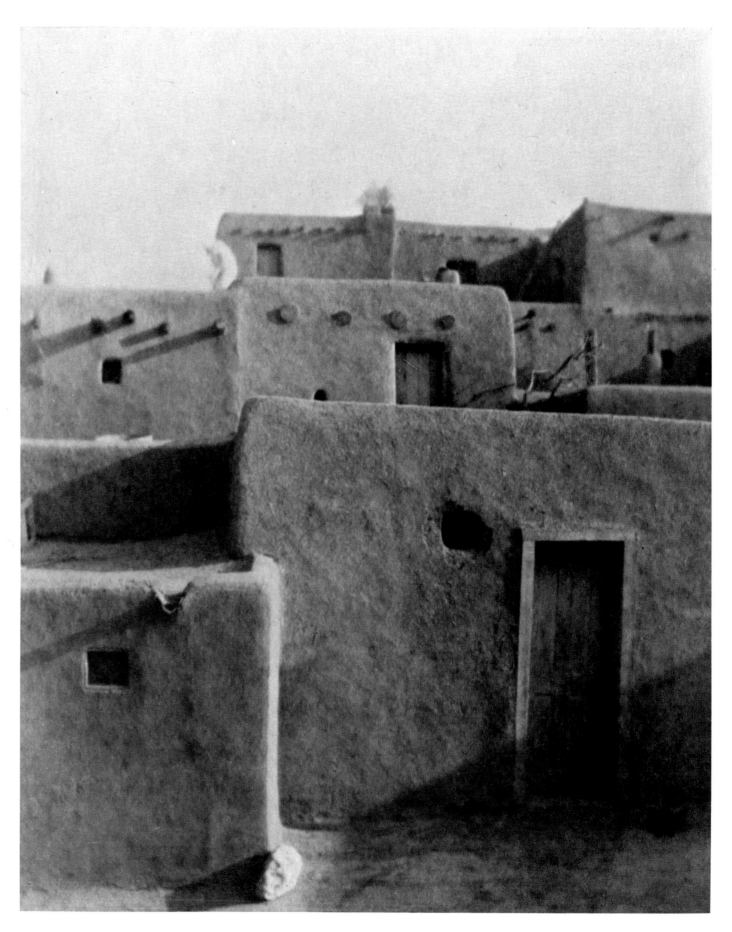

PLATE 75 *Adobe Walls, Taos, New Mexico* (c. 1920)
Clara Sipprell

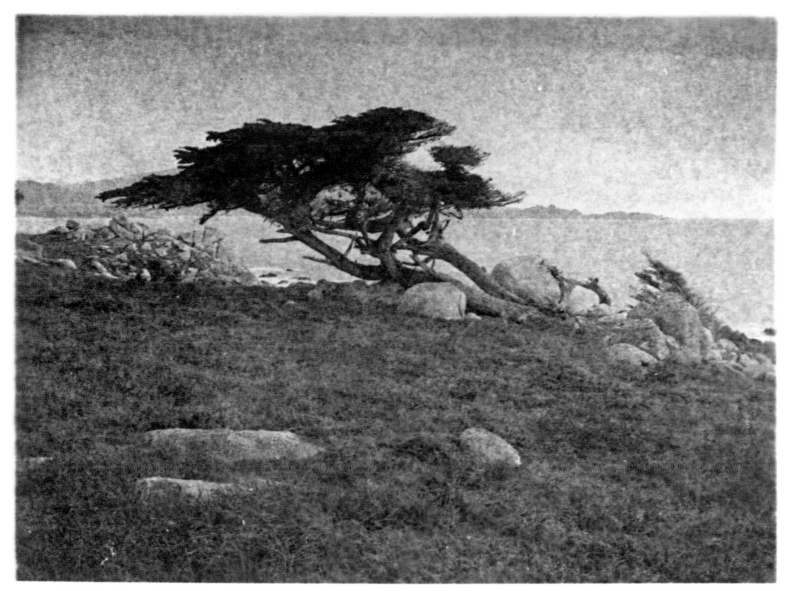

PLATE 76 *California Scene* (c. 1910–1920) Leopold Hugo

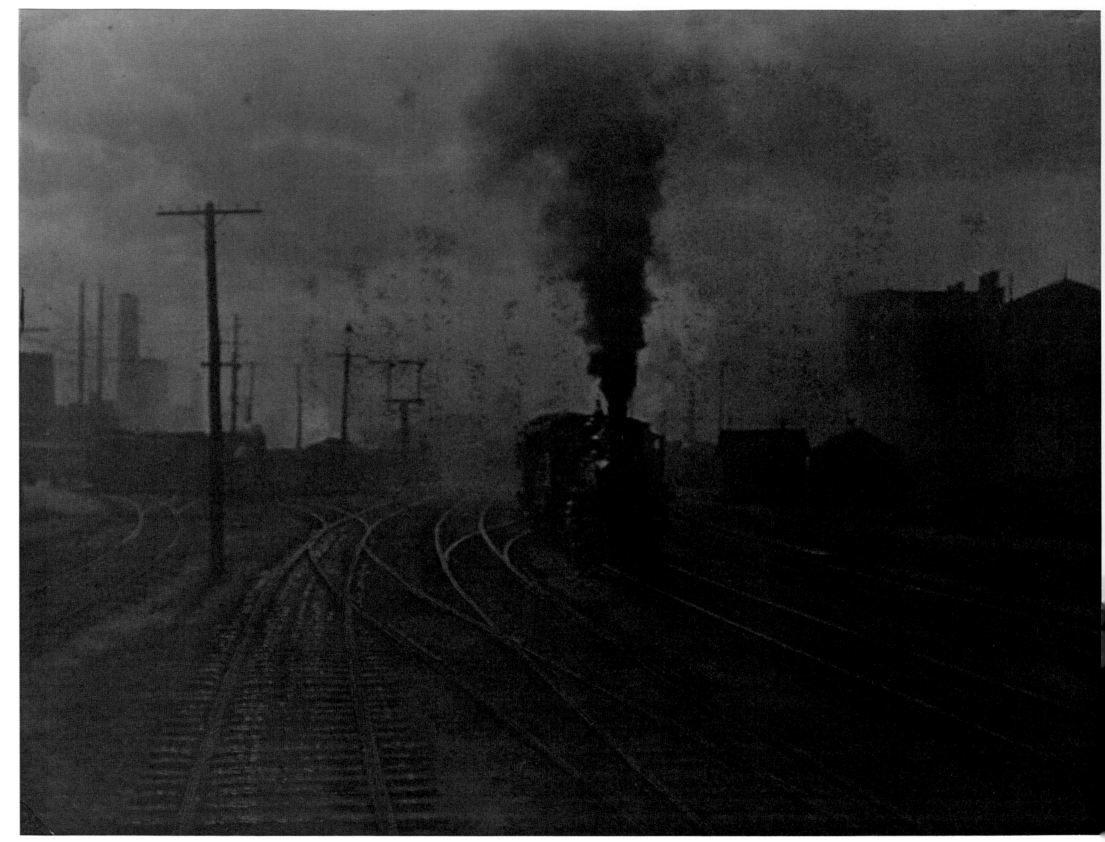

PLATE 77 *The Hand of Man* (1902) Alfred Stieglitz

84

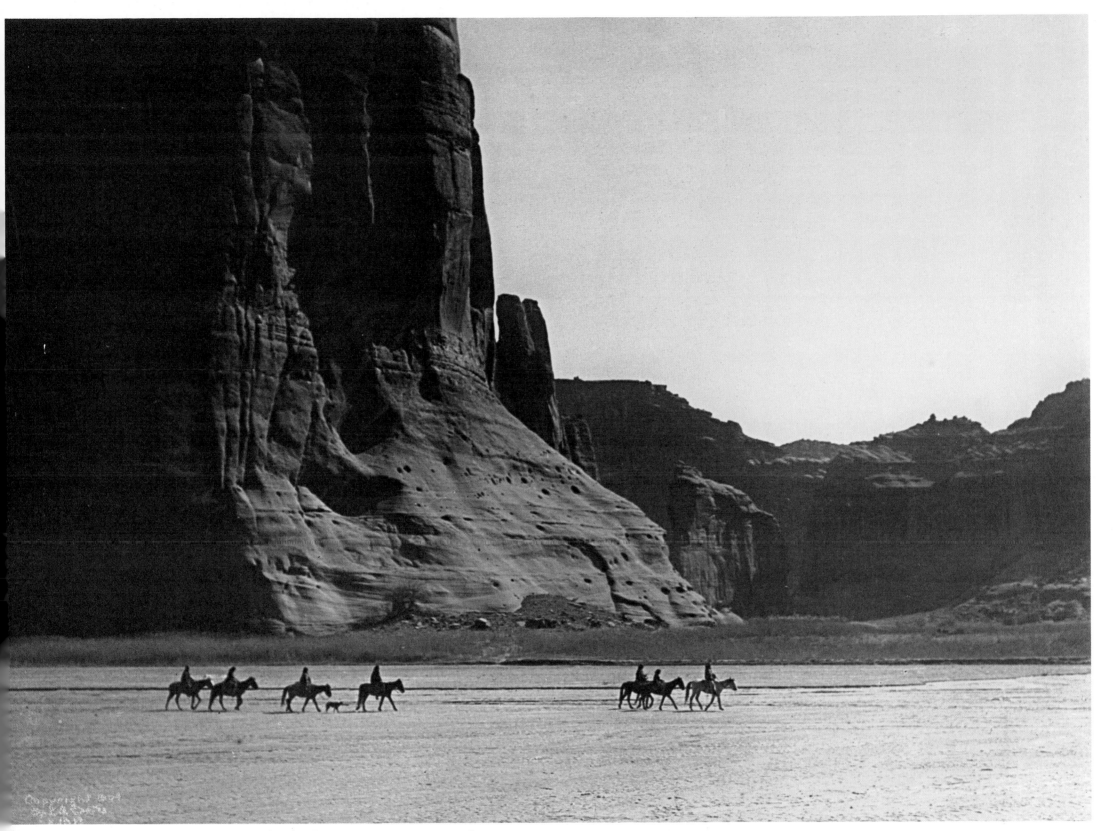

PLATE 78 *Cañon De Chelly* (1904) Edward S. Curtis

PLATE 79 *Charles M. Russell*
(c. 1924-1926) Dorothea Lange

The Straight Photograph and the Documentary Style

The Thing Itself

The publication of Paul Strand's candid street photographs and close-up abstractions of man-made forms in the final issues of *Camera Work* (1916–17) signaled the start of a new aesthetic that emphasized the virtues of clear, sharply focused images. Calling for a renewed respect for the particular qualities of photography, Strand derided the pictorialists' use of handwork and manipulation as "merely the expression of an impotent desire to paint." "Honesty no less than intensity of expression," Strand wrote, "is the prerequisite of a living expression."[1]

This renewed emphasis on the pure, unadulterated photograph found expression in two distinct, though related, styles: straight photography and documentary photography. The straight photographers, unlike the pictorialists who relished the atmosphere of a scene, emphasized clarity of form and the potential of beauty in any subject. Or, as Edward Weston put it, they valued the "aesthetic beauty of the thing itself" over "lovely poetic impressions."[2] Photographers working in a documentary vein shared these stylistic concerns for precisely rendered subjects, but they chose subjects that would elucidate some social concern. While the primary interest of many photographers working in the straight style was to produce images that would provide aesthetic pleasure, documentary photographers strove to make pictures that, through the very accuracy of their depiction of life, would be instructive and educational.

Edward Weston, who after renouncing his early pictorial work became one of the leading proponents of the new straight photography, wrote that a photographer's power lay

1 Paul Strand, "Photography," *Seven Arts* 2 (August 1917) reprinted in Beaumont Newhall, ed., *Photography: Essays and Images* (New York: Museum of Modern Art, 1980), p. 219.

2 Edward Weston, "Photography—Not Pictorial," *Camera Craft* 37, no. 7 (1930), reprinted in Nathan Lyons, ed., *Photographers on Photography* (Englewood Cliffs, Prentice-Hall, Inc., 1966), pp. 157–158.

3 Weston, "Photography," p. 157.

in his ability to persuade a viewer that "he is seeing not just a symbol for the object, but the thing itself revealed for the first time."[3] This concern for the essence of "the thing itself" and a fresh way of seeing familiar subjects provided the theme for practitioners of straight photography. The essence of a thing might be present in a revealing fragment of its total form as in Weston's headless nude (p. 118) or Alfred Stieglitz' portrait of Georgia O'Keeffe's hands (p. 93). The trick was to reveal each subject's particular character: Weston's nude seems languorous; O'Keeffe seems more tense and wrought. Even machines and machine-made things could have a formal beauty and their own essential character. Walker Evans's proud smokestack on the *Queen Mary* (p. 119) seems to differ in character from Willard Van Dyke's animate ventilator stacks (p. 119) or Charles Sheeler's elegant "bleederstacks" (p. 116). The most mundane and familiar subject, an old chair, for example, or half an apple, could be made to reveal its beauty to a receptive photographer (pp. 90, 112).

4 Beaumont Newhall, *The History of Photography*, 4th ed. (New York: Museum of Modern Art, 1978), p. 111.

Straight photography shared this interest in the fragmentary piece and a concern for form and the found patterns of daily life with the new modernism in painting. Stieglitz liked to tell friends that Picasso had praised *The Steerage* (1907), an image with a boldly dissected picture plane that is often cited as one of the earliest examples of photographic modernism.[4] The printed word, used by the Cubists in their paintings and collages often for humorous or ironic effect, was also used by photographers (pp. 104, 112, 122). Even abstractionism, a style that might seem ill-suited to the photographic medium, became a subject for photographic investigation. Carlotta Corpron's *Flowing Light* is an unmanipulated print of reflected light rippling across a sheet of plastic, but the abstract forms of the image bear no recognizable relationship to a concrete event (p. 109).

The documentary photograph—a picture providing evidence of a specific person, place, or thing that has been made with an intention to instruct or persuade—was not an invention of the twentieth century. The nineteenth-century expeditionary photographers who recorded the true appearance and geological structure of the American West were documentary photographers. So were the men who recorded Native American life for the Bureau of American Ethnology. In the 1880s, Jacob Riis pioneered in the use of the camera as a tool for gathering evidence about social conditions with his work in the slums of New York. But this kind of *social* documentary photography—as opposed to documentation for the purposes of geological or ethnographic inquiry—is essentially a twentieth-century phenomenon.

Lewis Hine, a trained sociologist whose documentary photographs of child laborers (p. 113) helped lead to the passage of child labor laws, wrote in 1909: ". . . the picture continues to tell a story packed into the most condensed and vital form. In fact, it is often more effective than the reality would have been, because, in the picture, the nonessential and

DETAIL PLATE 86
Woman of the High Plains. "If You Die, You're Dead— That's All." Texas Panhandle (1938) Dorothea Lange

88

conflicting interests have been eliminated."[5] Thus Hine, whose documentary concerns were quite different from Weston's more artistic interests, echoed Weston's faith in the photographer's ability to reveal the hidden essence of things, and voiced his own faith in the power of documentary photography.

During the Depression, the federal government, a major supporter of the photographers who documented the nineteenth-century West, again funded an ambitious program of documentary photography. In 1935, the Department of Agriculture formed a historical section of the Resettlement Administration, later known as the Farm Security Administration. Economist Roy Stryker, who headed the section, hired a talented team of photographers to help document the New Deal farm programs—among them Arthur Rothstein, Dorothea Lange, Walker Evans, and Ben Shahn (pp. 92, 95, 112, 114, 122, 123). Gradually, Stryker expanded his goal "to record on film as much of America as we could in terms of people and the land."[6] By 1943, when Stryker resigned his job, the FSA photographers had made nearly 270,000 photographs that, as Stryker said, "introduced Americans to America." Stryker wrote:

> What we ended up with was as well rounded a picture of American life during that period as anyone could get. The pictures that were used most were pictures of the dust bowl and migrants and half-starved cattle. But probably half of the file contained positive pictures, the kind that give the heart a tug.[7]

Roy Stryker dismissed Laura Gilpin's work as being "too pictorial" for his FSA project. Gilpin's photographs of Navaho life during the early years of the Depression do lack the biting edge of despair that marks the work of a contemporary like Dorothea Lange; but Gilpin's photographs are compassionate social documents, and they complement the government chronicle of rural and small-town America (pp. 94, 105, 121).

Gilpin disliked being called a "documentary" photographer because she thought the term implied a lack of attention to personal style and photographic composition. But no documentary photograph is a purely objective statement. All documentary photographers pay attention to subjective matters of both content and style as Hine acknowledged by calling his images "photo-interpretations." The FSA photographers, for example, made photographs that would satisfy Stryker's detailed shooting scripts: "What keeps the town going?"; "How do people spend their evenings—show this at varied income levels."[8] Arthur Rothstein even gave explicit directions to the subjects in his famous Dust Bowl photograph (p. 114) to enhance the drama of the scene he wanted to document.[9]

5 Lewis Hine, "Social Photography: How the Camera May Help in the Social Uplift," *Proceedings of the National Conference of Charities and Corrections* (June 1909), reprinted in Alan Trachtenberg, ed., *Classic Essays on Photography* (New Haven: Leete's Island Books, 1980), p. 111.

6 Roy Emerson Stryker and Nancy Wood, *In This Proud Land* (Boston: New York Graphic Society, 1973), p. 14.

7 Ibid., p. 9.

8 Ibid., p. 15.
9 Arthur Rothstein, "Direction in the Picture Story," *The Complete Photographer* 4, no. 21 (April 10, 1942): 1360.

Documentary photographs might also contain formal allusions to paintings. Laura Gilpin's *Navaho Madonna* makes reference to a classic theme (p. 105). Hine commented that the smiling mother in his photograph of a Russian family group at Ellis Island (p. 111) "takes a Mona Lisa view of the situation."[10] And Berenice Abbott's study of Penn Station, made as part of a Works Project Administration program to document New York City, includes the blurred form of a moving figure that suggests Marcel Duchamp's 1912 painting *Nude Descending a Staircase* (p. 102).

In documentary photographs such as these, the two central tensions in photography are most clearly revealed. On the one hand, the camera is an accurate recording device; on the other, it is a tool of creative expression. The special virtue of any great documentary photograph is that these two tensions are held in perfect balance.

10 Comment by Hine on verso of print.

PLATE 80 *Half-an-Apple* (1953) Wynn Bullock

PLATE 81 *White Door, Eureka, Nevada, 1973* (1973) Oliver Gagliani

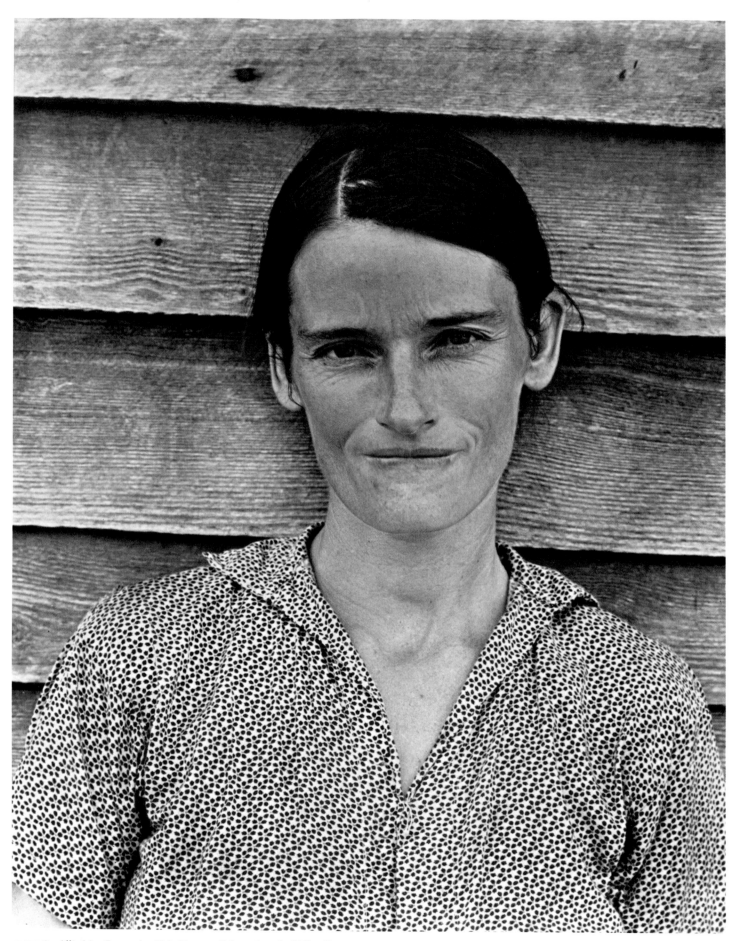

PLATE 82 *Allie May Burroughs, Hale County, Alabama* (1936) Walker Evans

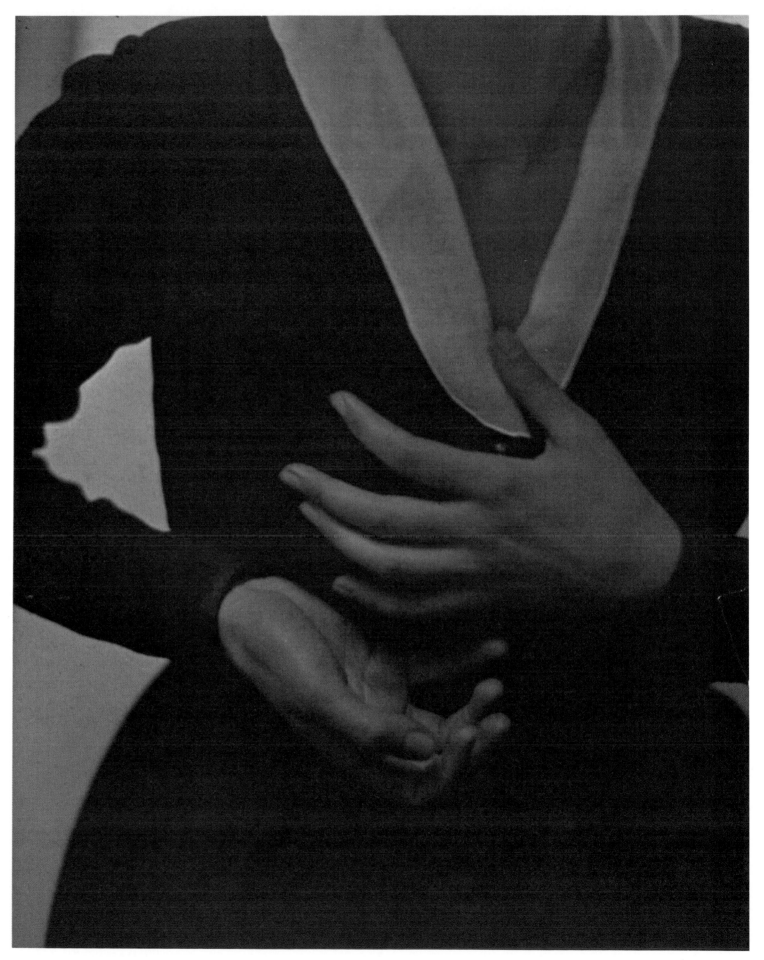

PLATE 83 [*Georgia O'Keeffe's Hands*]
(1917) Alfred Stieglitz

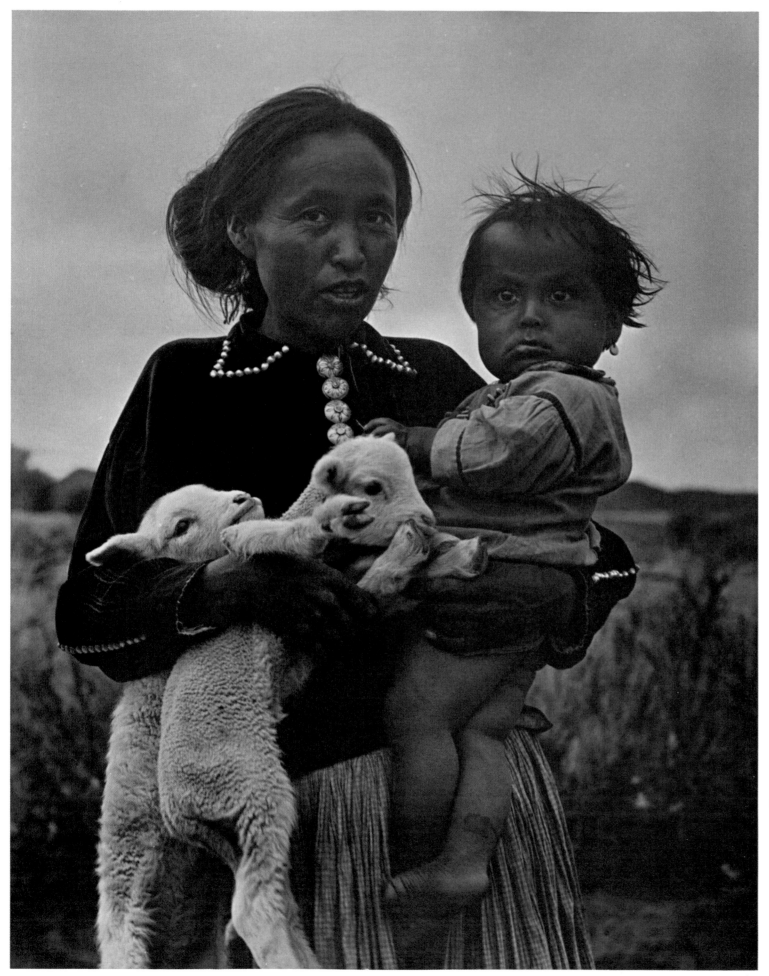

PLATE 84 *Navaho Woman, Child and Lambs*
(1931) Laura Gilpin

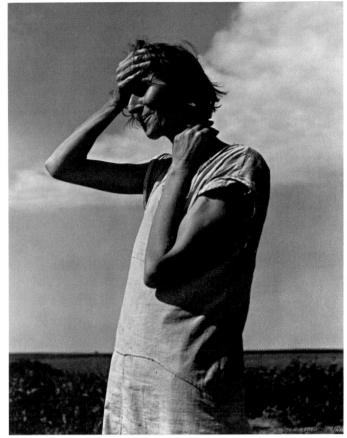

PLATE 86 *Woman of the High Plains. "If You Die, You're Dead—That's All." Texas Panhandle* (1938) Dorothea Lange

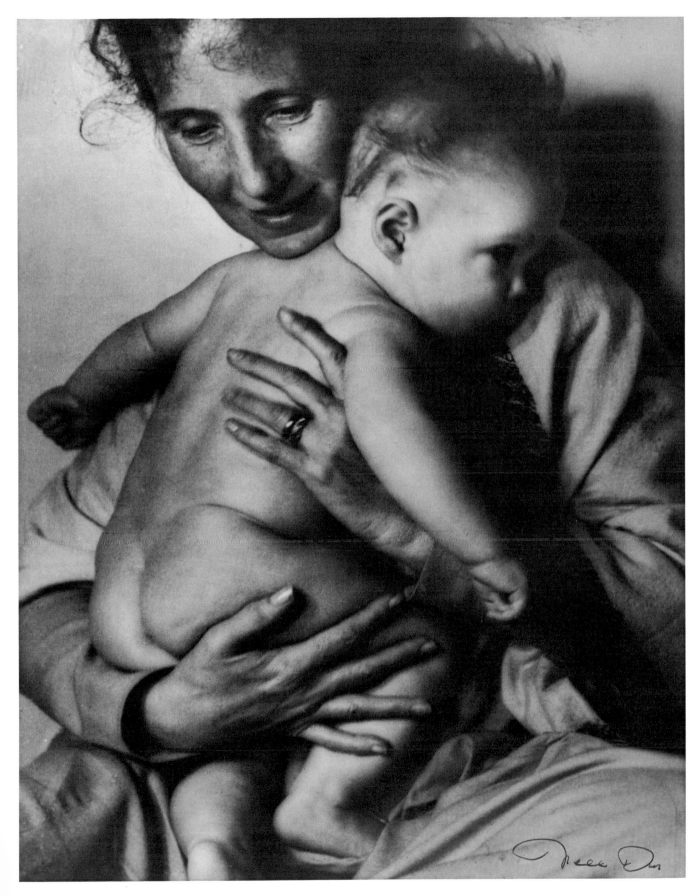

PLATE 85 *Happiness* (1940) Nell Dorr

95

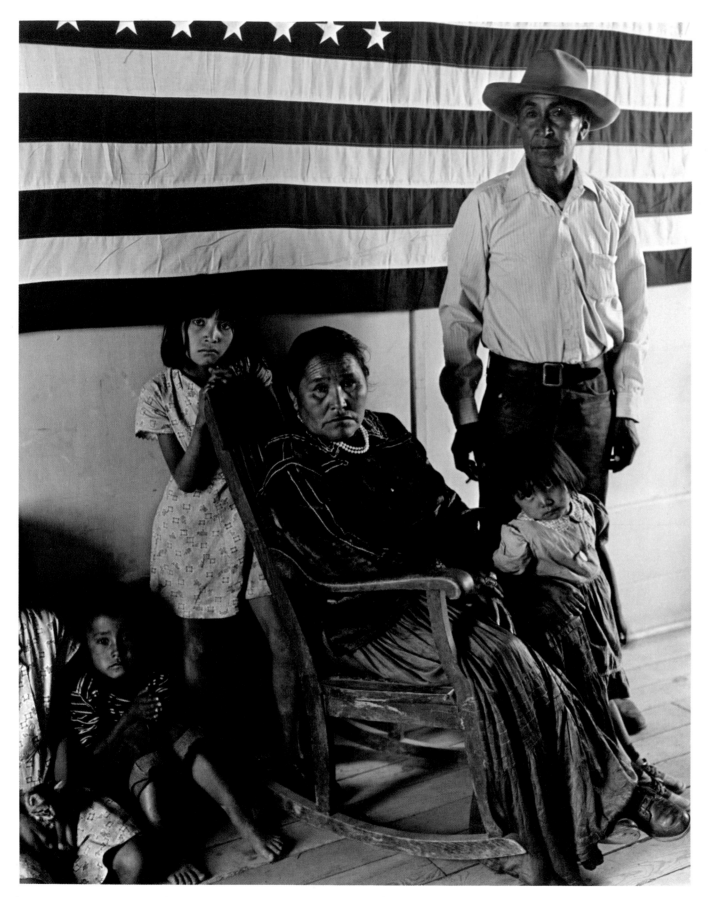

PLATE 87 *A Navaho Family* (1953) Laura Gilpin

PLATE 88 *"The World's Egg Basket" Petaluma, California 1938* (1938) John Gutmann

PLATE 89 *Before the Races* (late 1920s) Paul Grotz

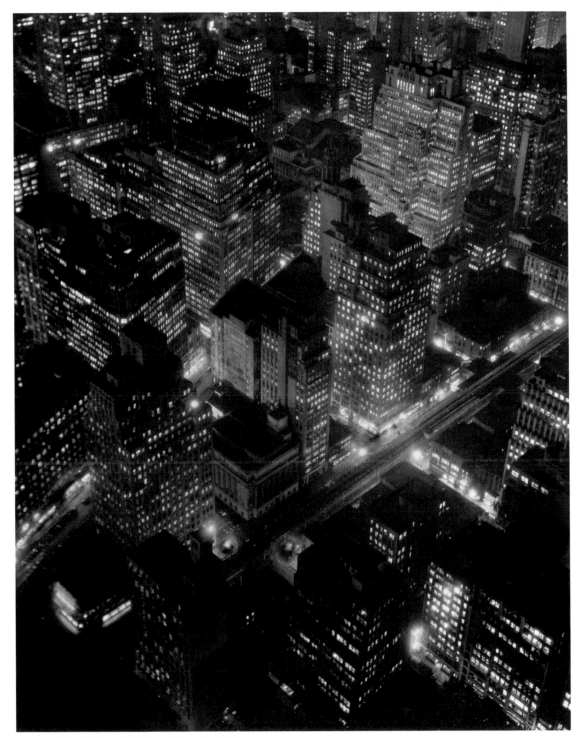

PLATE 90 *New York at Night* (1933) Berenice Abbott

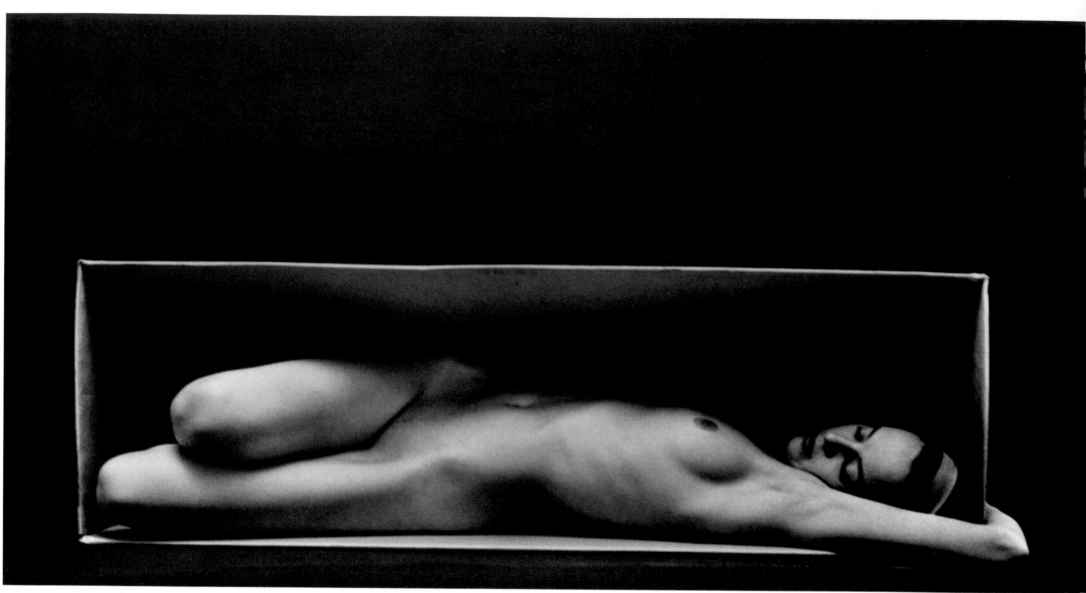

PLATE 91 *In the Box—Horizontal* (1962) Ruth Bernhard

100

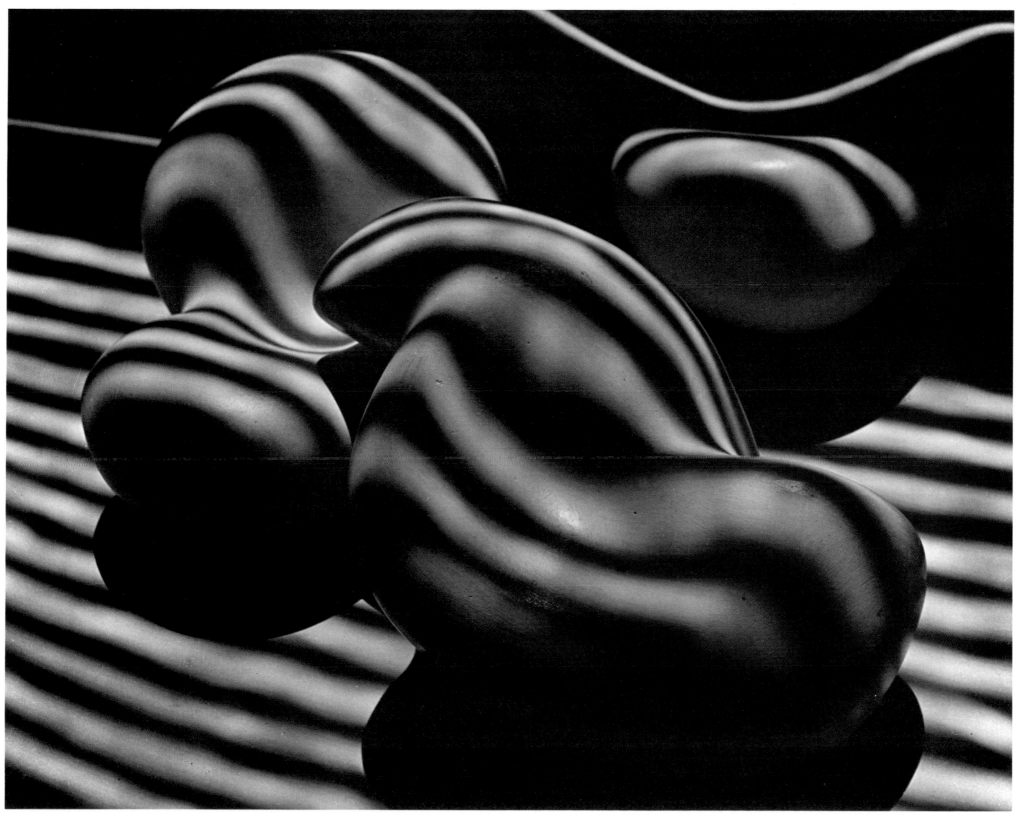

PLATE 92 *Light Follows Form* (1946) Carlotta M. Corpron

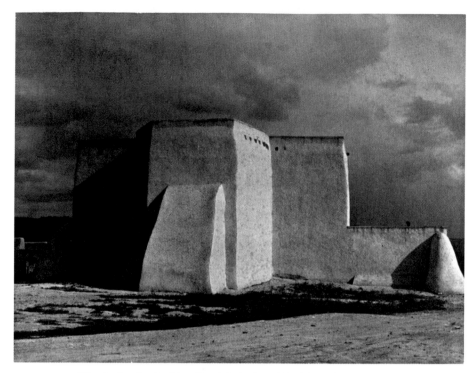

PLATE 93 *Church, Ranchos De Taos, New Mexico* (1930) Paul Strand

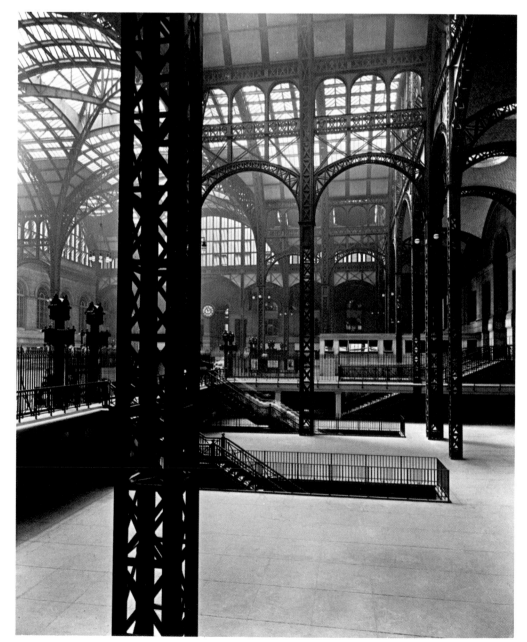

PLATE 94 *Pennsylvania Station, 1936* (1936) Berenice Abbott

102

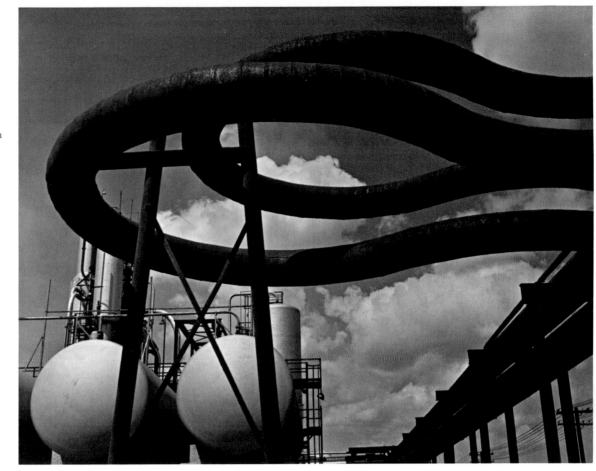

PLATE 95 *Gulf Oil, Port Arthur* (1941) Edward Weston

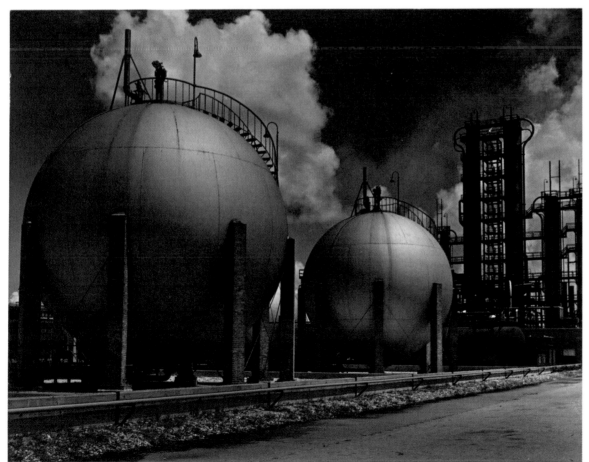

PLATE 96 *Gulf Oil, Port Arthur* (1941) Edward Weston

103

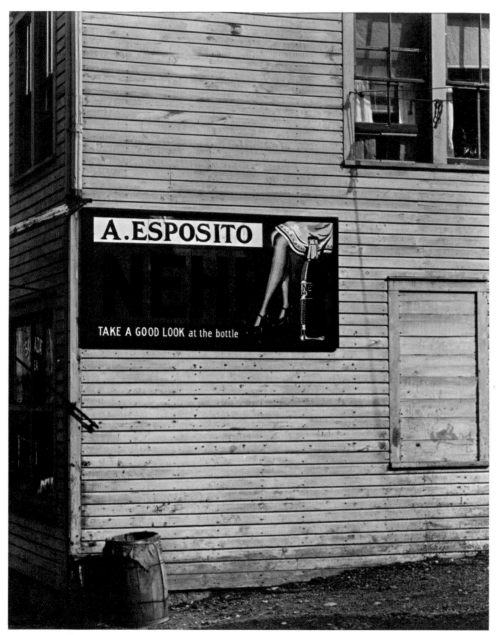

PLATE 97 *Nehi Sign on A. Esposito's Grocery* (1929) Ralph Steiner

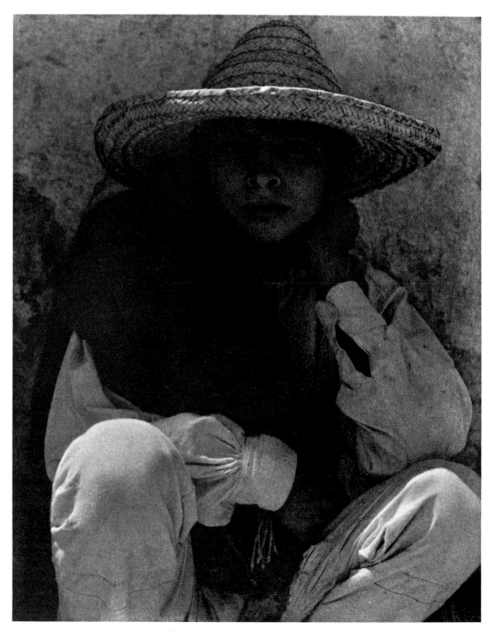

PLATE 98 *Boy. Hidalgo* (1933) Paul Strand

104

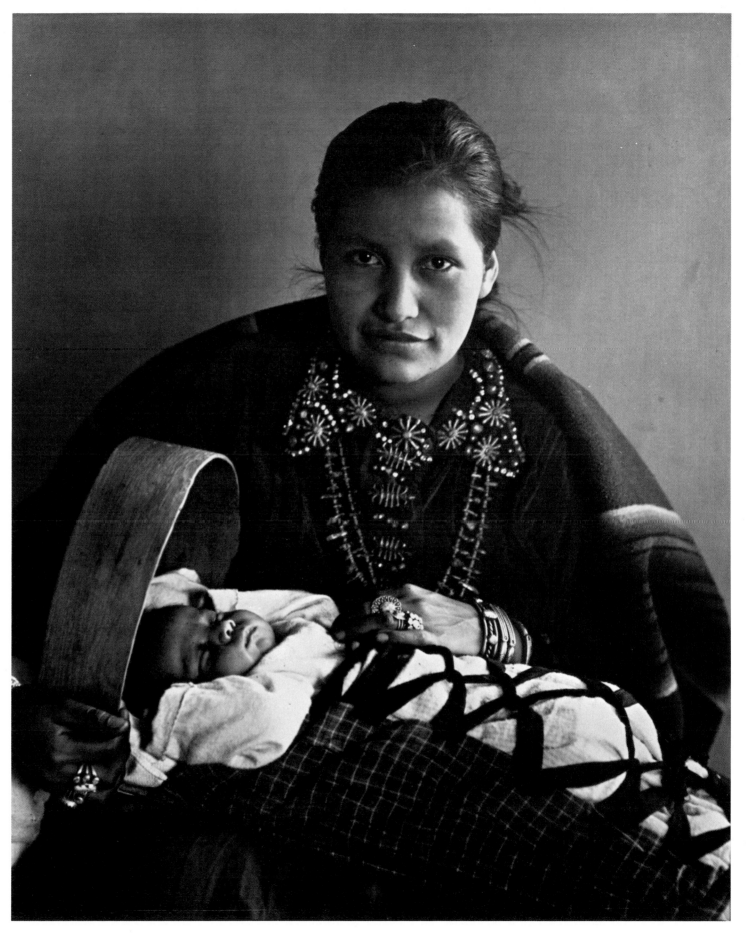

PLATE 99 *Navaho Madonna* (1932) Laura Gilpin

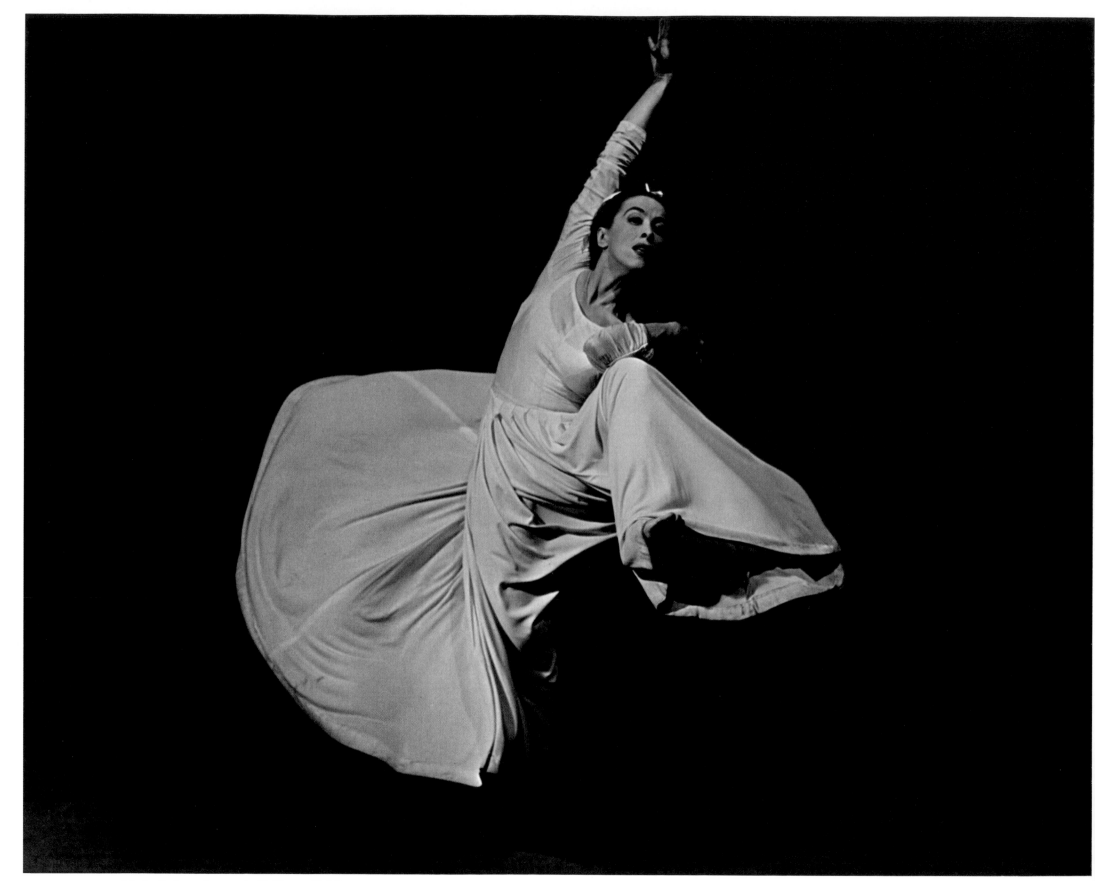

PLATE 100 *Martha Graham—Letter to the World, 1940 (Swirl)*
(1940) Barbara Morgan

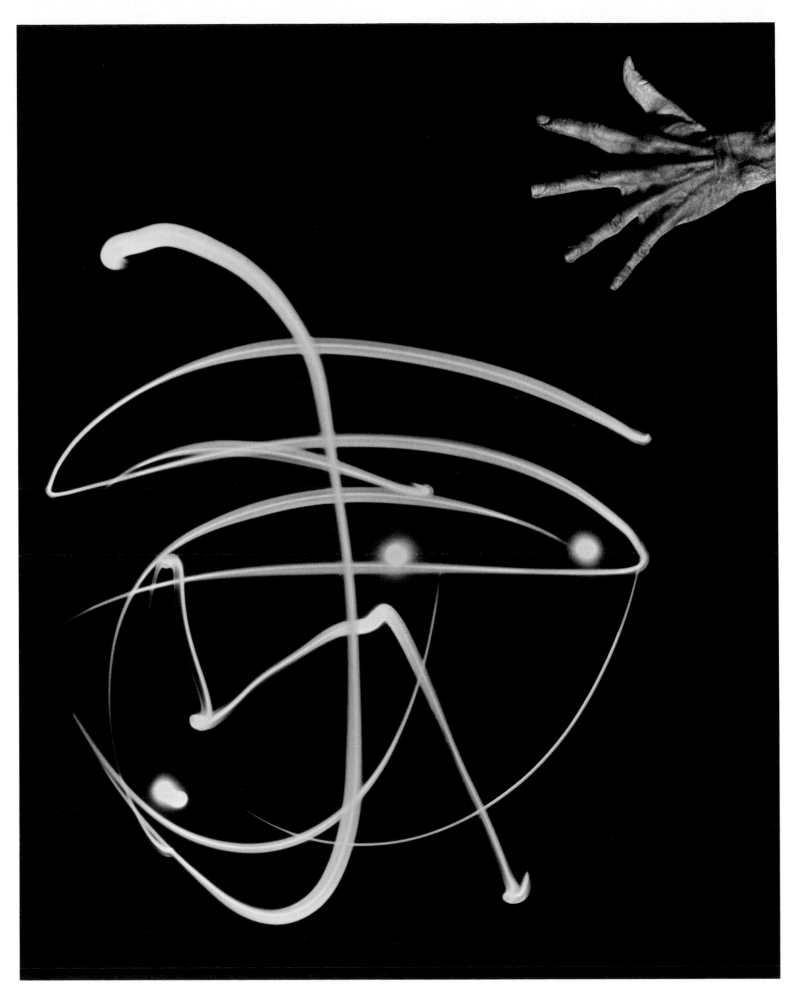

PLATE 101 *Pure Energy and Neurotic Man*
(1941) Barbara Morgan

107

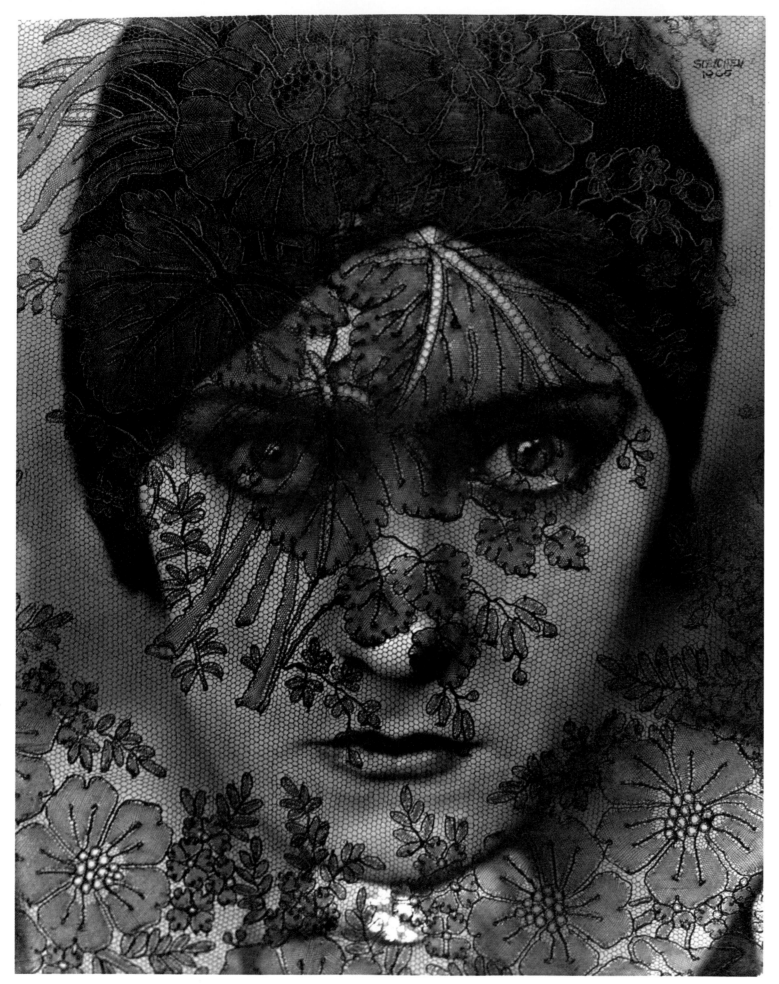

PLATE 102 *Gloria Swanson* (1924)
Edward Steichen

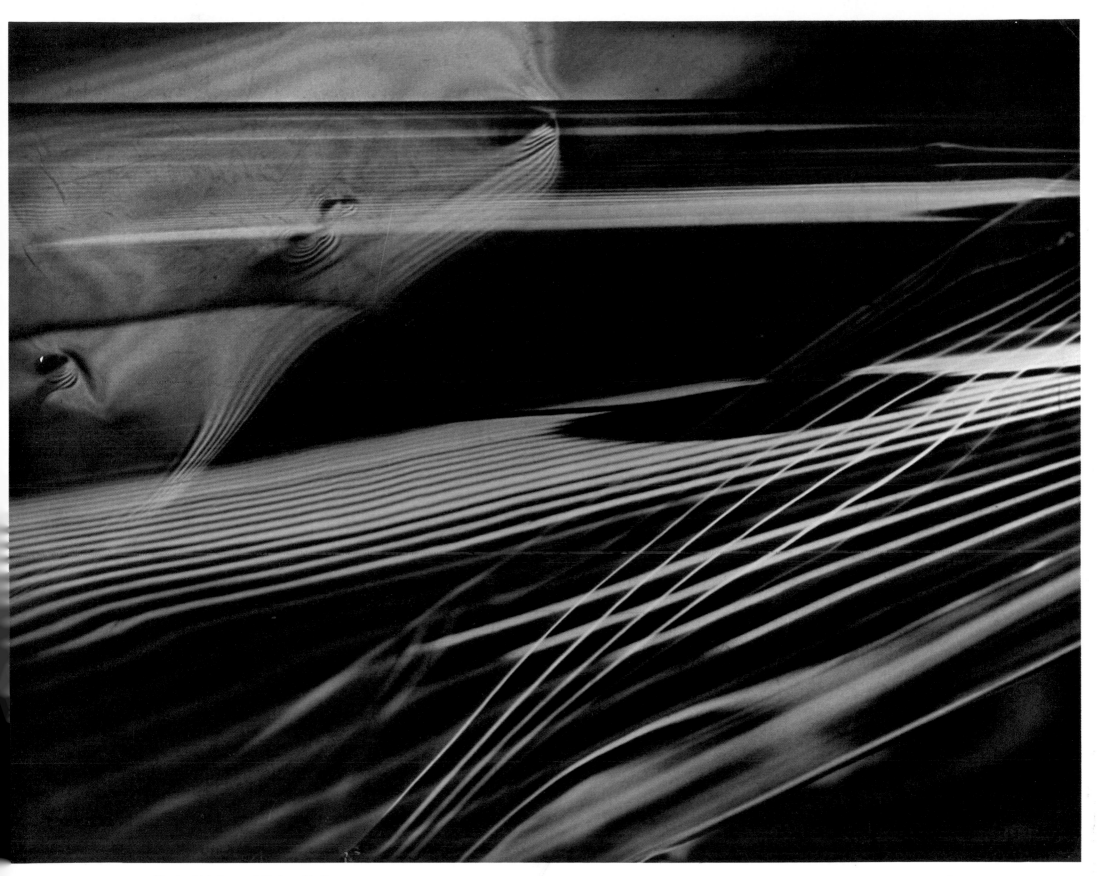

PLATE 103 *Flowing Light* (c. 1947) Carlotta M. Corpron

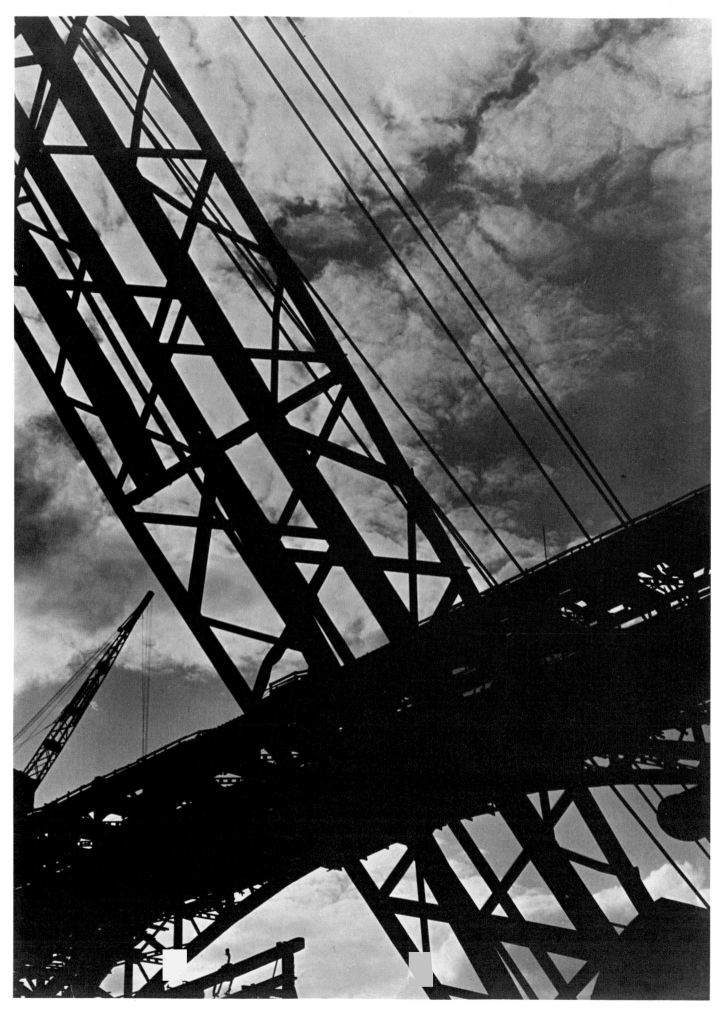

PLATE 104 *Early Russia/Dnieperstroi*
(c. 1930) Margaret Bourke-White

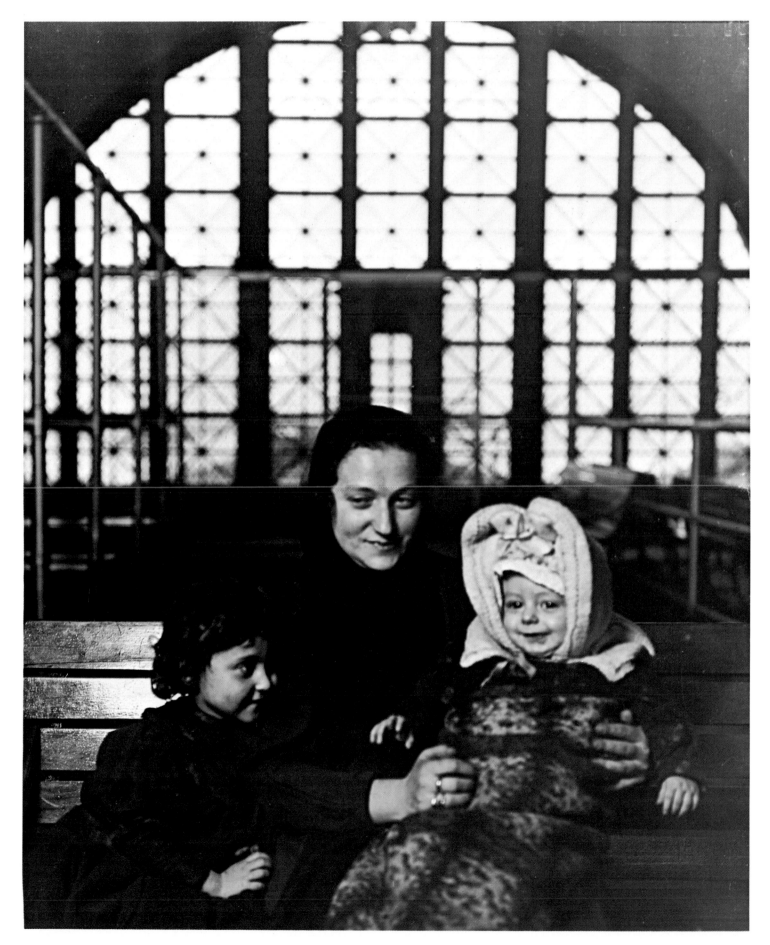

PLATE 105 *A Russian Family at Ellis Island*
(1905) Lewis Wickes Hine

111

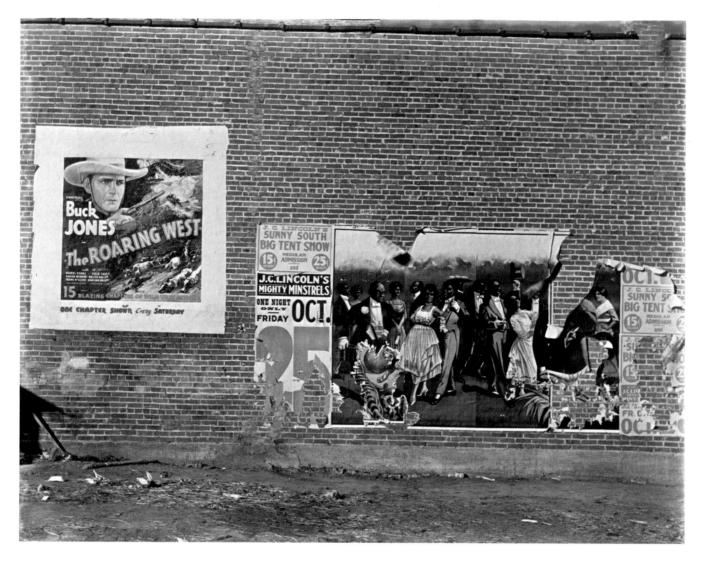

PLATE 106 *Billboard—Minstrel Show*
(1936) Walker Evans

PLATE 107 *Wicker Chair* (1929) Ralph Steiner

112

PLATE 108 *Near Waxahachie, Texas. October 1913* (1913) Lewis Wickes Hine

PLATE 109 *Bucks County Barn* (1918) Charles Sheeler

113

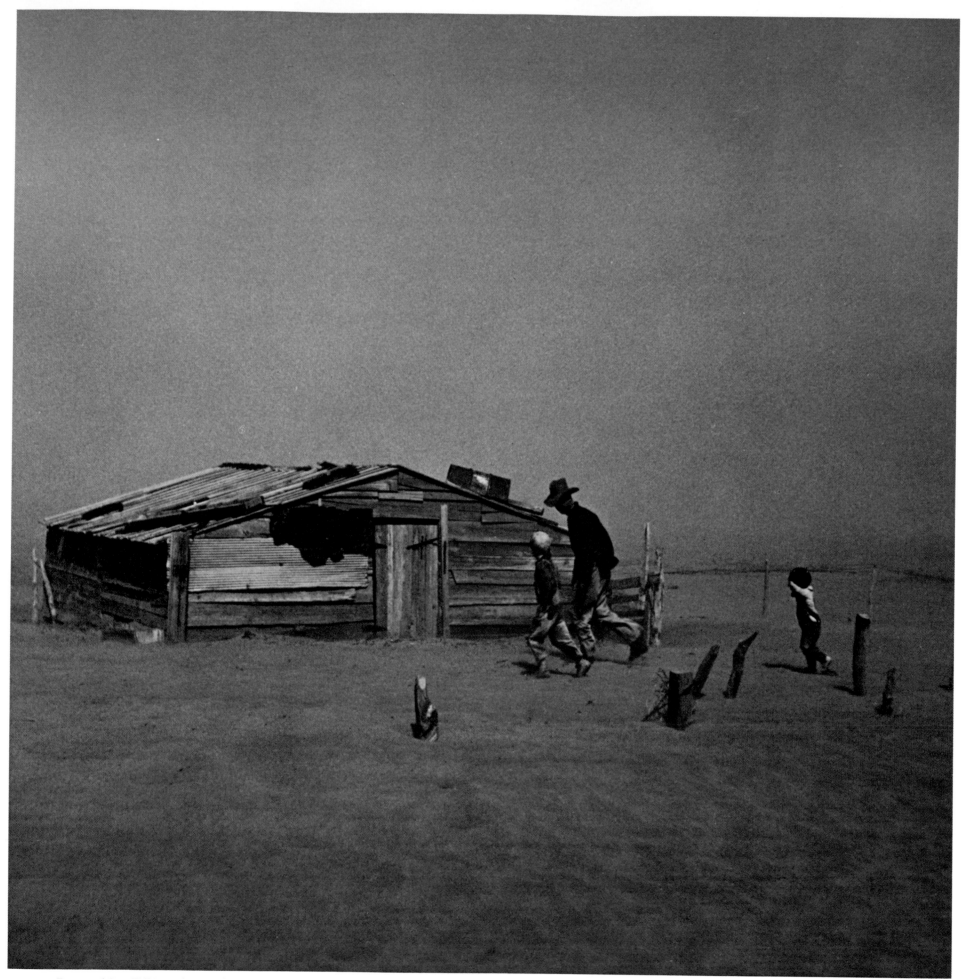

PLATE 110 *Farmer and Sons Walking in the Face of a Dust Storm* (1936) Arthur Rothstein

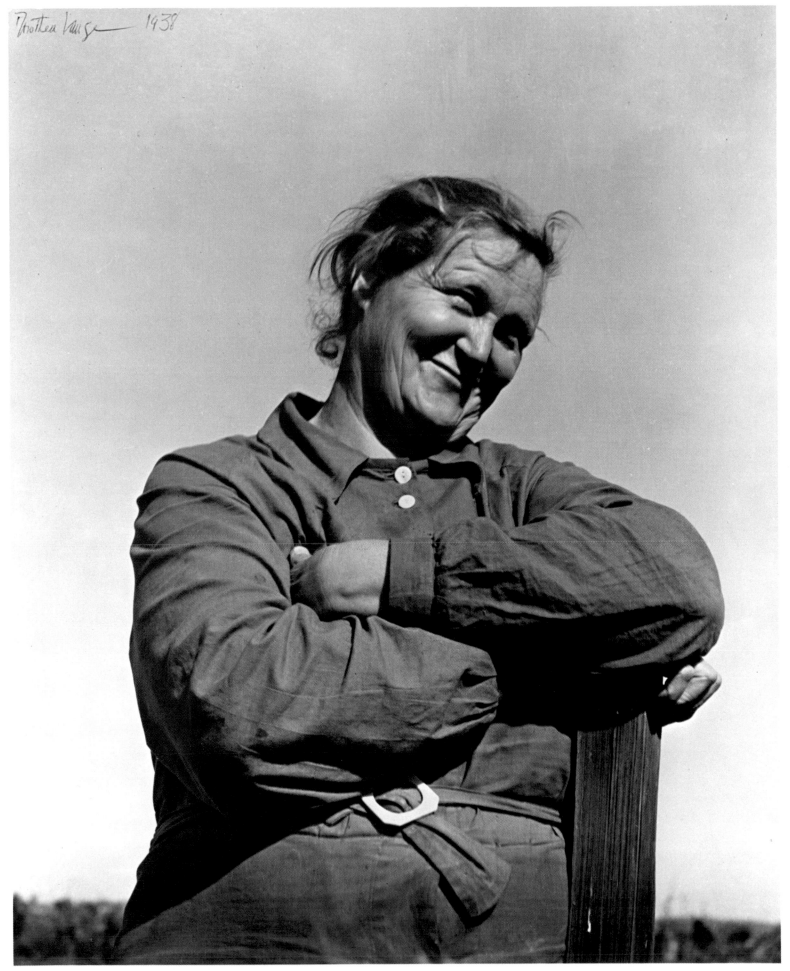

PLATE 111 *"She's a Jim-Dandy." Tulare County, California. 1938* (1938) Dorothea Lange

PLATE 112 *Bleeder Stacks, Ford Plant, Detroit* (1927) Charles Sheeler

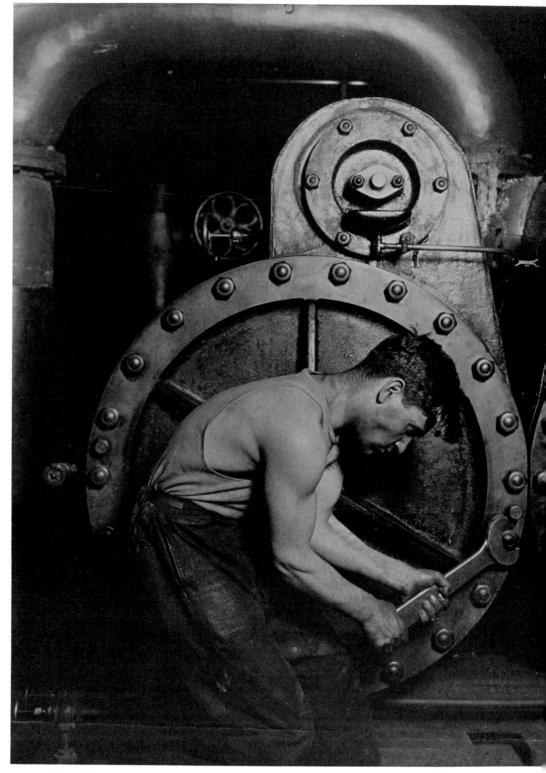

PLATE 113 [*Steamfitter*] (1921) Lewis Wickes Hine

116

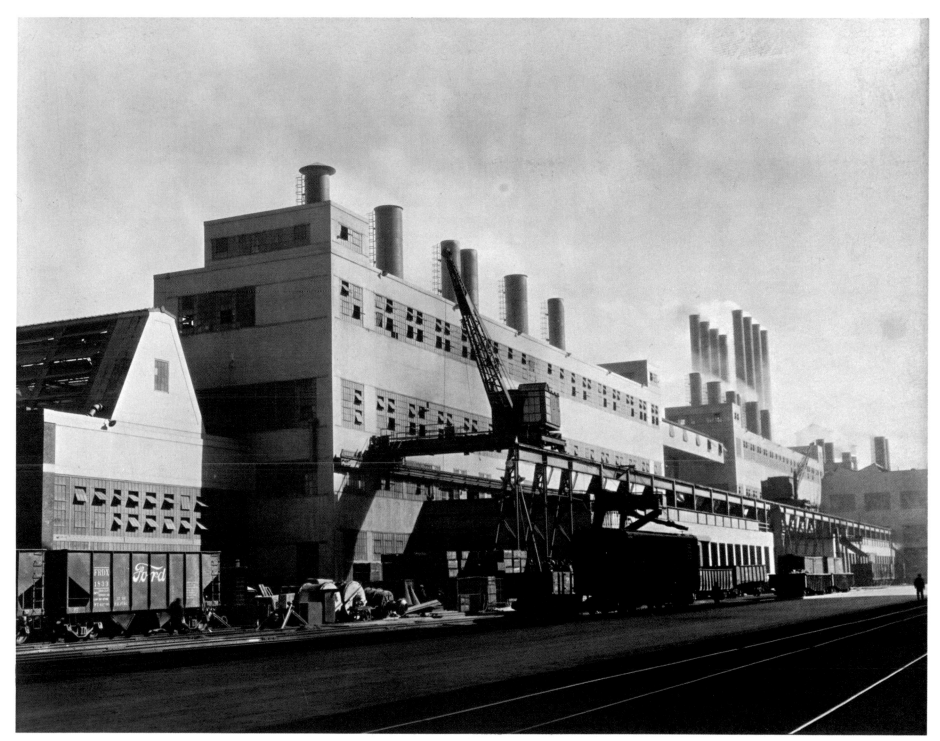

PLATE 114 *Production Foundry, Ford Plant, Detroit* (1927) Charles Sheeler

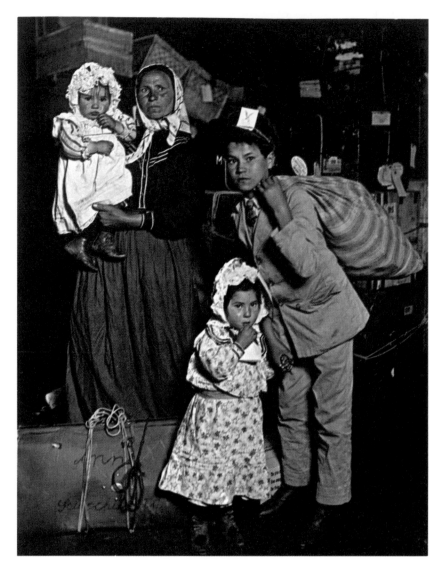

PLATE 115 *Looking for Lost Baggage, Ellis Island* (1905) Lewis Wickes Hine

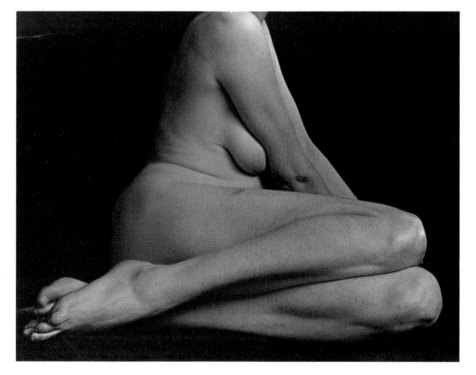

PLATE 116 *Nude* (1933) Edward Weston

118

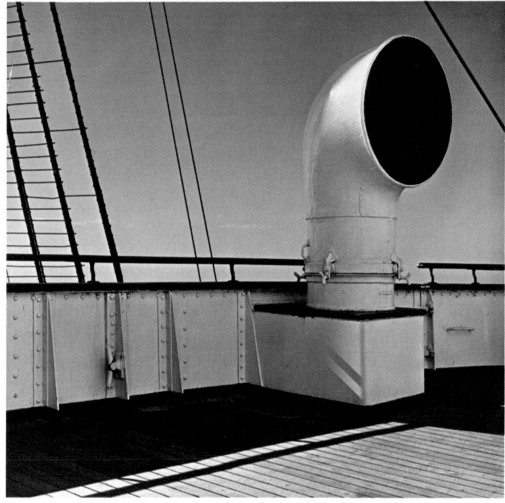

PLATE 118 *The Queen Mary* (c. 1940s) Walker Evans

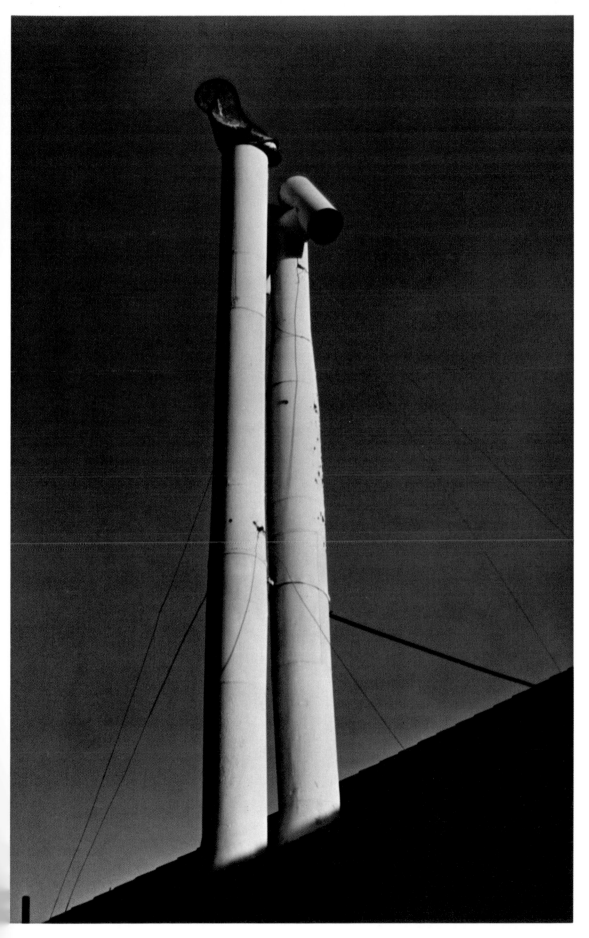

PLATE 117 *Ventilators* (c. 1930) Willard Van Dyke

119

PLATE 119 *The Open Door*
(c. 1932) Charles Sheeler

PLATE 120 *The Covered Wagon* (1934) Laura Gilpin

PLATE 121 *Northern California 1944* (1944) Dorothea Lange

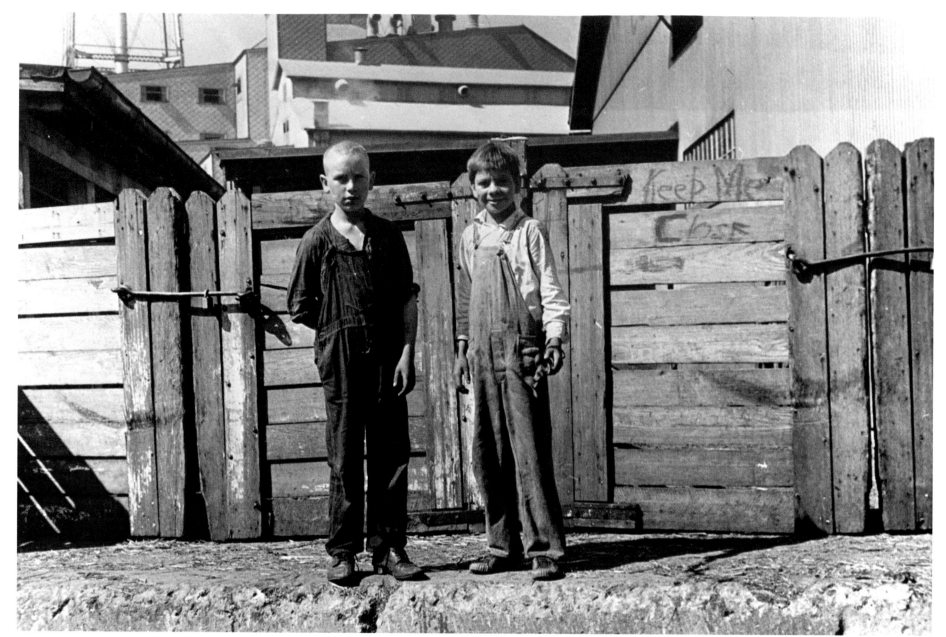

PLATE 122 *Keep Me Close* (c. 1938) Ben Shahn

122

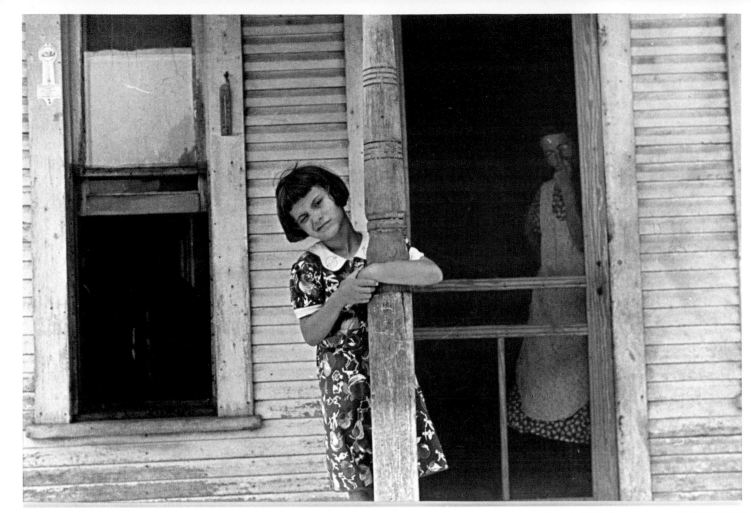

PLATE 123 *Daughter of Mr. Thaxton, Farmer near Mechanicsburg, Ohio, Summer 1938* (1938)
Ben Shahn

PLATE 124 [*Untitled, Subway Series*] (1938) Walker Evans

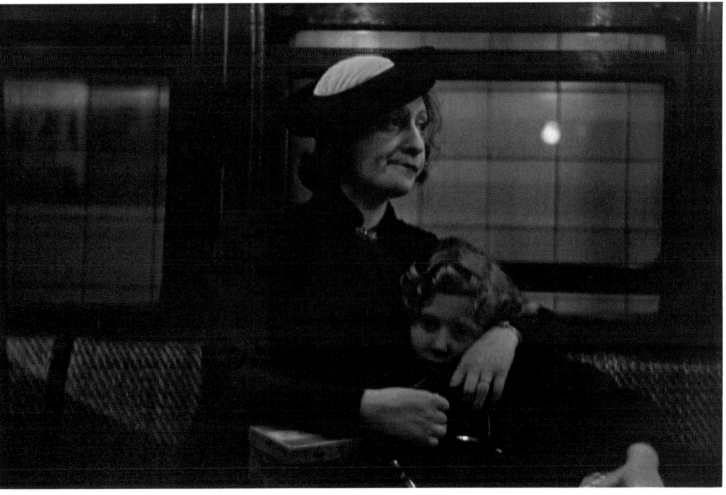

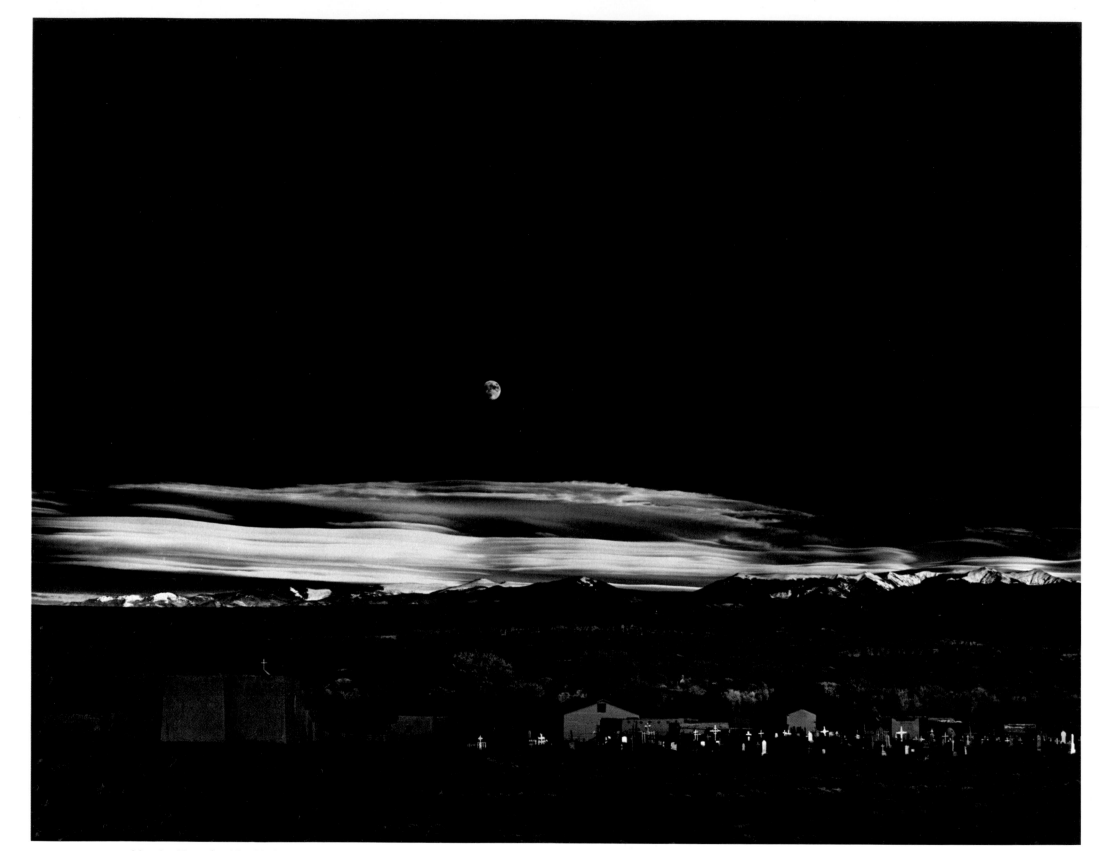

PLATE 125 *Moonrise, Hernandez, New Mexico*
(1941) Ansel Adams

The Twentieth-Century Landscape

No End to the Grandeurs and Intimacies

The great western landscape photographers of the nineteenth century sought, by and large, to convey concrete information about the land they described—its geological structure or its potential as a town site. The land they photographed was often unfamiliar, even threatening in its vast, uncharted reaches, and it was, perhaps, this sense of purpose that allowed the photographers to put fear at arm's length while they documented the features they had been sent to photograph. By the twentieth century, however, the American landscape was recognized as a less frightening and more familiar place that could easily be subjugated to a photographer's particular vision. The pictorialists at the turn of the century viewed the natural landscape as a mirror which could be made to reflect their own emotional or aesthetic ideas. Subsequent twentieth-century photographers have variously treated the landscape as a formal design problem, a grandiose stage drama, or as a metaphor for other concerns.

A viewer facing Laura Gilpin's image of Bryce Canyon (p. 127), Michael Smith's photograph of Cedar Breaks National Monument (p. 131), or Paul Caponigro's rhythmical study of a rock wall (p. 128), is uncertain of the size of the features being described. William Garnett's aerial view of plowed fields (p. 135) is even more abstract and disorienting. These photographs reduce the landscape to a formal pattern of lines and shapes, and lack the indications of scale that mark the more scientifically precise photographs of the nineteenth-century West.

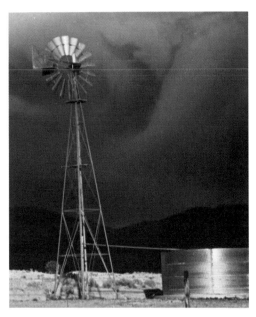

DETAIL PLATE 137
Storm near Santa Fe, New Mexico, 1965 (1965)
Liliane De Cock

The western landscape in the photographs of Ansel Adams or William Clift is a far more dramatic place, visualized as a complete scene rather than as a fragmentary pattern. Adams's photograph of the moon rising over Hernandez, New Mexico, and William Clift's picture of moonlight illuminating a cliff wall in the Canyon de Chelly are heroic photographs that celebrate the land and invest it with a kind of divine moral virtue (pp. 124, 133). Danny Lyons and Robert Adams, with their cooler, more dispassionate depictions of a decidedly undramatic landscape, undercut this notion of nature as an awesome and pristine force (pp. 126, 127). They photograph an inhabited landscape, places that are not merely regarded but used by man.

Like the pictorialists who portrayed the landscape as an external manifestation of their own ideas, other recent photographers have viewed the physical world as a metaphor for other concerns. Wynn Bullock's *Child in the Forest*, for example, describes a particular forest floor but is also a statement about the innocence of man (p. 127).

All of these photographs describe the American landscape but in different and distinct ways that reflect the hand of the individual photographer. Considered as a group, they reiterate the vitality and rich possibilities of photography as an art that can at once convey literal information and express personal style.

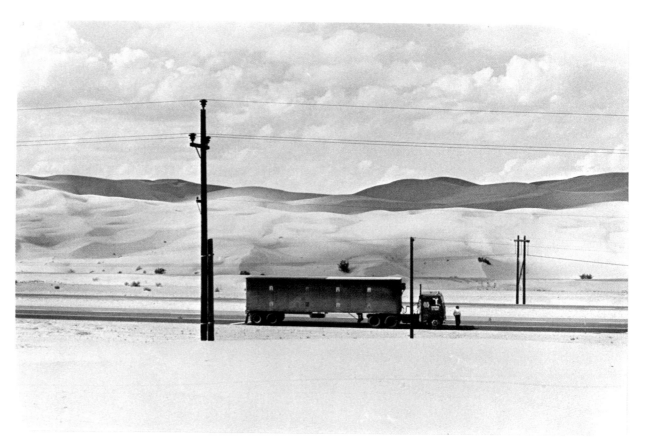

PLATE 126 *Truck in the Desert near Yuma, Arizona* (1962) Danny Lyon

126

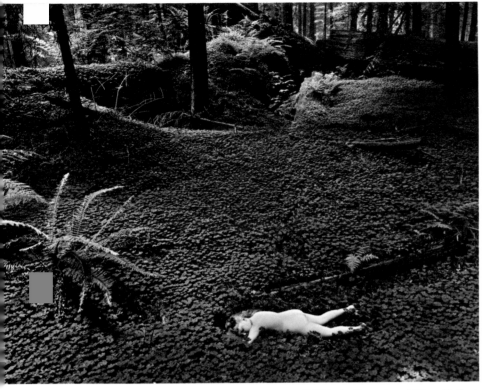

PLATE 127 *Child in the Forest* (1953) Wynn Bullock

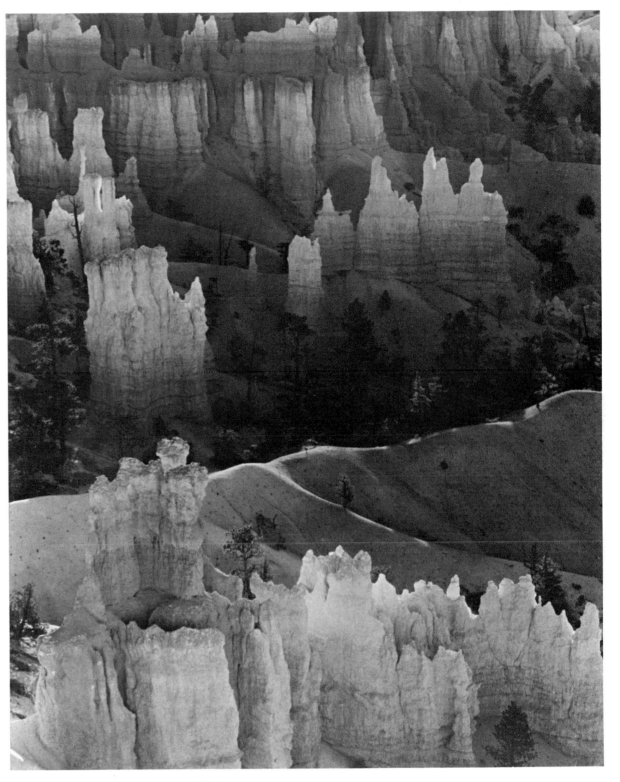

PLATE 129 *Bryce Canyon #2* (1930) Laura Gilpin

PLATE 128 *Alkali Lake, Albany County, Wyoming* (1979) Robert Adams

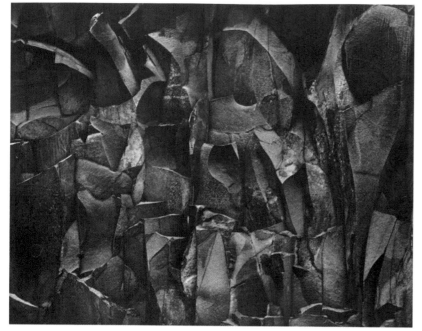

PLATE 130 *Rock, West Hartford, Connecticut*
(1959) Paul Caponigro

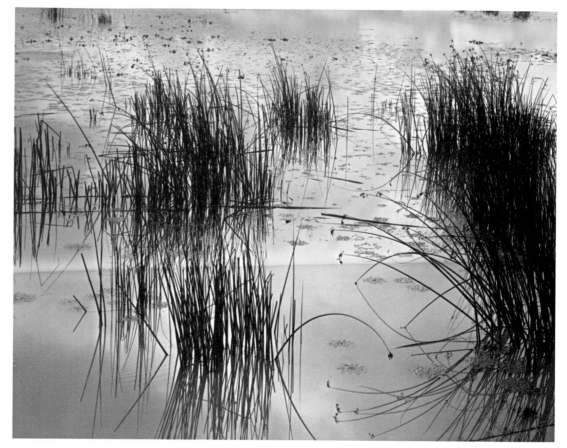

PLATE 131 *Untitled [Grasses in Water]*
(1960) Brett Weston

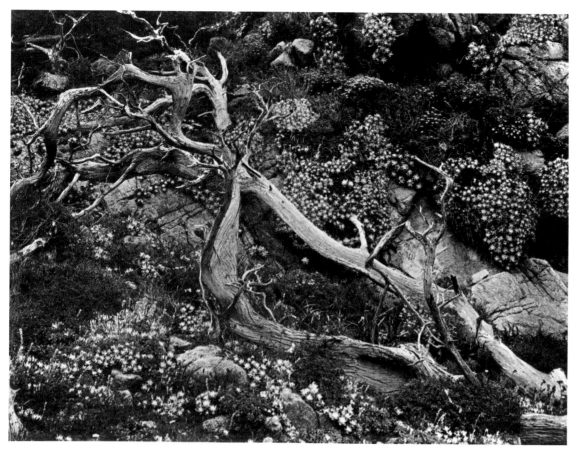

PLATE 132 *Untitled [Branch against Flowering Hillside]*
(1951) Brett Weston

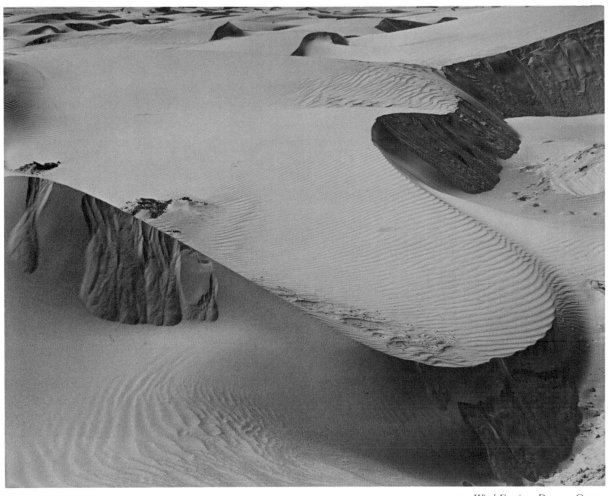

PLATE 134 *Wind Erosion, Dunes—Oceano* (1936) Edward Weston

PLATE 133 *Fog Bank* (c. 1947) Minor White

129

PLATE 135 *Storm from La Bajada Hill, New Mexico* (1946) Laura Gilpin

130

PLATE 136 *Cedar Breaks National Monument, Utah* (1975) Michael Smith

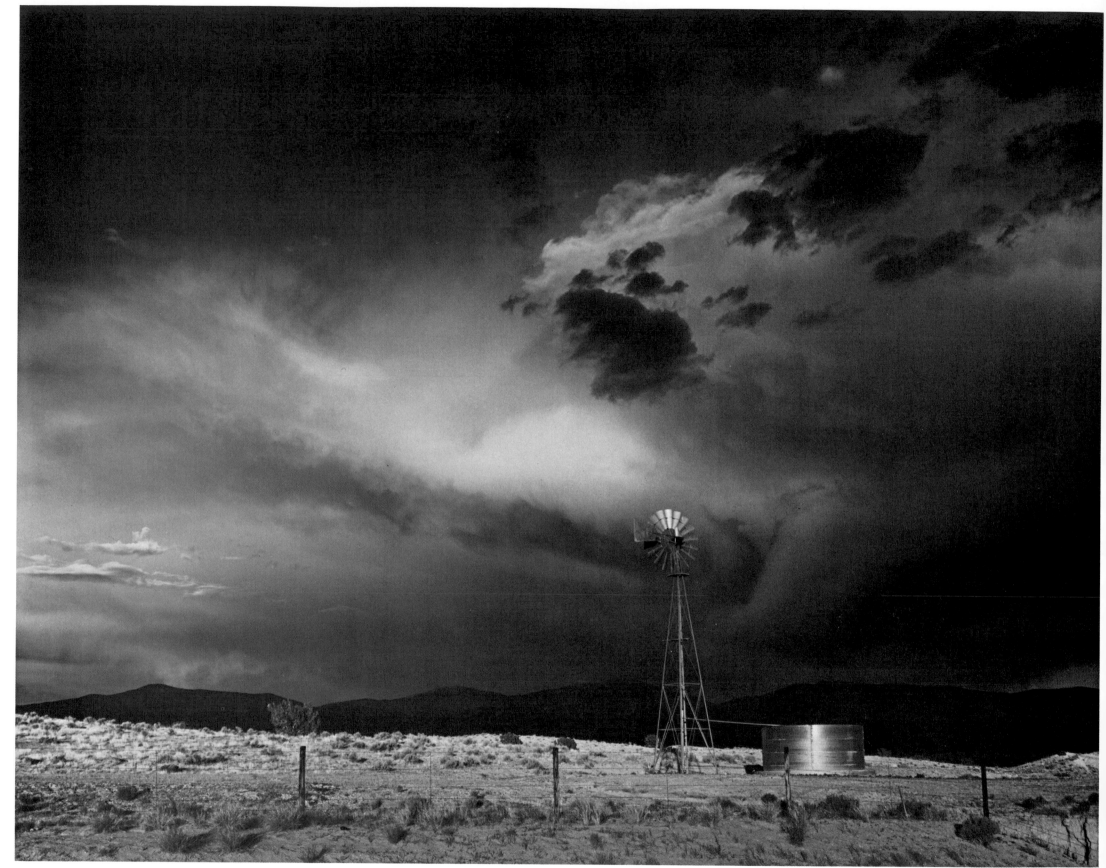

PLATE 137 *Storm near Santa Fe, New Mexico, 1965* (1965) Liliane De Cock

132

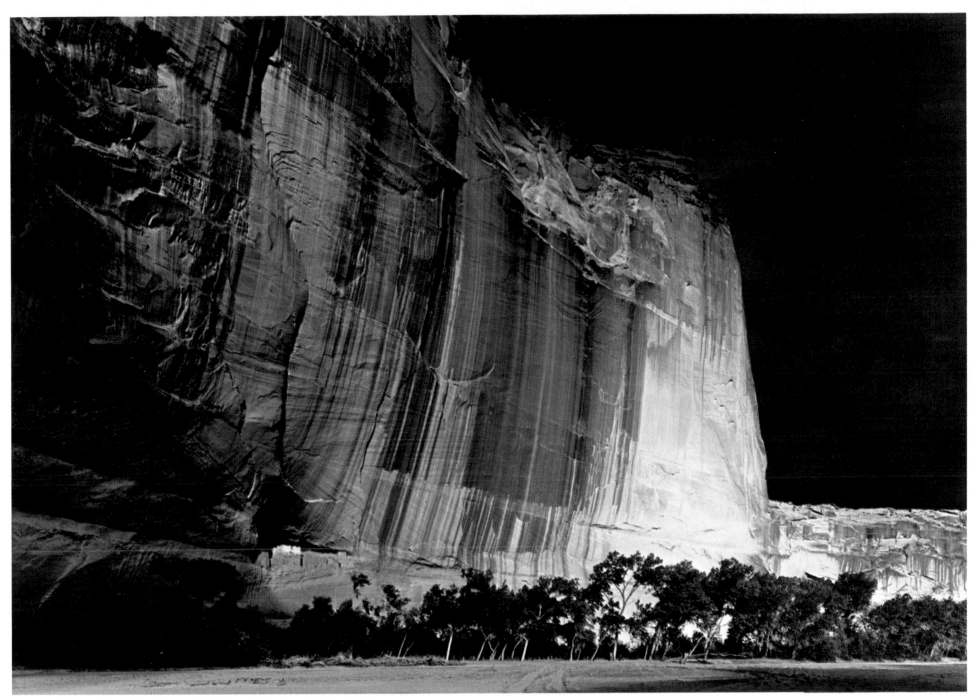

PLATE 138 *Canyon De Chelly, Arizona, White House Ruins* (1975) William Clift

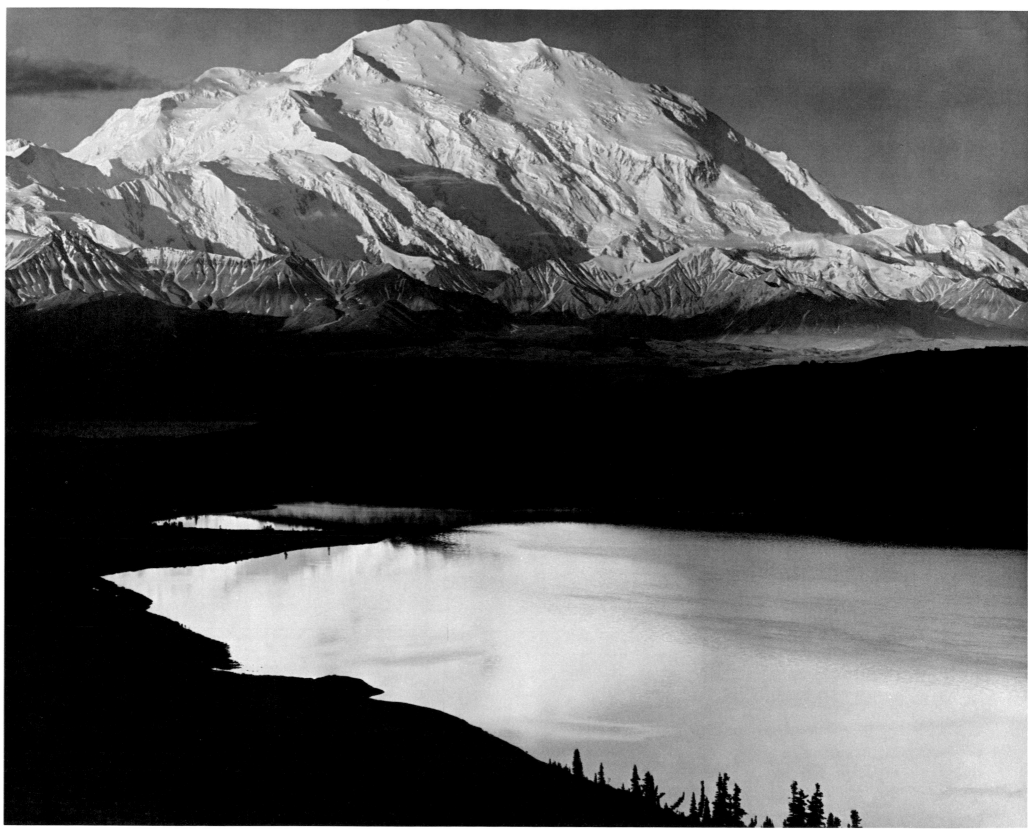

PLATE 139 *Sunrise, Mount McKinley, Mount McKinley National Park, Alaska. 1948* (1948) Ansel Adams

134

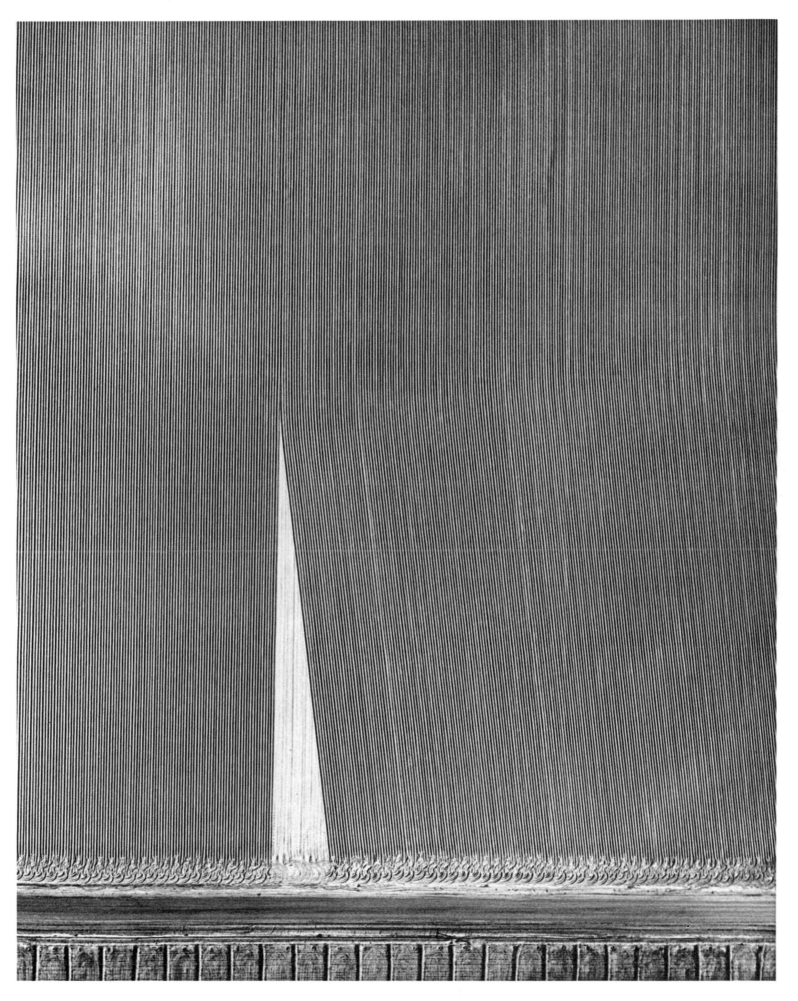

PLATE 140 *Plowed Field, Arvin, California*
(1951) William A. Garnett

CATALOGUE

by Carol Roark and Martha A. Sandweiss

Sizes shown are in inches, with vertical measurements first.
Titles in brackets are editors'.

Introduction

PLATE 1 *The Wreck of the Viscata*
Carleton E. Watkins, American (1829–1916)
Albumen silver print, 1868 (15½ × 20½)
80.33

Watkins worked extensively around the San Francisco area, compiling an inventory of popular views to market through his city gallery. The Viscata, which ran aground just outside of San Francisco Harbor on March 7, 1868, was a well-publicized and popular tourist attraction that Watkins photographed several times with both his mammoth-plate and stereo cameras.

Early Photography in America

PLATE 2 *Reverend Peter Jones (Kahkewaquonaby)*
David Octavius Hill, Scottish (1802–1870)
and Robert Adamson, Scottish (1821–1848)
Calotype, c. 1844–1846 (8 × 5⅞)
79.38

Jones, the son of a Welsh surveyor and an Ojibway Indian woman, was reared as an Ojibway. His father took him away from the tribe at the age of sixteen and had him baptized in the Wesleyan Methodist Church. He eventually became a minister and returned to spend the rest of his life as a missionary to his own people. This view, the earliest known photograph of a North American Indian, was made during a lecture tour of Scotland. Jones was photographed there by Hill and Adamson in both Indian and clerical garb.

PLATE 3 *Burial Place of Son of Henry Clay in Mexico*
Unknown photographer
Daguerreotype, 1847 (2¾ × 3¼)
81.65/40

Henry Clay, Jr., was killed during the Mexican War at the Battle of Buena Vista on February 23, 1847, buried a day or two later, and subsequently disinterred and returned to his native Kentucky. This stark photograph of his freshly dug grave is a remarkable daguerreotype, conveying a vivid sense of the harsh and bleak realities of a foreign war fought with the enthusiastic support of the American people.

PLATE 4 *Exeter, New Hampshire, Volunteers*
Unknown photographer
Daguerreotype, c. 1846 (3¼ × 4¼)
79.33

On May 13, 1846, the United States declared war on the Republic of Mexico. The two-year war, precipitated mainly by land disputes, involved 90,000 American troops—31,000 regulars and 59,000 volunteers. Though many soldiers had military portraits made before or after participating in the conflict, this is the only known view of American troops marching off to the Mexican War.

PLATE 5 *[General Wool Leading His Troops down the Street in Saltillo, Mexico]*
Unknown photographer
Daguerreotype, c. 1847 (2¾ × 3¼)
81.65/22

General John Wool and his troops were in Saltillo both before and after the battle in late February, 1847, at nearby Buena Vista, where the Americans won a decisive victory over the Mexican forces led by Santa Anna. This image of Wool and his troops was made within a moment or two of a similar, though reversed, view (probably by the same photographer) that is now in the Beinecke Library at Yale University. Together, the two images document the efforts of one of the world's earliest news photographers, deliberately recording an important event for posterity.

PLATE 6 *Colonel John Francis Hamtramck, Virginia Volunteers*
Unknown photographer
Daguerreotype with applied coloring, c. 1847 (4¼ × 3¼)
81.65/3

Colonel John Francis Hamtramck of the Virginia Volunteers was probably photographed in or around Saltillo where he served as commander of an infantry division and later as military governor during the American occupation of Mexico in 1847–48. Writer Josiah Gregg, who met Hamtramck in Saltillo, commented: "For pomposity, vanity and parade, he was not even excelled by General Wool. He was in almost the daily habit of riding about town, in full uniform, with a long tail of guard in his wake. . . ."

PLATE 7 *[James Knox Polk]*
Unknown photographer
Daguerreotype with applied coloring, c. 1849 (3¼ × 2¹¹⁄₁₆)
81.65/12

This recently discovered daguerreotype of President Polk may have been made at a portrait sitting in the White House in early 1849, shortly before Polk stepped down from office. Polk was repeatedly besieged by portrait artists during his term as president and once complained that he was "heartily tired" of the intrusions. Nonetheless, no portrait captured so well as this one the toll that the burdens of office took on this conscientious and hardworking man. With a worn and worried look upon his face, Polk seems lost in thought about his own fate and the future of his country.

PLATE 8 *Mexican Family*
Unknown photographer
Daguerreotype, c. 1847 (3¼ × 4¼)
81.65/18

*Though probably made by an American daguerreotypist,
normally employed in photographing the officers of the
American occupying forces, this portrait of a Mexican family
betrays none of the animosity one might expect towards the
representative of an invading army. More than a dozen
American daguerreotypists are known to have operated in
Mexico during the war with the United States in 1846–48.
Most were itinerants, following the American troops as they
moved from town to town.*

PLATE 9 *[Gold Mining Scene]*
Unknown photographer
Ambrotype with applied coloring, c. 1850s
(3⁷⁄₁₆ × 4¾)
81.88

*The gold rush of 1850 brought many people and a great deal
of money to California. Among those eager to take advan-
tage of the thriving business situation were practitioners of the
photographic arts. Their daguerreotypes and ambrotypes
required long exposure times, with the result that most of the
gold-rush images made were studio portraits of the miners
themselves. A number of photographers did make "views" or
outdoor scenes that showed mining camps and panning opera-
tions. Frequently, as in this case, the "gold" in the pans was
highlighted with an added touch of gold paint.*

PLATE 10 *[Woman and Child]*
Unknown photographer
Daguerreotype with applied coloring, c. 1850s
(5½ × 4¼)
70.67/2

*As one of the earliest practical photographic processes, the
daguerreotype found willing acceptance among Americans ea-
ger to have portraits of their friends and families. The 1860
census recorded 3,145 photographers, enough to supply every
large city with several studios and to service rural areas
through itinerant photographers. Daguerreotypes placed por-
trait images, previously available only to those wealthy
enough to commission an artist, within the reach of many
middle-class Americans.*

PLATE 11 *[Portrait of a Young Girl]*
Albert Sands Southworth, American
(1811–1894) and
Josiah Johnson Hawes, American (1808–1901)
Salt print, c. 1853–1862 (8 × 6)
81.85

*Best known for their daguerreotypes of influential nineteenth-
century leaders, Southworth and Hawes also produced paper*

*prints after 1853 by a process they learned from fellow da-
guerreotypist John Adams Whipple. Whether daguerreotype
or paper print, their work is distinguished by an insight
into the character of those whom they photographed. Their
work has a quality not found in the rather stiff and formal
portraits made by many early photographers who could not
transcend the technical burdens that the processes imposed.*

PLATE 12 *[Four Women]*
Unknown photographer
Ambrotype with applied coloring, c. 1857
(5½ × 4¼)
70.67/5

*The ambrotype process, patented in 1854, owed its success to
the fact that it was a less-expensive alternative to the
popular daguerreotype. Ambrotypes were made by placing
a wet-plate collodion negative in front of a dark surface
so that the resulting image looked positive. The one-of-a-
kind image was usually cased like a daguerreotype and
often sold as an "improved daguerreotype" that did not
have the bothersome reflections of the highly polished silver
daguerreotype plate.*

The Nineteenth-Century Landscape

PLATE 13 *Tower of Babel, Garden of the Gods*
William Henry Jackson, American (1843–1942)
Albumen silver print, c. 1880s (21⁵⁄₁₆ × 16¹⁵⁄₁₆)
81.47/2

*Jackson's rich view of this spectacular rock formation uses the
human figure to provide a sense of scale, a technique used
by most of the nineteenth-century landscape photographers.
As with a number of other Jackson images, this view was
widely reproduced in guidebooks that touted the spectacular
scenery around Colorado Springs.*

PLATE 14 *City of Atlanta, Georgia, No. 2*
George Barnard, American (1819–1902)
Albumen silver print, 1864 (10¹⁄₁₆ × 14¹⁄₁₆)
78.57/2

*George Barnard was the Union photographer on Sherman's
march through Georgia in 1864, near the close of the Civil*

*War. In this photograph, made as wagons prepare to accom-
pany Sherman on his march to the sea, one can see evidence of
the Union army's activities. The bank, considered a public
institution, is destroyed while the private buildings around it
are largely unharmed. The set for the city of Atlanta in
Gone with the Wind was reportedly designed from this
photograph.*

PLATE 15 *[U. S. Observatory]*
John Moran, American, born England
(1831–1903) or
Timothy H. O'Sullivan, American (1840–1882)
Albumen silver print, c. 1870–1871
(10⁹⁄₁₆ × 7¾)
81.91/6

*The Darien Expedition of 1870–71 was instructed by the
Department of the Navy to survey the entire Isthmus of
Darien (Panama) and make recommendations on the most
feasible route for a canal. Astronomical observations were
made to determine the coordinates of specific sites against
which survey data from the unknown interior could be com-
pared. O'Sullivan was the photographer on the 1870 trip,
but the exact location of this observatory is unknown; and it
is also possible that Moran made the photograph when he
was there in 1871.*

PLATE 16 *Island, Limon Bay*
John Moran, American, born England
(1831–1903)
Albumen silver print, 1871 (7⅞ × 11³⁄₁₆)
81.91/11

*John Moran, brother of the landscape artist Thomas Moran,
was the official photographer on the 1871 portion of the
Darien Expedition. Limon Bay, on the Pacific side of the
isthmus, was to be the western terminus of the proposed canal,
and Moran made numerous photographs documenting the
shoreline, rocks, and tides. The canal as it was actually built
did not use this route but crossed a section of the isthmus
further north, following the route of an existing railroad track.*

PLATE 17 *Chipeta Falls, Black Cañon of the
Gunnison*
William Henry Jackson, American (1843–1942)
Albumen silver print, 1883 (17 × 21)
71.94/23

*Chipeta Falls, named for the squaw of the Ute Indian Chief
Ouray, flowed only during the spring when heavy winter
snows melted. In this photograph, made to advertise the scen-
ery along the Denver and Rio Grande Railway, Jackson
posed his crew and traveling companions in an idyllic setting.
The large boxes on the flatcar contain the huge sheets of
glass necessary for his mammoth-plate negatives.*

PLATE 18 *[Niagara Falls]*

George Barker, American (active late 19th century)

Albumen silver print, 1888 (19⁵⁄₁₆ × 16½)

81.79

Active mainly in the vicinity of Niagara Falls, Barker was one of a number of photographers who catered to the public's desire to own pictures of dramatic and exotic places. In addition to scenic views of notable tourist attractions, Barker photographed sporting events, natural disasters, and sentimental views of home life. Many of his images were stereographs, designed to satisfy the armchair traveler.

PLATE 19 *San Francisco Mountains*

John K. Hillers, American, born Germany (1843–1925)

Albumen silver print, c. 1870s (13⅛ × 9⅞)

75.103/30

"Jack" Hillers originally joined John Wesley Powell's federally funded survey of the Grand Canyon country as a boatman, but he eventually became the expedition's chief photographer. The San Francisco Mountains, 12,000-foot-high volcanic peaks located in north central Arizona in the Colorado River basin, were observed by Hillers and members of the Powell survey crew several times during the 1872 season, but it is not known when this view was made.

PLATE 20 *Gibbon Falls, 84 Feet, Yellowstone National Park*

Frank Jay Haynes, American (1853–1921)

Albumen silver print, c. 1884 (17 × 21½)

71.9/1

In 1881, Haynes asked the Department of the Interior to appoint him as the official photographer of Yellowstone National Park. The Department responded by granting him a tract of land on park property from which he could operate his photographic concession. Numerous portraits of tourists, stereographic views of the attractions, and impressive studied compositions depicting the magnificent scenery—like this mammoth-plate view of the falls on the Gibbon River—were sold through the park studio.

PLATE 21 *Yosemite Stage by the Fallen Monarch. Mariposa Grove, 1894*

I. W. Taber, publisher, American (1830–1912)

Platinum print, 1894 (7³⁄₁₆ × 9⁵⁄₁₆)

81.51

The Mariposa Grove of giant sequoia trees has long been one of the most popular tourist attractions in the Yosemite Valley. In 1894, a visit to the Grove required a round-trip stagecoach ride over 80 miles long on dusty, deeply rutted roads. In this photograph, tourists pose atop the 28-foot-diameter trunk of a downed redwood called the "Fallen Monarch."

PLATE 22 *Mount Shasta from Sheep Rocks*

Carleton E. Watkins, American (1829–1916)

Albumen silver print, 1870 (8½ × 12⅜)

75.94/11

In 1870, Watkins joined Clarence King's United States Geological Exploration of the Fortieth parallel for the purpose of photographing California's Mt. Shasta and Lassen's Butte. Though trained as a geologist, King had a profound interest in art. An admirer of the English writer John Ruskin, he shared Ruskin's belief that a great artist must have an intimate knowledge of the sciences and be attuned to the divinity of nature. King personally selected Watkins as a photographer whose images would both document a site and express his Ruskinian point of view.

PLATE 23 *Cañon of The Rio Las Animas*

William Henry Jackson, American (1843–1942)

Albumen silver print, c. 1884 (21 × 17)

71.94/18

The railroad route through the Cañon of the Rio Las Animas from Durango to Silverton, Colorado, was an amazing engineering feat, sledge-hammered and blasted out of the rocky canyon walls in 1882. Jackson probably photographed this dramatic section of track along the Rockwood Ledge more than any other area along the Denver and Rio Grande Railway route. Here, a pair of elk antlers marks the special train Jackson used on railroad business.

PLATE 24 *[Watkins' Photographic Wagon along the C.P.R.R. Tracks, Utah]*

Carleton E. Watkins, American (1829–1916)

Albumen silver print, c. 1874 (6 × 7)

81.64/1

Watkins and the painter William Keith made their Utah excursion during the winter of 1873–74 with Watkins' photographic wagon riding piggyback on a Central Pacific Railroad car. Once the car had been parked on a siding, Watkins could use his wagon to explore scenery away from the track. This view, which shows the wagon, was made from a normal rectangular negative masked to print an oval image.

PLATE 25 *Mariposa Grove of Mammoth Trees, William H. Seward, 85 Feet in Circumference, 268 Feet High*

Eadweard Muybridge, American, born England (1830–1904)

Albumen silver print, 1872 (16⅞ × 21½)

72.32/5

Muybridge's Yosemite view illustrates splendidly the tenets of nineteenth-century Romanticism. The artists of the romantic school depicted the American landscape as a noble place, imbued with moral virtues that could inspire awe and respect from man. In this photograph, it is clear that man, represented by the figure with the tiny axe, is no match for the sublime splendor of Nature.

PLATE 26 *The Half-Dome from Glacier Point, Yosemite*

Carleton E. Watkins, American (1829–1916)

Albumen silver print, c. 1866 (8¼ × 12⅛)

75.94/19

When Watkins first visited Yosemite in 1861, he photographed mainly from the valley floor because it was almost impossible to transport his cumbersome equipment up the steep mountains. Returning in 1865 and 1866 in the employ of the California State Geological Survey, he took advantage of new, crudely cut trails to make sweeping vistas of the valley's geological features.

PLATE 27 *Perched Rock, Rocker Creek, Arizona*

William Bell, American (1836–1902)

Albumen silver print, 1872 (10⅞ × 8)

76.142/15

The Philadelphian William Bell served as photographer on the 1872 Wheeler Survey. This survey, begun in 1871 and headed by Lt. George M. Wheeler, sought to document topographical features in Utah, New Mexico, Arizona, and Nevada from a military point of view. Bell photographed "Perched Rock" to illustrate Samuel F. Emmon's geological theory that all changes in the earth's surface take place through movement—in this case the effects of wind. Nevertheless, the rock is portrayed in an artistic manner as though it was a portrait of a person or a study of a piece of sculpture.

PLATE 28 *Embudo, New Mexico*

William Henry Jackson, American (1843–1942)

Albumen silver print, c. 1880s (20¹¹⁄₁₆ × 16⁵⁄₁₆)

71.94/12

Embudo, New Mexico, the site of an abandoned Indian pueblo, is located on the southern extension of the Denver and Rio Grande Railroad, a company that frequently employed Jackson to make scenic views along its routes. By the time that Jackson made this photograph, the arid land was used mainly for ranching.

PLATE 29 *Vernal Fall. 350 Feet*

George Fiske, American (1835–1918)

Albumen silver print, c. 1879–1881 (7⅛ × 4⁵⁄₁₆)

80.57/7

A onetime employee of Carleton Watkins, Fiske also made his own views, concentrating on scenery around California and in Yosemite Valley. Fiske and his wife lived in Yosemite Valley off and on for nearly forty years, marketing a series of winter and summer views of "Yosemite and the Big Trees." The small size of this picture was typical for Fiske, and it contrasts with the grand, mammoth views favored by other Yosemite photographers.

PLATE 30 *The Summit of Lassen's Butte*
Carleton E. Watkins, American (1829–1916)
Albumen silver print, 1870 (8½ × 12⁷⁄₁₆)
75.94/15

Clarence King believed that catastrophism, a theory that violent geological and biological catastrophes rather than gradual Darwinian evolution, explained the development of life on earth. The dramatic rock formations of Lassen's Butte, explored during the Fortieth Parallel Survey in 1870, provided interesting subject matter for Watkins as well as seeming confirmation of King's theories.

PLATE 31 *Hercules' Pillars—Columbia River, Oregon*
William Henry Jackson, American (1843–1942)
Albumen silver print, n.d. (16½ × 20¾)
71.22/56

Twenty-seven miles east of Portland, Oregon, the Union Pacific Railroad passes between two gigantic rock formations known as the Pillars of Hercules. Their immense scale is demonstrated by the fact that the wind-disheveled fir tree growing from the top of the taller rock is forty feet high.

PLATE 32 *Cañon De Chelle. Walls of The Grand Cañon about 1200 Feet in Height*
Timothy H. O'Sullivan, American (1840–1882)
Albumen silver print, 1873 (8⅛ × 10⅞)
76.142/21

O'Sullivan photographed the Cañon de Chelle during the 1873 season of the Wheeler Survey. Even though the objective of survey photography was to document topography and advertise the survey's accomplishments so that it would receive additional funding, this view of the 1200-foot-high canyon walls cannot help but inspire awe. O'Sullivan uses the tiny cluster of expedition tents on the canyon floor to give a sense of the canyon's majestic scale.

PLATE 33 *Flooded Meadow*
Willard Worden, American (1873–1946)
Toned platinum print, c. 1902 (7 × 5)
79.84/1

Willard Worden was a San Francisco photographer, most often remembered as the official photographer of the Panama-Pacific Exhibition. Most of his views were San Francisco street scenes, including a number of photographs made during the 1906 earthquake. He also made views in the Sierra Nevada and along the Pacific Coast. This view shows the Pillars of Hercules on the Columbia River in Oregon, a site also photographed by Watkins and Jackson. Although Worden's work can be linked to the nineteenth-century landscapes of such men, he also demonstrated a pictorialist aesthetic in presenting a tranquil and flawless world.

PLATE 34 *East Rush, L.V.R.R.*
William Herman Rau, American (1855–1920)
Albumen silver print, c. 1900 (17 × 20⁷⁄₁₆)
82.9/1

Even though nineteenth-century photographic landscapes generally bring to mind the work of western explorer-photographers, many photographers, including the Philadelphian William Rau, were also active in the East. Rau's father-in-law was the survey photographer William Bell, and the two established a Philadelphia studio together in 1877. Following the precedent of western railways, the Lehigh Valley Railroad hired Rau in 1899 to produce a portfolio of views, including this photograph, along their route from Perth Amboy to Niagara Falls and Buffalo.

PLATE 35 *A Glimpse of Guanajuato, Mexico*
William Henry Jackson, American (1843–1942)
Albumen silver print, c. 1883–1884
(16¹⁵⁄₁₆ × 21⁵⁄₁₆)
81.47/1

Jackson's first trip to Mexico was commissioned by the Mexican Central Railway in 1883. Trips in this and subsequent years provided material for both publicity views and an album of Mexican scenes published by Jackson. Guanajuato, which lies 180 miles northwest of Mexico City, was the subject of this mammoth-plate view, which was published (as were many Jackson views) as a wood engraving in Harper's Weekly illustrating an article on the beauty of the region.

PLATE 36 *Pueblo De Taos, New Mexico*
William Henry Jackson, American (1843–1942)
Albumen silver print, c. 1883 (17 × 21)
71.94/15

Jackson's mammoth-plate view of the picturesque Taos Pueblo reflects his superb skills of composition. The staggered tiers of the Pueblo balance the sensitive study of figure, light, and shade in the foreground, creating an image in which the placid and serene sense of place draws its strength from careful, artistic composition.

PLATE 37 *Three Patriarchs, Zion Canyon, Rio Virgen, Utah*
John K. Hillers, American, born Germany (1843–1925)
Albumen silver print, 1872 (9⅞ × 13)
75.103/11

As expedition photographer for the Powell Survey, Hillers explored the Grand Canyon of the Colorado and neighboring territory including Zion Canyon on the Virgen River, a site named by the Mormons. F. S. Dellenbaugh, who went through the Canyon as a member of the Powell Survey, described this view in an article in Scribner's Magazine. "In the foreground are chaotic masses of red rocks through which the river tears its way; green cottonwoods and bushes then inject their note, leading on to a huge vermillion pyramid whose precipices cleave the sky in the May-day sun."

Nineteenth-Century Portraits

PLATE 38 *The Great Layton, Circus Performer*
Harrison Putney, American (1864–1950)
Modern gelatin silver print from original dry-plate negative, 1885 (5 × 7)
78.131/23

Many circus performers passed through Leavenworth, Kansas, stopping to purchase equipment from the C. W. Parker Company. A number, including the slack wire artist "The Great Layton," posed for publicity shots in Harrison Putney's studio.

PLATE 39 *H. Lissik, Circus Performer, Twirling Baton*
Harrison Putney, American (1864–1950)
Modern gelatin silver print from original dry-plate negative, 1886 (7 × 5)
78.131/18

The Lissiks were a husband and wife team who specialized in a variety of balancing and chain-of-event acts, bringing entertainment and "culture" to small American towns. Here the dapper Mr. Lissik demonstrates his expertise with a baton.

PLATE 40 *Wyoming Cowboy*
Charles D. Kirkland, American (1857–1926)
Albumen silver print, c. 1895 (7³⁄₁₆ × 4⁵⁄₁₆)
79.36/6

Pandering to the demand for information on life in the West that resulted in scores of dime novels and traveling wild west shows, the Wyoming photographer Charles Kirkland published his own series of photographs entitled "Views of Cowboy Life and the Cattle Business." Here, a rather dapper Wyoming cowboy reinforces romantic notions about life as a cowpuncher.

PLATE 41 *[Four Children]*
Unknown photographer
Modern gelatin silver print from original dry-plate negative, c. 1890s (7 × 5)
78.127/156

Pictures of a growing family have long been family traditions regardless of the community's size or wealth. Here, dressed in their finest, four young girls from Leavenworth, Kansas, pose for the camera of an unidentified local photographer on this very special occasion.

PLATE 42 *Harry Wiekler*
Unknown photographer
Modern gelatin silver print from original
dry-plate negative, 1901 (7 × 5)
78.127/110

Work from local photographic studios provides a wealth of information on prominent individuals, town growth, and important events. This image, also from the files of an unknown Leavenworth, Kansas, photographer, gives a glimpse of Mr. Wiekler's character as he clowns for the camera.

PLATE 43 *A Zuni Eagle Cage*
John K. Hillers, American, born Germany
(1843–1925)
Albumen silver print, 1879 (7¼ × 9⁵⁄₁₆)
67.2554

Hillers made this photograph of Kesh-pa-he and the eagle and eagle cage of the River Bank House, home of the pueblo governor, on an 1879 survey of New Mexico and Arizona pueblos and archeological ruins. The survey was one of the first acts commissioned by John Wesley Powell, director of the newly formed Bureau of Ethnology, a branch of the Smithsonian. The Zuni revered the eagle as the hunter god of the "upper region" or sky, viewing it as a mediator between man and the more mysterious, powerful, and immortal natural elements.

PLATE 44 *Woman Pirouetting (.277 Second)*
Eadweard Muybridge, American, born
England (1830–1904)
Collotype, 1887 (7³⁄₁₆ × 16⅛)
81.81

Muybridge's classic studies of movement in man and animals are documented in the 781 plates of his major work, Animal Locomotion, begun in 1884 at the University of Pennsylvania. A brilliant analysis of anatomy and movement, the studies strongly influenced the work of Muybridge's artist friend Thomas Eakins as well as that of Frederic Remington, Edgar Degas, and Marcel Duchamp.

PLATE 45 *Little Big Man. Ogalalla Dakota*
Charles M. Bell, (active Washington, D. C.,
1870s)
Albumen silver print, 1877 (7⅞ × 5⁷⁄₁₆)
67.720

Using standard papier mâché sets, a painted backdrop, and interchangeable props, Charles M. Bell photographed many of the important Indians who visited Washington, D.C.

during the 1870s. Although little is known about Bell himself, it is apparent that he used the same costumes and props over and over again, regardless of the tribe of the individual portrayed.

PLATE 46 *Sitting Bull*
David F. Barry, American (1854–1934)
Albumen silver print, c. 1884 (7½ × 5¹⁄₁₆)
67.466

During the 1870s and 1880s, David F. Barry made a living photographing military men stationed at the military posts in the vicinity of Bismarck, North Dakota. After the battle of Little Big Horn, he expanded his work to include photographs of Indians and their way of life. Sitting Bull sat for Barry numerous times. This is probably the most famous view, made about the time that Sitting Bull began to realize the futility of active resistance and concentrated instead on the market value of his notoriety by traveling with Buffalo Bill's Wild West Show. A nineteenth-century newspaper contained the comment that, "Even old Sitting Bull sat down in captivated meditation and looked his most human before Barry's camera."

PLATE 47 *The Mess Wagon*
Laton Alton Huffman, American (1854–1931)
Albumen silver print, c. 1890s (6 × 7¹⁵⁄₁₆)
67.706

Good camp cooks were hallowed institutions on round-ups since bad ones made an already difficult situation intolerable. Here "Mexican John," cook for the XIT Ranch, prepares pies to accompany dinner. Huffman worked out of Miles City, Montana, recording colorful range life before barbed wire and mechanization brought it to a close.

PLATE 48 *[Jesse James on Horseback]*
Unknown photographer
Tintype, c. 1870 (2½ × 3¾)
78.120

Even outlaws had their sentimental and humorous moments. In this tintype, part of a James family album, Jesse is recorded for posterity as he stages a mock hold-up for the camera.

PLATE 49 *A Chinese Bagnio, San Francisco*
I. W. Taber, publisher, American (1830–1912)
Albumen silver print, c. 1880s (4¹¹⁄₁₆ × 7¹¹⁄₁₆)
81.86

Isaiah West Taber of San Francisco was a leading nineteenth-century publisher of photographic views. Although he was himself a photographer, Taber also published the work of numerous assistants and other photographers under his own

imprint. Most notable along this line was the work of Carleton Watkins who went bankrupt in 1876 and was forced to turn his negatives over to Taber. Constantly promoting San Francisco, Taber published scores of views of the city including this image of a bathhouse in Chinatown.

PLATE 50 *The Medicine Man—Taken at the Battle of Wounded Knee, South Dakota*
George Trager, (active Chadron, Nebraska,
1889–1892)
Albumen silver print, 1891 (4⁹⁄₁₆ × 7½)
67.102

Although George Trager was active as a photographer for only a short period, he happened to be in the right place at the right time, following on the heels of the Seventh Cavalry after the Battle of Wounded Knee. The stark and gruesome depictions of bodies frozen in the snow or dumped into mass graves sold widely, presumably to those eager to understand what had really happened, and were reproduced in government reports about the massacre.

PLATE 51 *Mexican Boy Captured by Comanches*
Unknown photographer
Platinum print, negative c. 1871, print later
(4¹⁄₁₆ × 2½)
67.2221

Shortly after he was elected president, U.S. Grant responded to corruption and scandal in the Indian Bureau. The Quakers, who believed that humane, Christian treatment would solve most of the Indian problems, were put in charge of the Kiowa, one of the most troublesome groups of agency Indians. Lawrie Tatum was appointed agent and stationed at Fort Sill, Oklahoma. Tatum heard about a number of white and Mexican captives, who had been captured by Comanches and then sold to the Kiowa, and he negotiated for their release. It is believed that this photograph shows one of a dozen Mexican captives released to Tatum between 1869 and 1873.

PLATE 52 *William H. Macdowell*
Thomas Eakins, American (1844–1916)
Platinum print, c. 1884 (3⁹⁄₁₆ × 2⁹⁄₁₆)
81.90

Although Eakins is best known as a portrait painter whose realistic paintings had a profound impact on the development of a modern aesthetic in American art, he was also a photographer. Most of his photographs are studies of family or friends, and the best reveal the same perceptive understanding of the subject that marks Eakins' finest painting. This view of Eakins father-in-law, William H. Macdowell, was made in the backyard of the Eakins home at 1729 Mount Vernon Street in Philadelphia.

PLATE 53 *U.S. Grant, 80 Ft. Circ., Mariposa Grove [Portrait of Eadweard Muybridge]*
Attributed to Charles Leander Weed, American (1824–1903)
Albumen silver print, 1872 (20½ × 15⅞)
82.8

This photograph, made among the giant redwoods in the Mariposa Grove, shows Muybridge at the end of his 1872 Yosemite trip seated on a glass-plate negative box. The image has been attributed to several photographers including Weed, George Fiske, and even Muybridge himself. Weed, a veteran of large plate work in Yosemite, was associated with the publishing firms that sponsored and distributed Muybridge's 1872 views. Fiske, who also photographed extensively in Yosemite, had some experience with large negatives when he worked with Carleton Watkins. All of his own work is 11 × 14 inches or smaller, however, and it therefore seems unlikely that he would have made this large view. The supposition that Muybridge made his self-portrait is hampered by the technological limitations that early cameras would have imposed.

PLATE 54 *Mrs. Wilson's Nurse*
Unknown photographer
Modern gelatin silver print from original dry-plate negative, c. 1890s (7 × 5)
78.127/158

Countless black women earned their living caring for the children of well-to-do whites. Though a statement of an accepted way of life, this image clearly demonstrates the emotional bonds that transcend economic necessity.

PLATE 55 *Miss Annie Oakley (Little Sure Shot)*
John Wood, (active late 19th century)
Albumen silver print, c. 1880s (5¹¹⁄₁₆ × 4¹⁄₁₆)
Mazzulla Collection

Annie Oakley's skill with a rifle and her showmanship made her name a household word during the seventeen years that she appeared as the opening act for Buffalo Bill's Wild West Show. She was dubbed "Little Sure Shot" by Sitting Bull, who traveled with the show after 1885. This view was made at the request of a reporter who interviewed Oakley so that he could have a woodcut made to illustrate his article.

The Pictorial Style

PLATE 56 *Washington Square, New York*
Laura Gilpin, American (1891–1979)
Platinum print, 1916 (8 × 6¹⁄₁₆)
Gift of Laura Gilpin
79.95/33

In 1916, at the suggestion of photographer Gertrude Käsebier, Gilpin left her native Colorado to study at the Clarence H. White School of Photography in New York, the leading institution for the study of pictorial techniques. Working with such teachers as White, Max Weber, and Paul Anderson, Gilpin learned the principles of design and the mechanics of platinum printmaking that served her for the rest of her long career.

PLATE 57 *The Prelude*
Laura Gilpin, American (1891–1979)
Platinum print, 1917 (6⅛ × 7⅞)
Gift of Laura Gilpin
79.95/87

Gilpin studied violin as a child and all her life remained interested in the similarities between music and photography. "One," she said, "is continual sound; the other is continual tone." From her good friend Brenda Putnam, a well-known sculptor and the pianist in this photograph, Gilpin said she learned that "there is no form without shadow."

PLATE 58 *Peppers*
Paul Outerbridge, American (1896–1958)
Platinum print, c. 1923 (4½ × 2⁹⁄₁₆)
80.37

Although a student and teacher at the Clarence H. White School of Photography, a center of the pictorial movement, Outerbridge was concerned mainly with the abstraction of form. His early platinum prints of still lifes and everyday objects, made during the 1920s, constitute his best work in this vein and were frequently used as commercial illustrations in fashion and literary magazines.

PLATE 59 *Still Life*
Baron Adolf De Meyer, American, born France (1868–1946)
Photogravure (from *Camera Work*, no. 24), 1908 (7⅝ × 6³⁄₁₆)
Gilpin Bequest

Baron De Meyer traveled in the circles of high society promoting the artistic avant-garde and photographing social notables for Vogue and Vanity Fair. Both De Meyer's portraits and still lifes, his two main subjects, are studies in carefully composed lighting and arrangement.

PLATE 60 *San Francisco, April 18th, 1906*
Arnold Genthe, American (1869–1942)
Gelatin silver print, 1906 (7¹¹⁄₁₆ × 13¹⁄₁₆)
80.25/4

On the morning of April 18, 1906, Genthe and other San Francisco residents were confronted with the eerie sight of a city crumbling before their eyes. As the day of the great

earthquake wore on, Genthe recorded this view on Sacramento Street looking towards the bay. The facade of the house on the right fell into the street, as its occupants sat calmly on chairs watching the clouds of smoke down the hill. Other groups stood motionless in the street, retreating a block only when the fire came too close. In his autobiography Genthe acknowledges that this view is a "pictorially effective composition," as well as an image with tremendous historical importance.

PLATE 61 *The Orchard*
Clarence H. White, American (1871–1925)
Photogravure, (from *Camera Work*, no. 9), negative 1902, print 1905 (8 × 6⅛)
78.61

Clarence White had a tremendous impact on American photography through his own work, in his role as a founder of the Pictorial Photographers of America and the Photo-Secession, and, most significantly, as a teacher. Through the Clarence H. White School of Photography, he shaped the careers of Steichen, Gilpin, Lange, Struss, Outerbridge, Bourke-White and many other influential twentieth-century photographers. The Orchard, made while he was still living in Newark, Ohio, working as a bookkeeper, is typical of White's efforts to capture images of idealized youth and beauty through the use of family and close friends as subjects and his sensitive handling of light.

PLATE 62 *Narcissus*
Laura Gilpin, American (1891–1979)
Platinum print, 1928 (9⅝ × 5⅝)
Gift of Laura Gilpin
79.95/84

Gilpin was one of the few twentieth-century masters of the platinum printing process, a technique that yields an exceptionally wide range of subtle blacks and greys. Though she sometimes used the commercially prepared platinum papers that were available until about 1937, she preferred to coat her own papers by hand.

PLATE 63 *[Portrait of Daughter]*
Alice Boughton, American (1865–1943)
Platinum print, c. 1909 (5¹⁵⁄₁₆ × 6⅜)
80.10/1

Boughton worked primarily as a portraitist who sought to portray the essential qualities and individual characteristics of her sitters. She adapted her technique to her subject, believing that children and older people should be portrayed using a light scheme of whites and greys suggesting a delicate, ethereal quality, while strong blacks and browns were more suitable for men or persons with distinctive coloring. This delicate image has a quality much like that of a pencil drawing.

PLATE 64 *Still Life*
Ira Martin, American (1886–1960)
Platinum print, c. 1921 (6 × 4⁹⁄₁₆)
81.60

Martin, for many years the staff photographer at the Frick Collection, was president of the Pictorial Photographers of America during the late 1920s and early 1930s. The organization encouraged the work of established photographers, such as Clara Sipprell, Laura Gilpin, Gertrude Käsebier, and Jane Reece, through traveling exhibitions and promoted artistic photography among its members through lecture meetings and monthly print competitions. This still life is a classic example of the ideals of pictorialist photography in terms of its soft-focus effect, studied artistic composition, and the use of platinum printing.

PLATE 65 *Yellowstone National Park*
Louise Deshong Woodbridge, American (1848–1925)
Platinum print, c. 1912 (3⁷⁄₁₆ × 4¹⁄₁₆)
81.70

Woodbridge's work incorporates her interest in geography, art, and science with a sophisticated yet straightforward approach to her subject matter. Along with fellow Philadelphia photographers John G. Bullock, Henry Troth, Robert S. Redfield, and John C. Browne, sometimes referred to as "The Bullock Group," she produced fine landscapes that drew heavily on the resources of her scientific knowledge. This unusual western view has a decidedly modern abstract quality, emphasizing form at the expense of clear geological description.

PLATE 66 *Lorado Taft: The Man and His Work*
Jane Reece, American (1869–1961)
Carbon print, 1917 (8⅜ × 6½)
81.61

A pictorialist who sometimes exhibited with the photographers of the Photo-Secession, Reece's career centered around her portrait work in her Dayton, Ohio studio. She often photographed artists, including the Beaux Arts-trained sculptor Lorado Taft who is shown here in his Chicago studio beside a full-sized plaster cast of his sculpture "The Fountain of Time."

PLATE 67 *The Goldfish [Yvonne Verlaine]*
Edward Weston, American (1886–1958)
Platinum print, 1917 (9¼ × 7½)
79.90/2

This early soft-focus print of the dancer Yvonne Verlaine shows evidence of retouching, a technique Weston repudiated when he embraced a direct, sharply focused style that came to be known as "straight" photography. As his tastes changed, Weston became dissatisfied with his early pictorial work and destroyed most of his early negatives.

PLATE 68 *Mohave Indian Children*
Frederick Imman Monsen, American, born Norway (1865–1929)
Toned gelatin silver print, c. 1890s (10⁹⁄₁₆ × 15⁵⁄₁₆)
80.50/1

Monsen was an anthropologist, photographer, lecturer, and western explorer who focused his studies on the Indian tribes of the American Southwest. Feeling that his "trustful" records of Southwestern Indians would have historical and ethnological value, Monsen made it his lifework, drifting from village to village and living according to local custom in order to gain access to ceremonies and activities of daily living that few non-Indians ever saw.

PLATE 69 *Watching the Dancers*
Edward S. Curtis, American (1868–1952)
Platinum print, 1906 (7⅝ × 6)
79.54/2

Edward S. Curtis' lifework was the compilation of over 2,200 photographs in The North American Indian *published as a series of 20 volumes and portfolios documenting disappearing lifestyles and customs. Curtis made this view at Walpi Pueblo where a group of unmarried women, identified by their hair style, sat on the topmost roof watching dances in the plaza below.*

PLATE 70 *A Nakoaktok Chief's Daughter*
Edward S. Curtis, American (1868–1952)
Photogravure, 1914 (15¼ × 11½)
77.1/334

In Canada, Curtis photographed the eldest daughter of a Kwakiutl chief as she presided over a potlatch given by her father. She sits on a platform supported by figures symbolically representing her slaves.

PLATE 71 *Has-No-Horses*
Gertrude Käsebier, American (1852–1934)
Platinum print, 1898 (9¼ × 7⅛)
79.35/3

Earlier portraits of American Indians often depicted them in stagelike settings holding artifacts supplied by the studio. In photographing the Dakota Chief Has-No-Horses and other Indians who were members of Buffalo Bill's Wild West Show, Käsebier discarded the props in favor of a more probing and sensitive study, consistent with her aesthetic values as a pictorialist photographer.

PLATE 72 *Watching the Approach of the Fire*
Arnold Genthe, American (1869–1942)
Gelatin silver print, 1906 (13⁹⁄₁₆ × 10⅛)
80.25/3

Although Genthe's cameras were destroyed by the great San Francisco earthquake of 1906, he borrowed one from

his dealer to document the disaster's effect on the city. This image, made on the first day of the quake, shows residents seated on a hillside watching the spectacle as though it were an epic motion picture.*

PLATE 73 *Bay Bridge, New York*
Karl Struss, American (1886–1981)
Platinum print, c. 1912–1913 (3⁹⁄₁₆ × 4½)
80.54

Best known as a Hollywood cinematographer, Struss was also a still photographer of considerable renown. As a member of the Photo-Secession, he, with his teacher Clarence White, was instrumental in the establishment of the Pictorial Photographers of America. For Struss, composition was the key element in making a picture work. Developing a skill that would serve him well in cinematography, he sought to fill the space in his viewfinder with the heart of an image, cropping with his camera instead of in the darkroom.

PLATE 74 *The Steerage*
Alfred Stieglitz, American (1864–1946)
Photogravure, negative 1907, print 1915 (13⅞ × 10)
79.92

In June, 1907, Stieglitz and his wife and daughter sailed for Paris on a large steamer. Describing the photograph he made on the trip, Stieglitz says: "Coming to the end of the deck I stood alone, looking down. There were men, women, and children on the lower level of the steerage. A narrow stairway led up to a small deck at the extreme bow of the steamer. A young man in a straw hat, the shape of which was round, gazed over the rail, watching a group beneath him. To the left was an inclining funnel. A gangway bridge, glistening with white paint, led to the upper deck. The scene fascinated me." He ran to get his camera, hoping the scene would remain as he had first seen it. It had. "I released the shutter. If I had captured what I wanted, the photograph would go beyond any of my previous prints. It would be a picture based on related shapes and deepest human feeling—a step in my own evolution, a spontaneous discovery."

PLATE 75 *Adobe Walls, Taos, New Mexico*
Clara Sipprell, American, born Canada (1885–1975)
Platinum print on tissue, c. 1920 (9¼ × 7¹¹⁄₁₆)
80.13/1

Sipprell's work thoroughly embraces the tenets of the pictorialist mode, utilizing soft-focus effects, warm tones, and the practice of printing or mounting photographs on tissue paper. Although she earned her living as a portraitist, her best works are the still lifes and landscapes which became studies in abstract design.

142

PLATE 76 *California Scene*
Leopold Hugo, American, born Prussia
(1860–1933)
Gelatin silver print, c. 1910–1920 (5⅞ × 7¹⁵⁄₁₆)
80.53

Pictorial photographers used a wide variety of exotic technical processes to enhance the aesthetic quality of the images. Leopold Hugo experimented widely to perfect techniques that would compliment the character of his pictorially appropriate subject matter. He often used wax-paper negatives and chloride and bromine developing methods to get the soft grainy texture he wanted in his landscapes, toning the images with sepia or magenta washes to increase the range of effects.

PLATE 77 *The Hand of Man*
Alfred Stieglitz, American (1864–1946)
Platinum print, 1902 (9¾ × 12¼)
78.112

Stieglitz had more impact on the development of photography and modern art than almost any other individual. For him, photography was not only art, it was a way of living, the power to see. His subject matter was not important in and of itself, but rather for what it expressed. Others photographed mere machines, but Stieglitz' view of this trainyard in Long Island City is a metaphor for his feelings about industrialization.

PLATE 78 *Cañon De Chelly*
Edward S. Curtis, American (1868–1952)
Toned gelatin silver print, 1904 (5½ × 7⅝)
79.54/3

Cañon de Chelly is a longtime stronghold of the Navaho people and is scattered with ruins of earlier settlements. When Curtis photographed, the canyon floor was dotted with farms and orchards serving as the "garden spot of the reservation." While expedition photographers such as O'Sullivan had marveled at the canyon's scenic grandeur, Curtis saw both the natural beauty and the significance it held as a Navaho stronghold.

The Straight Photograph
and the Documentary Style

PLATE 79 *Charles M. Russell*
Dorothea Lange, American (1895–1965)
Gelatin silver print, negative c. 1924–1926,
print later (11¹³⁄₁₆ × 10¹⁄₁₆)
61.424

In a letter offering her photograph of the artist, Charles M. Russell, to the Amon Carter Museum, Dorothea Lange

describes the situation in which it was made: "As I look at the photograph, what I remember is the atmosphere, the light, the qualities of easy-going conversation, or communication, between Charlie Russell and Maynard Dixon, in whose studio it was made. I was not a participant, I was just there, and the camera was with me, and I saw it, and I did it. Charlie Russell did not sit for me. I doubt if he knew that the picture had been made, for they were in conversation and the camera was not the reason for the visit."*

PLATE 80 *Half-an-Apple*
Wynn Bullock, American (1902–1975)
Gelatin silver print, 1953 (7½ × 8⅝)
74.20/3

Bullock's detailed and directly focused photograph of an apple section captures the essence of taste, texture, flavor, and color of this perfect specimen. He felt that such an image could depict the quality that makes an apple an apple more clearly than any written description.

PLATE 81 *White Door, Eureka, Nevada, 1973*
Oliver Gagliani, American (b. 1917)
Gelatin silver print, negative 1973, print 1980
(10¼ × 13)
81.34

Originally trained as a musician, Gagliani renewed an adolescent interest in photography after a hearing loss hampered his musical studies. He studied under Minor White and Ansel Adams and spent a portion of his early career making photographs in the California state parks. Gagliani sees many similarities between classical music and photography, often describing his highly personal photographs with musical analogies.

PLATE 82 *Allie May Burroughs, Hale County, Alabama*
Walker Evans, American (1903–1975)
Gelatin silver print, 1936 (9½ × 7⁹⁄₁₆)
78.48/1

This image is one of a number of photographs of the Burroughs family that Evans made during the summer of 1936 as part of a proposed article on cotton sharecroppers in the South. Evans, on loan from the Farm Security Administration, collaborated on the project with author James Agee. Although the original article never appeared, Agee and Evans published their material in 1939 as the classic work, Let Us Now Praise Famous Men.

PLATE 83 *[Georgia O'Keeffe's Hands]*
Alfred Stieglitz, American (1864–1946)
Gelatin silver print, 1917 (9¾ × 7¹¹⁄₁₆)
81.87

This photograph is one of five images made in the spring of 1917 at "291" Gallery in New York City during Stieglitz'

first photographic session with O'Keeffe. The session was the beginning of a composite portrait of hundreds of images that explored the feelings and facets of their intense relationship. Stieglitz' numerous images, made both before and after their marriage in 1924, are an expression of his belief that a single image could never be a complete portrait of any person.*

PLATE 84 *Navaho Woman, Child and Lambs*
Laura Gilpin, American (1891–1979)
Platinum print, 1931 (13½ × 10½)
Gift of Laura Gilpin
79.95/90

From 1931 to 1933, Gilpin's close friend Elizabeth Forster was a health care worker on the Navaho Reservation at Red Rock, Arizona. On her frequent trips to visit Forster, Gilpin benefited from the Navaho's trust in her friend to make a warm and personal record of their life. On her return visit to the reservation some twenty-five years after making this picture, she unexpectedly met, then photographed, this woman's husband holding the nephew of the small boy in this picture. Both images appeared in The Enduring Navaho *(1968), Gilpin's tribute to the Navaho people and their ability to adapt to a rapidly changing world.*

PLATE 85 *Happiness*
Nell Dorr, American (b. 1893)
Gelatin silver print, negative 1940, print later
(13⅞ × 10¹³⁄₁₆)
81.77

Nell Dorr's work is personal and closely tied to her firm belief in the ideals of motherhood and family life. Her book, Mother and Child, *from which this image comes, grew out of a desire to express her grief over the loss of her daughter who died leaving a small child. The moments the book depicts are the special, happy times which are preserved as a celebration of motherhood.*

PLATE 86 *Woman of the High Plains. "If You Die, You're Dead—That's All." Texas Panhandle*
Dorothea Lange, American (1895–1965)
Gelatin silver print, negative 1938, print later
(12¾ × 10¼)
65.172/8

The American Country Woman *was an ongoing project that occupied Dorothea Lange for over twenty-five years. While some of the images in this photographic essay observe the bounty of life, this photograph of a woman in the Texas Panhandle during the drought years reflects a land that wore away at those who tried to wrest a living from it. Lange made the photograph on a Farm Security Administration trip to Texas in which she documented the farmland and families devastated by the Dust Bowl.*

PLATE 87 *A Navaho Family*
Laura Gilpin, American (1891–1979)
Gelatin silver print, 1953 (11¹³⁄₁₆ × 7¾)
78.92/15

Gilpin returned to photograph on the Navaho Reservation in the early 1950s, after an absence of nearly fifteen years, during which she had published several photographic books on the Southwest and worked as a photographer for Boeing Company. She was moved by the welcome she received from old friends and startled by the profound changes taking place in traditional Navaho life. She photographed her friends the Nakais against the only bit of decoration in their sparsely furnished house, the American flag that draped the coffin of their son killed in World War II.

PLATE 88 *"The World's Egg Basket" Petaluma, California 1938*
John Gutmann, American, born Germany (b. 1905)
Gelatin silver print, 1938 (7¾ × 8⁵⁄₁₆)
80.21

John Gutmann was a promising Expressionist painter when he fled from the troubled German political situation in 1933. He settled in San Francisco and began a 30-year career as a teacher and photo-journalist, whose interest in language was often reflected by his work.

PLATE 89 *Before the Races*
Paul Grotz, American, born Germany (b. circa 1910)
Gelatin silver print, late 1920s (6⁹⁄₁₆ × 9¹⁄₁₆)
80.47

The composition of this photograph, made at Belmont Race Track, Long Island, reflects Grotz' training as a Bauhaus architect. Although encouraged by a friendship with Walker Evans during the late 1920s, Grotz abandoned his photographic career in 1934 and went to work as Art Director for Architectural Forum.

PLATE 90 *New York at Night*
Berenice Abbott, American (b. 1898)
Gelatin silver print, 1933 (13⁵⁄₈ × 10½)
78.25/2

Abbott photographed New York City during the 1930s as part of a WPA Federal Art Project to document the power and changing scale of the city. This classic image shows Manhattan at night from an unusual angle, substantiating Abbott's philosophy that an image should have, ". . . objectivity . . . with the mystery of personal selection at the heart of it."

PLATE 91 *In the Box—Horizontal*
Ruth Bernhard, American, born Germany (b. 1905)
Gelatin silver print, 1962 (7⅜ × 18⅜)
81.76

For Ruth Bernhard, the human body is a universal form to be studied and depicted in its most essential and harmonious elements. This image of a body is a study of form—not the portrait of a particular individual. It is a celebration of the physical structure and spiritual force maintaining life.

PLATE 92 *Light Follows Form*
Carlotta M. Corpron, American (b. 1901)
Gelatin silver print, negative 1946, print 1976 (10½ × 13½)
Gift of Carlotta M. Corpron
81.35/5

During the 1940s, while teaching at Texas Woman's University in Denton, Texas, Corpron explored ways to photograph light as a modeler of form. This photograph was made in her classroom, as the afternoon light flowed through venetian blinds and struck the plaster shapes she used as teaching aids.

PLATE 93 *Church, Ranchos De Taos, New Mexico*
Paul Strand, American (1890–1976)
Platinum print, 1930 (3⅝ × 4¾)
81.66

Strand's landscapes focus on the relationship between the elements and the man-made world. In the Ranchos de Taos church, he found a subject that provided him with an endless combination of forms, particularly the mass of the adobe structure against the cloudy New Mexico sky. His intention that the directly focused, "straight" works capture the "spirit of place" in New Mexico succeeded, not only in the photographs themselves, but in the impact they had on American photography. Most notable, perhaps, was their influence on Ansel Adams who spent part of the summer of 1930 living with the Strands in Taos. Upon seeing Strand's sharp negatives, Adams decided to abandon his musical career, give up soft-focus photography, and develop his own "straight" photographic vision.

PLATE 94 *Pennsylvania Station, 1936*
Berenice Abbott, American (b. 1898)
Gelatin silver print, negative 1936, print 1979 (9⁹⁄₁₆ × 7⅜)
80.36

Abbott's New York work focused on sections of the city that depicted its changing environment. This image was one of several made at Pennsylvania Station that Abbott printed for the first time only a few years ago.

PLATE 95 *Gulf Oil, Port Arthur*
Edward Weston, American (1886–1958)
Gelatin silver print, 1941 (7½ × 9⅝)
80.23/1

Commissioned by the Limited Editions Club to make photographs for an illustrated edition of Walt Whitman's The Leaves of Grass, *Weston traveled over 20,000 miles in a 10-month period, covering the United States from Texas to Maine. In a postcard to his sister, he reported that he had found "an unexpected gold mine" in the refinery city of Port Arthur and planned to work there for a few days.*

PLATE 96 *Gulf Oil, Port Arthur*
Edward Weston, American (1886–1958)
Gelatin silver print, 1941 (7¾ × 9½)
80.23/2

A variant of this view was published in the 1942 publication of The Leaves of Grass.

PLATE 97 *Nehi Sign on A. Esposito's Grocery*
Ralph Steiner, American (b. 1899)
Gelatin silver print, 1929 (9⁹⁄₁₆ × 7⁷⁄₁₆)
Gift of James H. Maroney, Jr.
80.27/2

Although Steiner comments that he simply photographs things that he likes or that amuse him, he is a master of the visual joke. This photograph, from the 1929 summer that he spent learning to be a photographer, is clear evidence both of Steiner's penetrating sense of humor and unique point of view.

PLATE 98 *Boy. Hidalgo*
Paul Strand, American (1890–1976)
Photogravure, negative 1933, print 1967 (6⁵⁄₁₆ × 4⅞)
67.202/14

The portraits in Paul Strand's Mexican Portfolio, from which this image is taken, reflect the pride and dignity in the people who inspired his work. Most of the photographs were candid images made with a prism attachment that enabled Strand to take a photograph at a ninety-degree angle to the direction in which the camera was pointed. Although Strand photographed in Mexico in 1932 and 1933, it was not until 1940 that the prints became available in a portfolio of hand-pulled, photogravure plates. The portfolio was reprinted in 1967.

PLATE 99 *Navaho Madonna*
Laura Gilpin, American (1891–1979)
Gelatin silver print, 1932 (9½ × 7⁷⁄₁₆)
78.92/20

Gilpin's Navaho images frequently make reference to classical themes, betraying Gilpin's formal training at the Clarence H. White School and her emphasis on the importance of good composition and well-ordered design.

PLATE 100 *Martha Graham—Letter to the World, 1940 (Swirl)*
Barbara Morgan, American (b. 1900)
Gelatin silver print, 1940 (15¼ × 19¼)
74.21/7

This image appeared in Morgan's book, Martha Graham: Sixteen Dances in Photographs *(1941). Deeply moved by the originality and emotional resonance of Graham's modern dance techniques, Morgan photographed her and her troupe for five years seeking to make "pictures which contain the essential emotion of that dance."*

PLATE 101 *Pure Energy and Neurotic Man*
Barbara Morgan, American (b. 1900)
Gelatin silver print, 1941 (19 × 15⅛)
74.21/16

Although best known for her dance photography, Morgan has used photomontage as a medium for social commentary since the mid-1930s. She made this print with two negatives, combining one of her "light drawings" with an image of a "'grabby' hand" to illustrate what she calls "the ego-power struggle in our world."

PLATE 102 *Gloria Swanson*
Edward Steichen, American, born Luxembourg (1879–1973)
Gelatin silver print, negative 1924, print 1965 (13⅝ × 10⅝)
81.68

Edward Steichen photographed Gloria Swanson for Vanity Fair, *a sophisticated magazine that presented the best in social trends, art, literature, sports, and humor between 1914 and 1936. In his autobiography,* A Life in Photography, *Steichen describes making the photograph. "At the end of . . . [a long] session, I took a piece of black lace veil and hung it in front of her face. She recognized the idea at once. Her eyes dilated, and her look was that of a leopardess lurking behind leafy shrubbery, watching her prey. You don't have to explain things to a dynamic and intelligent person like Miss Swanson. Her mind works swiftly and intuitively."*

PLATE 103 *Flowing Light*
Carlotta M. Corpron, American (b. 1901)
Gelatin silver print, c. 1947 (10¹¹⁄₁₆ × 13⁹⁄₁₆)
Gift of Carlotta M. Corpron
81.35/7

Corpron became a photographer because she "had this intense desire to create with light." This delicate image of filtered sunlight, rippling across a sheet of plastic, captures the essence of light as it creates design, reveals space, and charts time and motion.

PLATE 104 *Early Russia/Dnieperstroi*
Margaret Bourke-White, American (1904–1971)
Gelatin silver print, c. 1930 (19¼ × 13¹⁵⁄₁₆)
Gift of James H. Maroney, Jr.
80.24

Fascinated by the process of industrialization and the beauty of machines, Bourke-White wrangled a rare opportunity to visit Russia and document post-revolutionary industrialization during the early 1930s. The Dnieper Bridge, built with American technical assistance, was the largest project attempted in Russia at that time. Bourke-White studied the changing designs formed by the cranes against the ragged edges of the clouds and, when they harmonized, snapped the shutter.

PLATE 105 *A Russian Family at Ellis Island*
Lewis Wickes Hine, American (1874–1940)
Gelatin silver print, 1905 (9⁹⁄₁₆ × 7⅝)
81.78

Hine began his Ellis Island project as a study for the Ethical Cultural School, a progressive trade school in New York City, to record the "social spirit" of and develop sensitivity for the plight of non-English-speaking immigrants. As many as 5,000 persons were processed through the immigration center at Ellis Island each day. Of this photograph, Hine comments that, ". . . the mother takes a Mona Lisa view of the situation."

PLATE 106 *Billboard—Minstrel Show*
Walker Evans, American (1903–1975)
Gelatin silver print, 1936 (7¾ × 9⅝)
78.48/2

This FSA image demonstrates Evans's use of a previously untapped vocabulary, the colloquial expression of human existence seen in billboards and vernacular architecture. Evans did not feel that the photographer should construct a "meaningful" image from such a set of elements, but discover and record instances where the situation made its own statement with such an impact that the image itself would stand as fact.

PLATE 107 *Wicker Chair*
Ralph Steiner, American (b. 1899)
Gelatin silver print, 1929 (7⁹⁄₁₆ × 9½)
80.27/1

Although this is probably Steiner's best-known image, he laments the fact that ". . . many people think it is the only picture I've ever made." After viewing Paul Strand's work, Steiner determined to master the 8 × 10 camera and spent a summer photographing without interruption. Of this image,

made during that summer, he says, "Late one day I saw the sun, about to go down over the horizon, casting the shadow of a chair on a porch wall. No one in the world's history ever set up a huge, cumbersome 8 × 10 camera and snapped the shutter as fast as I did. Ten seconds later the shadow was gone from the wall."

PLATE 108 *Near Waxahachie, Texas. October 1913*
Lewis Wickes Hine, American (1874–1940)
Gelatin silver print, 1913 (4¼ × 6⅜)
Gift of Mr. and Mrs. Allan M. Disman
78.111/31

The photographs that Hine made for the Child Labor Study Commission were intended to make the "invisible" masses of child workers visible, aiding the cause of those who were pushing for reform of child labor laws. This image shows the boys from the Baptist Orphanage near Waxahachie, Texas, picking cotton after school hours. Hine's work was clearly focused; he felt it essential that his work be 100 percent pure or straight so that no one would doubt that he was documenting actual conditions.

PLATE 109 *Bucks County Barn*
Charles Sheeler, American (1883–1965)
Gelatin silver print, 1918 (9⅝ × 7⅝)
80.22/2

Beginning in 1915, Sheeler depicted this country barn in Pennsylvania in a variety of mediums, including photography, watercolor and gouache, and crayon. In many ways, this picture represents a transition from the commercial architectural photography of his early years to his exploration of photography as a medium that could be valuable to his painting and drawing.

PLATE 110 *Farmer and Sons Walking in the Face of a Dust Storm*
Arthur Rothstein, American (b. 1915)
Gelatin silver print, negative 1936, print later (10 × 9¹⁵⁄₁₆)
80.56/3

Rothstein was the first photographer to join the Farm Security Administration project. Influenced by Strand and Sheeler, his photographs are typically clearly defined and studied. This more unusual, journalistic view was staged by Rothstein. Framed in front of the shed to dramatize the poverty-stricken circumstances, Rothstein asked both the father and older son to lean into the wind as they walked. He had the little boy hold back, holding his hand over his face. The photograph, Rothstein says, "proved its point well."

145

PLATE 111 *"She's a Jim-Dandy." Tulare County, California. 1938*
Dorothea Lange, American (1895–1965)
Gelatin silver print, negative 1938, print later
(12⅞ × 10�5/16)
65.172/24

In her introduction to the photographic essay, The American Country Woman, *Lange states that the twenty-eight photographs are of ". . . women of the American soil . . . not well advertised women of beauty and fashion. . . . These women represent a different mode of life. They are of themselves a very great American style. They live with courage and purpose, a part of our tradition."*

PLATE 112 *Bleeder Stacks, Ford Plant, Detroit*
Charles Sheeler, Amcrican (1883–1965)
Gelatin silver print, 1927 (9⁹/16 × 7⁹/16)
80.22/4

Sheeler's commission to photograph the Ford plant at River Rouge was, in retrospect, a pivotal point in modern photography. Innovative in terms of both subject matter and vision, the photographs brought Sheeler recognition. The bleeder stacks were designed to regulate pressure by releasing excess gas through valves on top of the stacks. The clarity of this view reflects Sheeler's precisionist eye in a distilled form; the observer looks directly at the subject and each element, form, and space contributes exactly the substance needed to let the mind view the image as an integral whole. As Sheeler said, ". . . photography has the capacity for accounting for things seen in the visual world with an exactitude for their differences which no other medium can approximate."

PLATE 113 *[Steamfitter]*
Lewis Wickes Hine, American (1874–1940)
Toned gelatin silver print, 1921 (16⅝ × 12³/16)
81.80/3

This steamfitter or powerhouse mechanic worked in the power plant of the Pennsylvania Railroad system. In his series of "work portraits" made during the 1920s and 1930s, Hine tried to document the positive aspects of labor —the tremendous strength, energy, and beauty of American industry. He wanted both management and labor to appreciate the potential energy that could be generated by American industry.

PLATE 114 *Production Foundry, Ford Plant, Detroit*
Charles Sheeler, American (1883–1965)
Gelatin silver print, 1927 (7½ × 9⁷/16)
80.22/1

Sheeler spent six weeks studying the Ford plant before any photographs were made. As a result, each of the thirty-two images in the series has a powerful internal integrity that

concentrates on a comprehensive depiction of basic structural relationships. This view shows the west side of the production foundry which, at the time, was the world's largest. The diagonals of the railroad tracks underscore the strength in the horizontal structure of the building.

PLATE 115 *Looking for Lost Baggage, Ellis Island*
Lewis Wickes Hine, American (1874–1940)
Gelatin silver print, negative 1905, print later
(5⅝ × 4⅜)
81.80/1

Although he already understood the basic principles of photography, it was at Ellis Island that Hine mastered the aesthetic art of photography. Hine allowed the subjects to be themselves, feeling that their expressions about the situation were the most valid comments that could be made. Here, a hopeful Italian family ponders the fate of their belongings.

PLATE 116 *Nude*
Edward Weston, American (1886–1958)
Gelatin silver print, 1933 (3⅝ × 4⅝)
65.157

Although Weston debated whether realism or abstraction was the truest intent of photography, he felt that his pictures of nudes, made mainly during the mid-1930s, combined both a sense of flesh and blood and, as he described in his Daybook, *". . . the most exquisite lines, forms, and volumes."*

PLATE 117 *Ventilators*
Willard Van Dyke, American (b. 1906)
Gelatin silver print, negative c. 1930, print later (9½ × 5¹⁵/16)
80.2/5

Van Dyke, along with Ansel Adams, Imogen Cunningham, and others, was instrumental in founding f64, a group that espoused the tenets of "straight" photography. Van Dyke recalled that this image was made one afternoon on his way home from Berkeley to Piedmont when he saw the shafts posed in front of a deep blue sky. For him, Van Dyke said, the shafts had, ". . . a kind of tender fragility almost human in feeling."

PLATE 118 *The Queen Mary*
Walker Evans, American (1903–1975)
Gelatin silver print, c. 1940s (10⁷/16 × 10⁹/16)
80.26

As the 35-millimeter camera became the workhorse of the professional photographer and the use of artificial studio lighting became the norm, Evans remained an old-fashioned craftsman using his 8 × 10 view camera and the sun.

PLATE 119 *The Open Door*
Charles Sheeler, American (1883–1965)
Gelatin silver print, c. 1932 (10 × 8)
80.22/3

By 1932, Sheeler had given up most of his photographic work to concentrate on painting. The few images that he did make were preliminary studies for paintings or drawings. "The Open Door" is an almost exact model for his 1932 Conte crayon drawing of the same name. The photograph, however, contains imperfections such as patched plaster, a dangling latch string, and a metal patch on the door that disappear in the precisionist drawing.

PLATE 120 *The Covered Wagon*
Laura Gilpin, American (1891–1979)
Gelatin silver print, 1934 (19½ × 15⅝)
Gift of Laura Gilpin
79.95/98

Gilpin photographed this Navaho family in a traditional wagon as they descended from the Lukachukai Mountains towards Red Rock, Arizona. Gilpin's photographic document of Navaho life The Enduring Navaho *(1968) emphasized the enduring aspects of traditional culture and presented an essentially optimistic view for the survival of old traditions in a modern world. This was in marked contrast to the view of an earlier photographer, Edward S. Curtis, who called his most famous photograph of the Navaho "The Vanishing Race."*

PLATE 121 *Northern California. 1944*
Dorothea Lange, American (1895–1965)
Gelatin silver print, negative 1944, print 1965
(12¾ × 10½)
65.172/14

One woman depicted in the photographic essay The American Country Woman, *who had a special relationship with Lange, was her next-door neighbor, Lyde Wall, who helped care for the family during Lange's bouts with cancer. In her remarks accompanying the image, Lange said of her, "Friend and neighbor who makes the world's best apple pie, and knows everything going on for miles around."*

PLATE 122 *Keep Me Close*
Ben Shahn, American, born Lithuania
(1898–1969)
Gelatin silver print, c. 1938 (6½ × 9½)
80.30/4

In this image, Shahn captures not only the spirit of friendship but the literary pun on the fence. Ben Shahn is known primarily as a painter; but as a photographer for the Farm Security Administration, he used a camera to record his impressions of everyday life. Shahn liked the camera's ability to capture and preserve a moment or special fragment of an experience, and in this image he captures not only the spirit of friendship but the literary pun on the fence.

PLATE 123 *Daughter of Mr. Thaxton, Farmer near Mechanicsburg, Ohio, Summer 1938*
Ben Shahn, American, born Lithuania (1898–1969)
Gelatin silver print, 1938 (6⁷⁄₁₆ × 11⁹⁄₁₆)
80.30/9

Roy Stryker, who directed the FSA photographic project, said that Shahn, who had little photographic training, ". . . came back with pictures that were like his paintings—imaginative, beautiful things not restricted by technique." The photographs, Stryker continues, ". . . were often out of focus and overexposed or underexposed. When Arthur or Walker Evans or Carl Mydans would get to worrying about technique, I'd bring out Shahn's photographs and say, 'look what Shahn has done and he doesn't know one part of a camera from another.' I wanted them to know how small a part the mechanical tool—the camera—played in making a good picture."

PLATE 124 *[Untitled, Subway Series]*
Walker Evans, American (1903–1975)
Gelatin silver print, 1938 (5¹⁄₁₆ × 7⁵⁄₈)
82.2

This image is from a series Evans made in the New York City subway system during the late 1930s and 1940s. He used a hidden camera to photograph people so they would not be aware that they were being photographed. The resulting work is a study of the infinite variety and conformity among the masses of people who are all too easily faceless and nameless.

The Twentieth-Century Landscape

PLATE 125 *Moonrise, Hernandez, New Mexico*
Ansel Adams, American (b. 1902)
Gelatin silver print, 1941 (15¹⁄₁₆ × 19¼)
65.41

This image may be the best-known image in twentieth-century photography. Adams described the "incredible vista" before him as he drove past the tiny village where the photograph was made. "The moon was about two days before full, and the buildings and crosses were illuminated by a gentle diffuse sunlight coming through the clouds of a clearing storm. I almost drove my car into a ditch and emerged in a state of intense excitement, commanding my companions to get my tripod, my camera case, etc. The light was going while I was frantically trying to place myself and my camera in the right spot." Unable to find his exposure meter, Adams made an estimate based on the light reflected by the moon and made the picture. He started to change the film holder to take another

shot but the light failed and, ". . . the magical quality of the scene was gone forever."

PLATE 126 *Truck in the Desert near Yuma, Arizona*
Danny Lyon, American (b. 1942)
Gelatin silver print, negative 1962, print 1979 (8¹³⁄₁₆ × 13)
Gift of George Peterkin, Jr.
80.67/1

Photographer and film-maker Danny Lyon works with a keen sense of social awareness. He photographed the civil rights movement in the South as staff photographer for the Student Non-Violent Coordinating Committee in 1963–64 and later worked with motorcycle club members and prisoners to produce collaborative statements about their lives. His views represent what has been called a "social landscape" in which the photograph not only comments on the world but represents the photographer's involvement in it.

PLATE 127 *Child in the Forest*
Wynn Bullock, American (1902–1975)
Gelatin silver print, 1953 (7⁹⁄₁₆ × 9⁹⁄₁₆)
74.20/1

This photograph of Bullock's daughter Barbara hung at the beginning of Edward Steichen's extremely popular "Family of Man" exhibition at the Museum of Modern Art in 1955. The photograph evoked a wide range of public reaction. Some viewers saw a "oneness with nature," while others sensed a deeply disturbing feeling of death or abandonment. The intense reaction has made the image one of Bullock's best-known photographs.

PLATE 128 *Alkali Lake, Albany County, Wyoming*
Robert Adams, American (b. 1937)
Gelatin silver print, 1979 (8¹⁵⁄₁₆ × 11³⁄₁₆)
80.20/2

Adams' landscape photographs are not reverential views of a pristine environment, but reflect the hand of man on the American landscape. Most of his photographs are of subjects west of the Missouri River, where Adams has retraced the routes taken by earlier travelers, looking at the scenes that were part of their experience and photographing them in a twentieth-century context.

PLATE 129 *Bryce Canyon #2*
Laura Gilpin, American (1891–1979)
Platinum print, 1930 (9⅞ × 7⅞)
76.158/1

Gilpin is one of the few women ever to have met with success or recognition in landscape photography, a field traditionally dominated by men. She began photographing the southwestern landscape around 1915, and later published small booklets on the Pikes Peak region (1926), and Mesa Verde (1927).

In 1949 she published The Rio Grande: River of Destiny, a major study of the river and its impact upon the land and the people of the Southwest.

PLATE 130 *Rock, West Hartford, Connecticut*
Paul Caponigro, American (b. 1932)
Gelatin silver print, 1959 (10⅜ × 13⅛)
78.28/2

Caponigro's approach to the landscape clearly reflects the influence of his work with Minor White, who believed that photographs should express the essence of personal beliefs. Caponigro says that: ". . . my own interest in the stones was less with trying to ascertain their exact use or meaning, than in trying to record in the photographic image the atmosphere and magnetic power of these stone arrangements."

PLATE 131 *Untitled [Grasses in Water]*
Brett Weston, American (b. 1911)
Gelatin silver print, 1960 (7¹¹⁄₁₆ × 9⅝)
74.18/2

A master printer who does all of his own darkroom work, Brett Weston has strong feelings for the marked definition blacks and whites give. In this photograph, the blacks are spiked accents against the light backdrop of water and sand. While his father's work often accentuated the sensuous fullness of the landscape, Brett Weston's images are more abstract, dealing with the juxtaposition of forms and the power balance between light and dark.

PLATE 132 *Untitled [Branch against Flowering Hillside]*
Brett Weston, American (b. 1911)
Gelatin silver print, 1951 (10⅜ × 13⁷⁄₁₆)
65.156/8

As the second son of Edward Weston, Brett Weston bears the mark of his influence, yet is a master photographer in his own right. He apprenticed with his father in Mexico and, like Edward, has focused much of his work on the landscape and natural forms. Much of this work deals with the geometry of natural objects composed so that the photograph will have a strong force and rhythm.

PLATE 133 *Fog Bank*
Minor White, American (1908–1976)
Gelatin silver print, c. 1947 (3¾ × 4¹¹⁄₁₆)
82.6

This photograph is an opening plate in White's essay "Song Without Words," a sequence first exhibited in 1948 at the San Francisco Museum of Modern Art and later incorporated into his book, Mirrors Messages Manifestations. The essay is composed of seascapes made on the California coast. For White, the series explained a vision: "There must have been a long pause. A thought broke through. I don't know the words any more. What must animate my pictures from now on, I want no name for."

PLATE 134 *Wind Erosion, Dunes—Oceano*
Edward Weston, American (1886–1958)
Gelatin silver print, 1936 (7⁹⁄₁₆ × 9⁹⁄₁₆)
64.174

Weston photographed the dunes at Oceano between 1935 and 1937 when he was living in Santa Monica. The drifting dunes appealed to Weston not only for their abstract qualities, but also for the full, sensuous pattern that his eye could discern. Charis Wilson, Weston's second wife, marveled at the visual education that Weston's work on the dunes provided. At first, she says, it was difficult to equate the photographs and the tan sandhills; but as she studied the prints trying to decipher Weston's point of view, she was able to see the dramatic qualities that attracted Weston and his camera.

PLATE 135 *Storm from La Bajada Hill, New Mexico*
Laura Gilpin, American (1891–1979)
Gelatin silver print, 1946 (16 × 20)
Gift of Laura Gilpin
79.95/96

Gilpin regarded this dramatic landscape as one of her most successful photographs. The sharp, clear tones of the image reflect the new, hard-edged style that she adopted when she moved to New Mexico after World War II, and abandoned the softer atmospheric style of her earlier pictorial work.

PLATE 136 *Cedar Breaks National Monument, Utah*
Michael Smith, American (b. 1942)
Gelatin silver print, 1975 (7⅝ × 9⅝)
77.89/9

Smith is a self-taught photographer who works almost exclusively with large format landscape views. Although Smith's approach is direct, reference points such as horizon lines and spatial relationships are often skewed so that the viewer cannot lean on traditional visual cues to define the significance of the various elements. The resulting image fosters what Smith hopes is ". . . an exciting new interaction between itself and the viewer."

PLATE 137 *Storm near Santa Fe, New Mexico, 1965*
Liliane De Cock, American, born Belgium (b. 1939)
Gelatin silver print, 1965 (14¾ × 18¼)
74.23/4

Liliane De Cock came to the United States from Belgium in 1960 and moved to California where she took up photography. Her career has been nurtured by association with influential American photographers. Brett Weston recommended her to Ansel Adams, with whom she worked for nine years, and Barbara Morgan is her mother-in-law. Even so, her landscapes and portraits have an independent and personal point of view that Ansel Adams calls, ". . . a world of individualistic beauty and intensity."

PLATE 138 *Canyon De Chelly, Arizona, White House Ruins*
William Clift, American (b. 1944)
Gelatin silver print, 1975 (13½ × 19)
80.1/3

Clift lives and works in Santa Fe, New Mexico, and is inspired by the vast stretches of unspoiled landscape around him. In the tradition of previous generations of photographers who worked in the Canyon de Chelly, Clift's moonlight view of the White House Ruins evokes a majestic awe that encompasses the tremendous scale of the canyon and praises its natural beauty.

PLATE 139 *Sunrise, Mount McKinley, Mount McKinley National Park, Alaska. 1948*
Ansel Adams, American (b. 1902)
Gelatin silver print, 1948 (14¹⁵⁄₁₆ × 18¾)
69.26

Ansel Adams has been a staunch conservationist throughout his photographic career. Motivated by a deep concern for the protection of the natural environment, he notes that his work approaches ". . . the splendors and minutiae of elemental Nature . . . with a reverential lens." This photograph, produced while Adams held a Guggenheim Fellowship to photograph and publish material on America's national parks and monuments, was made at an elevation of 2,000 plus feet, 30 miles away from the mountain in a rare escape from the hazy fog that usually shrouds the 18,000-foot-high peak.

PLATE 140 *Plowed Field, Arvin, California*
William A. Garnett, American (b. 1916)
Gelatin silver print, negative 1951, print later (19⅞ × 15¹³⁄₁₆)
81.73

Although Garnett made architectural and criminological photographs before a World War II stint in the Signal Corps as a motion picture cameraman, he is best known for his aerial photography. Garnett is a pilot who uses his plane as a tool to direct his photographic vision. His work reflects the often sensuous beauty of the abstract forms, textures, and colors of a landscape in which individual elements are subordinate to the overall pattern.

Portraits of Photographers

Alfred Stieglitz, An American Place
Ansel Adams, American (b. 1902)
Gelatin silver print, negative 1938, print
1969 (11¹¹⁄₁₆ × 8⅝)
69.21

Wynn Bullock
Imogen Cunningham, American (1883–1976)
Gelatin silver print, 1960 (7¾ × 7¾)
78.113

Self-Portrait, Monument Valley, Utah
Ansel Adams, American (b. 1902)
Gelatin silver print, 1958 (12¼ × 9½)
78.70

Ben Shahn
Walker Evans, American (1903–1975)
Gelatin silver print, negative 1934, print 1971
(3¹⁵⁄₁₆ × 5⅞)
78.71/2

149

Berenice Abbott
Consuelo Kanaga, American (1894–1978)
Gelatin silver print, c. 1930 (10 × 7⅞)
78.26

Self-Portrait, Curtain for Hat
Walker Evans, American (1903–1975)
Gelatin silver print, 1928 (4¼ × 2⅞)
78.48/4

Edward Weston
Tina Modotti, Mexican, born Italy (1896–1942)
Gelatin silver print, c. 1923–1924 (3¼ × 4)
80.38

150

Beaumont Newhall and Ansel Adams Jumping
Barbara Morgan, American (b. 1900)
Gelatin silver print, negative 1942, print 1970
(14 × 16½)
74.21/15

Charles Sheeler and His Favorite Beech Tree
Barbara Morgan, American (b. 1900)
Gelatin silver print, negative 1945, print 1971
(12¾ × 10¼)
72.9

Laura Gilpin
Mary Peck, American (b. 1952)
Gelatin silver print, 1978 (7¹³⁄₁₆ × 9¹¹⁄₁₆)
Gift of Mary Peck
80.7

Clarence White
Edward Steichen, American, born Luxembourg
(1879–1973)
Photogravure, (from *Camera Work*, no. 9),
negative 1903, print 1905 (8½ × 6⁷⁄₁₆)
Gilpin Bequest

Portrait of Gertrude Käsebier
Clara Sipprell, American, born Canada
(1885–1975)
Platinum print, 1914 (8⁷⁄₈ × 6⁷⁄₈)
80.32

153

William Henry Jackson
Charles Tremear, American (c. 1866–1943)
Daguerreotype, c. 1939 (2½ × 2)
71.73/1

Dorothea Lange
Paul S. Taylor, American (b. 1895)
Gelatin silver print (mounted on wood block),
1935 (4 × 3½)
77.43

Ansel Adams
Edward Weston, American (1886–1958)
Gelatin silver print, 1943 (7½ × 9⅝)
73.6

Index of Photographers

PHOTOGRAPHER PAGE(S)

Berenice Abbott 99, 102
Ansel Adams 124, 134, 149
Robert Adams 127
Robert Adamson 12
George Barker 29
George Barnard 25
David F. Barry 56
Charles M. Bell 56
William Bell 37
Ruth Bernhard 100
Alice Boughton 72
Margaret Bourke-White 110
Wynn Bullock 90, 127
Paul Caponigro 128
William Clift 133
Carlotta M. Corpron 101, 109
Imogen Cunningham 149
Edward S. Curtis 77, 78, 85
Liliane De Cock 132
Baron Adolf De Meyer 67
Nell Dorr 95
Thomas Eakins 59
Walker Evans 92, 112, 119, 123, 149, 150
George Fiske 39
Oliver Gagliani 91
William A. Garnett 135
Arnold Genthe 68-69, 80
Laura Gilpin 62, 66, 71, 94, 96, 105, 121, 127, 130
Paul Grotz 98
John Gutmann 97
Josiah Johnson Hawes 19
Frank Jay Haynes 31
David Octavius Hill 12
John K. Hillers 30, 47, 53
Lewis Wickes Hine 111, 113, 116, 118
Laton Alton Huffman 57
Leopold Hugo 83
William Henry Jackson 20, 28, 34, 38, 41, 45, 46
Consuelo Kanaga 150
Gertrude Käsebier 79

Charles D. Kirkland 52
Dorothea Lange 86, 95, 115, 121
Danny Lyon 126
Ira Martin 73
Tina Modotti 150
Frederick Imman Monsen 76
John Moran 26, 27
Barbara Morgan 106, 107, 151, 152
Eadweard Muybridge 35, 54-55
Timothy H. O'Sullivan 26, 42
Paul Outerbridge 67
Mary Peck 152
Harrison Putney 48, 51
William Herman Rau 44
Jane Reece 74
Arthur Rothstein 114
Ben Shahn 122, 123
Charles Sheeler 113, 116, 117, 120
Clara Sipprell 82, 153
Michael Smith 131
Albert Sands Southworth 19
Edward Steichen 108, 153
Ralph Steiner 104, 112
Alfred Stieglitz 81, 84, 93
Paul Strand 102, 104
Karl Struss 81
I. W. Taber 32, 58
Paul S. Taylor 154
George Trager 58
Charles Tremear 154
Willard Van Dyke 119
Carleton E. Watkins 2, 33, 34, 36, 40
Charles Leander Weed 59
Brett Weston 128
Edward Weston 75, 103, 118, 129, 154
Clarence H. White 70
Minor White 129
John Wood 61
Louise Deshong Woodbridge 73
Willard Worden 43

Masterworks of American Photography
The Amon Carter Museum Collection

Designed by
Design for Publishing, Inc., Bob and Faith Nance
Homewood, Alabama

Text composed in Linotron Bembo by
Graphic Composition, Inc.
Athens, Georgia

Film prepared by
Classic Color
Dallas, Texas

Printed and bound by
Kingsport Press, Inc.
Kingsport, Tennessee

Text sheets are Lustro Offset Enamel Cream by
S. D. Warren Company
Boston, Massachusetts

Endleaves and front sides are Elephant Hide by
Process Materials Corporation
Rutherford, New Jersey

Spine and back are Sturdite by
The Holliston Mills, Inc.
Kingsport, Tennessee

PUBLISHER'S NOTE:

Oxmoor House, *in an effort to produce a volume of singular excellence, chose to use a four-color process in reproducing the original black-and-white photographs in this collection. In this way, the antique qualities and subtle color variations (due either to primitive photographic processes or to discoloration from aging) were more accurately depicted.*